Photographing
Changing Light

Photographing
Changing Light

A Guide for Landscape Photographers

Ken Scott

photographers'
pip
institute press

First published 2004 by

Photographers' Institute Press/PIP

166 High Street, Lewes

East Sussex, BN7 1XU

ISBN 1 86108 380 7

British Cataloguing in Publication Data

A catalogue record of this book is available from the British Library.

Publisher: Paul Richardson

Art Director: Ian Smith

Managing Editor: Gerrie Purcell

Commissioning Editor: April McCroskie

Production Manager: Stuart Poole

Editor: Gill Parris

Designer: Danny McBride

Photographic credits: Cliff Carter, front cover, bottom row, second from right, and pp. 147, 149, 154 col. 1, 156 and 157

Wayne Gosden, front cover inside flap

All other photographs were taken by Ken Scott

Typeface: Clearface, Antique Olive

Colour reproduction by Graphics Kent

Printed and bound by Stamford Press in Singapore

FRONT COVER PHOTOGRAPHS

Top left: Winter Sunlight and Barn, near Durdonnell (p. 159); Top right: Snowdonia Ridges (p. 83); Bottom left: Layered Reflections,
Llyn Llydaw (p. 63); Second from left: Stacked Ridges, Grand Canyon (p. 70); Bottom right: Mist on Thornthwaite Beacon (p. 106).

BACK COVER PHOTOGRAPHS

Top left: Weisskugel in Morning Light (p. 42); Top right: Fireclouds, Glaslyn (p. 111); Bottom left: Downland Riders (p. 91);
Bottom right: Evening Gale, Hove (p. 138).

PREFACE

Almost all of the images in this book were made as a personal response to an experience of the light and the land, very much of the moment. When I released the shutter, I had no pre-determined aim or intended message. It is only over time that the photographs have assumed an identity through the memories and feelings they invoke for me.

I have chosen the mountain images in this book primarily to illustrate my approach, because mountains are my passion and a great playground for changing light; you should feel free to apply the ideas to your own passions.

Changing light, as a subject, is self-evident. Through the interaction of light and land the landscape is constantly moving, never static, and here I explore how we, as photographers, can come to understand and be more aware of what is happening at any moment. We can learn how to predict and to make our own luck. Then we can be in the right place at the right time, responding intuitively with appropriate photographic techniques. My aim is to convey the excitement whilst also attending to the practical matters, in terms of important principles of using the camera.

Everyone will see something very different in each photograph, in the same way that we see things very differently in the real world; this is illustrated well when two photographers produce totally different results from the same shoot. But, whatever your perceptions, you will find in this book nature in its many guises: topography, geology, physical geography, meteorology, and, occasionally, evidence of man's interventions.

I hope that you will be able to involve yourselves in the images, and also that you will see new things in your appreciation of the landscape. Above all, if you are inspired, go out tomorrow, newly refreshed with knowledge of how beautifully simple photography can be.

Finally, consider for a moment the fragility of the natural world. It will be tragic if in some future time the only remaining trace of our wonderful landscapes lies in our photographic records. Surround yourself with beauty, for it is good for the soul. Appreciate it and take the very best care of it.

Ken Scott

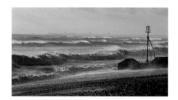

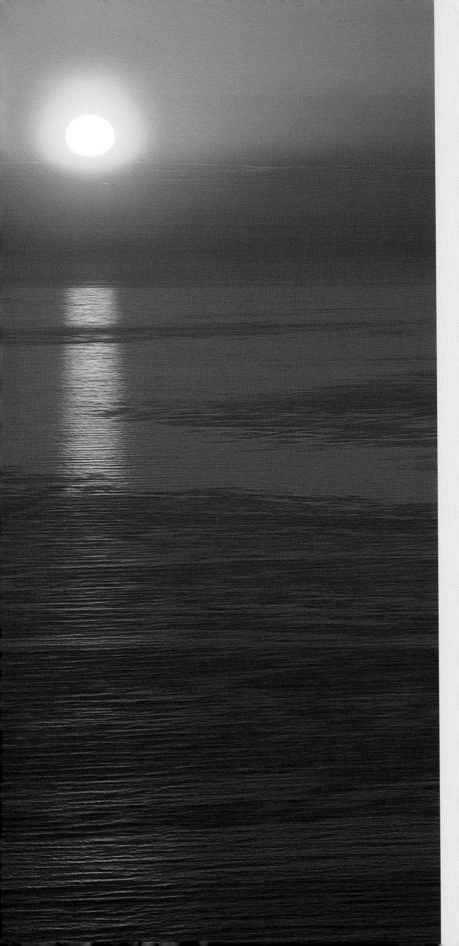

CONTENTS

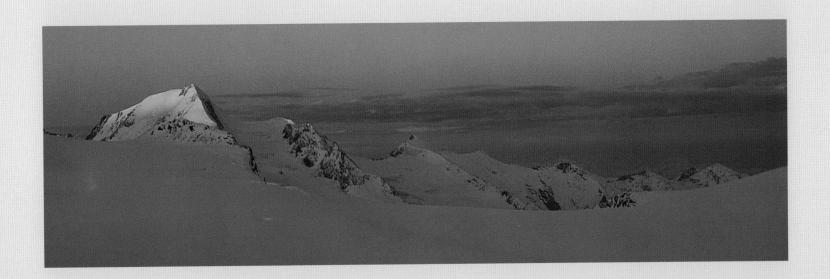

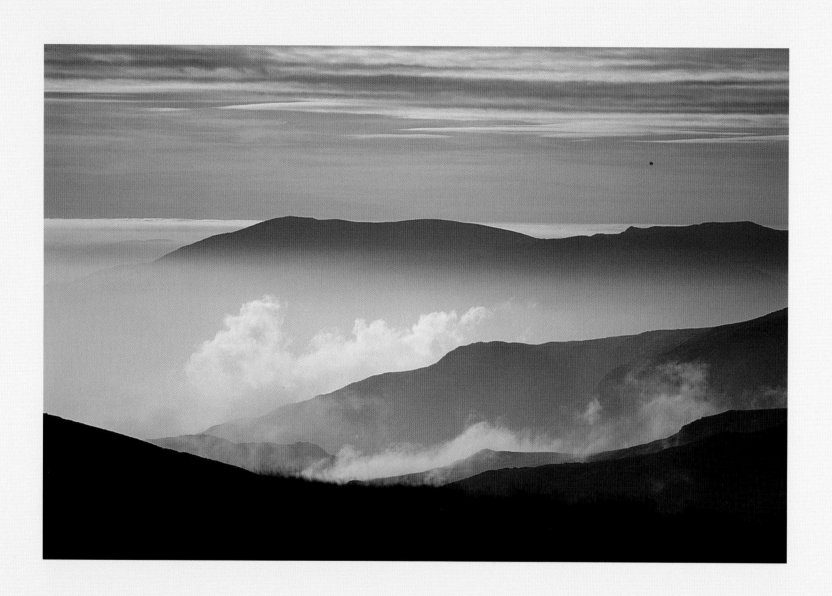

INTRODUCTION

I started taking photographs in the late 1970s and early 1980s in the usual way, making photographs as a record of my travels and early adventures in the mountains. The mountains excited me hugely; it was not so much the physical challenge of climbing, as the experience of space, the peace and tranquillity, and the ever-changing light and cloud on the ridges.

Beautiful scenes would continually come into view, coinciding from time to time with wonderful light. Occasionally, I enjoyed the luxury of being able to watch, to wait patiently, to choose the moments to capture with the camera. At other times, a scene would present itself unexpectedly, demanding an instant and intuitive response.

I knew little about photography then, but I did like some of my images, and I was aware that the photographs I liked the most had something in common: the quality of the light, various in endless ways. My failure rate was high, though, and during this time I read many books and looked at countless photographs in an attempt to teach myself more formally what photography was supposed to be about. But what I was reading about photographing the landscape seemed, mostly, to be at odds with my own experiences.

The books were telling me that landscape photography was a patient, waiting game. I should plan ahead, arrive at a location with a tripod, set it up carefully with a considered composition, and wait for the light to happen. A tripod, it seemed, was essential for the sharpness of the image, yet for me its use seemed very static and killed the spontaneity of the moment.

I realize now that this 'traditional' approach was rooted by necessity in the heavy equipment used by photography's pioneers. Ansel Adams, for example, broke new ground by hauling his large-format plate cameras, plates and developing tanks into the wilderness of North America. Adams had no choice but to use his cameras in a considered and deliberate manner: the camera was too bulky to hold by hand, and the plates demanded long exposures. The plates were also scarce, and each one demanded absolute attention to exposure and detail of composition so as not to waste it. Adams' results were, of course, stunning in sharpness and clarity. The approach was right for its time, and it is still appropriate today in certain situations of light, and for photographers using larger-format cameras. However, modern lightweight equipment, coupled with good technique, does not have these limitations. It is perfectly suited to a more active approach to landscape photography, in keeping with the pace of changing light.

For a long time, despite my instincts, I thought that I was doing it wrong. The encouragement I needed, though, came in the mid-1980s when I first discovered the work of British expeditioner John Beatty, and American mountaineer Galen Rowell. These guys were truly engaged with the subject of their photography, using a camera intuitively and actively to capture the very essence of the landscape. Similarly, I was captivated by the expedition images made by great climbers like Chris Bonington and Doug Scott.

I believe that there are two essential aspects to developing a responsive and intuitive approach to photographing the changing light: firstly, we must be aware of light, and think about photographing light, as opposed to photographing things or places; secondly, the best photography comes from being passionate about, and fully engaged in, the subject or the environment.

The importance of light, and the changes in light are illustrated in Section 1, which compares images that were made in the same place at different times and in different light. The pairs of images cover just a few minutes, consecutive days, different seasons, and, in some cases, several years. My aim is to demonstrate photographically that returning to a place almost guarantees you a new experience of light.

Section 2 explores how we can become more at one with the landscape, through a selection of images that required no special technique. They are intuitive compositions of light that seemed to present themselves.

Sections 3 and 4 explore two particular types of responsive photography that become possible when we are fully engaged: in Section 3 we look at those moments in landscape photography where a scene of changing light demands either an instant and intuitive response, or a more traditional waiting game to capture the precise moment in time; while in Section 4, we look at capturing movement (of water or light particularly) and explore the changing perspectives of lens and viewpoint to create more elusive compositions.

In each section I encourage the use of simple, affordable, equipment. Almost all of the images in this book were made using a simple Pentax ME Super 35mm camera, many with the standard 50mm lens. It is a camera I know extremely well and use intuitively.

Throughout the text, I refer to the principles of techniques I have used. I have tried to keep these as simple as possible so that they may become spontaneous, and I have tried to be generic.

The colours and nuances of natural light are so various that it seems almost criminal to alter them in any way, so I have not used filters for the images in this book (save for a skylight 1B and the occasional polarizer). If the light is not right, then return another time – or make a pair of images, as in Section 1.

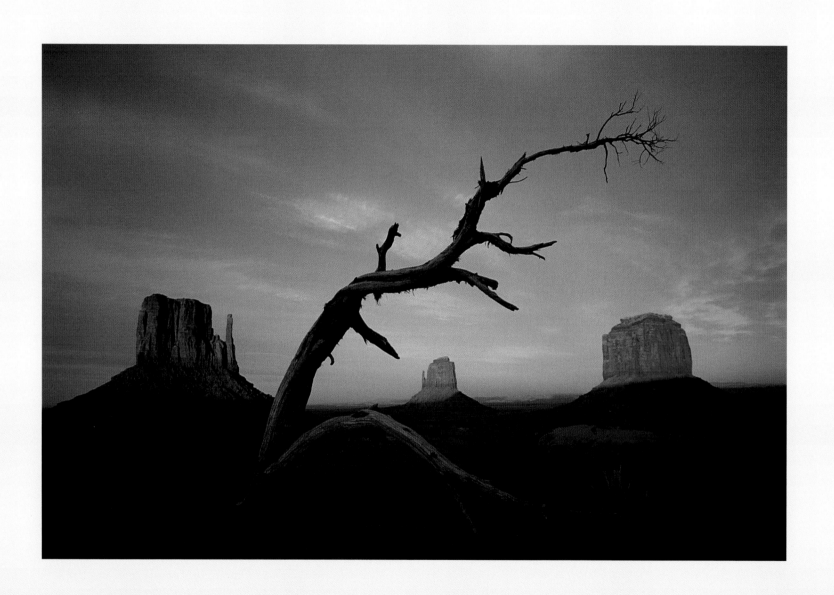

Section 1 **Change** in the landscape

Open to Change

Most of the time I do not set out to photograph a place. Places do not change much. Light, however, changes hugely, and it is the quality of light that is often the difference between an interesting photograph and a truly exciting one.

Most photographers understand this, but often our approach to landscape photography is still based on place. This is illustrated by a tendency to take many more pictures on holiday than when at home. When we travel, the places we visit are new and exciting to us, and we are inspired to take photographs. At home, though, in familiar surroundings, there is a tendency to take places for granted.

When the intention is to photograph a place, we tend to accept whatever light prevails, even if we have planned, for example, to be there in the early morning or late afternoon to take advantage of low-angled sunlight. If light does not happen, we take the photographs anyway and put the disappointing results down to bad luck. Worse, we place a coloured filter on the lens and make what may be an attractive image, but one which is ultimately unreal. Conversely, if we are blessed with good light, we attribute our successes to planning and other skills. This is simply human nature.

When, however, we seek to photograph light, we open ourselves to an infinite world of possibilities. We begin to learn when it happens, and to predict it. We can begin to make our own luck and put ourselves into situations where light can work for us, into places where the light interacts in the best ways with the land.

It is light that breaks me out of my routine. Sometimes it is the sudden onset of exciting light that switches me into action; at other times it is the promise of light, perhaps a clearing storm or the approach of a cold front in late afternoon. Wherever I am, I try to be sensitive to light, to approaching weather, to change, so that I can respond appropriately when it happens.

Dramatic change occurs almost without registering in our day-to-day perceptions: whether it be the changes of season, or the daily cycle of light from dawn to dusk – and on into moonlight. In the images that follow, we will experience change in all its guises, subtle changes in colour over several minutes. We will revisit the same places on different days, sometimes in different years, to photograph new light on familiar scenes.

Exercises

1. Look through your collection of images and find six or so that you really enjoy from different places, preferably close to home. Revisit the places at least once, taking a reference print with you. For some of the time, do not even think about photography; simply allow yourself to take in what you see. In whatever light prevails, make an image with precisely the original composition. You will not have made that image before.

2. Over the course of several days, look out of your window. Just appreciate the light, the shadows and contrasts, the shapes and the colours. Notice the sky, from hazy white to deep blues. Is there a difference between morning and evening? Record your thoughts in a notebook. Make a series of images.

Rock Spires, Glyder Fach – Snowdonia National Park, North Wales, 1990 and 1995

Glyder Fach and its neighbouring summit Glyder Fawr are characterized by huge, chaotic heaps of boulders created by thousands of years of thermal action.

On the descent from Glyder Fach, between the two peaks, there is this prominent set of spires.

50mm lens, exposure metered from sky and bright mist in a wider view to let shadows go to silhouette, Fuji Velvia

Conditions on the winter day of the first image were perfect for photography. Mist was lingering below in the valleys and the air was crystal clear. Passing the spires I was struck by the way that they formed a perfect mountain profile against the sky. My immediate instinct was to try to represent them in such a way as to elevate their 6m (20ft) height to the apparent scale of mountains much greater.

Crouching down, or standing up higher, is a great way to open up or close down a scene. In this case climbing higher opened up the horizon, allowing me

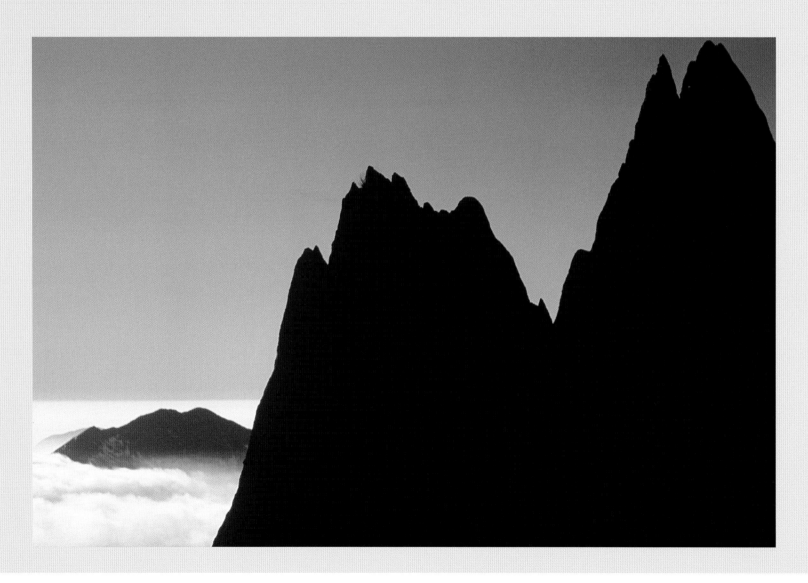

to include the peak of Lliwedd and the mist. At the same time, getting down low increased the apparent height of the spires. Combining these two techniques created the scale of this image.

There is always a strong temptation to return to a place of inspiration, to remake a classic image. I crossed the mountains again in 1995 on a pleasant but ordinary day in the height of summer. Although some clouds provided a little interest in the sky, there was nothing inspiring about the flat, midday

light and hazy air, and the spires no longer resembled the high peaks of before, especially as the grass had grown taller.

Light in the landscape changes constantly, almost guaranteeing that we will never take the same image twice.

50mm lens, small aperture for depth of field, Fuji Sensia ISO 100

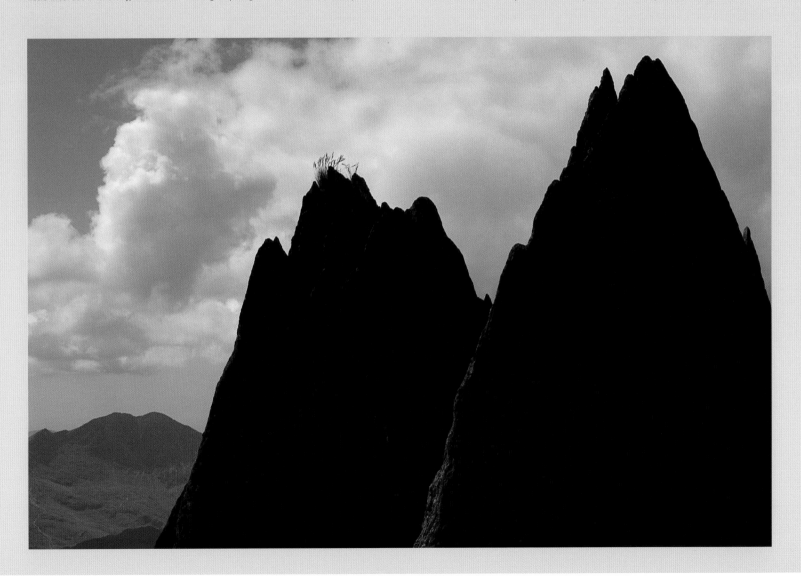

Solitary Tree – near Upper Beeding, West Sussex, England, 1991

This solitary dead tree stood in the Adur valley close to my home, and became the subject of frequent visits until it was felled. We are often apt to forget or ignore places that are close to home, yet they provide the best opportunities to make photographs of familiar places in new light. These two images were made just one week apart in the winter of 1991.

24mm wide-angle lens, hyperfocused at a small aperture to retain sharpness in the foreground grass and the tree, Fuji RF50

The light in this view of my tree and the distant South Downs was watery, creating just the hint of shadow. A balanced composition including both the tree and the hills required a wide-angle lens, but this also created a very empty foreground. In open country, clumps of grass or arrangements of rocks provide ideal foreground fillers.

This second image was made just a week later when the temperature had soared to 15°C (59°F). The bright morning sun and deep-blue sky led me to consider a slightly different composition. I was also helped on this occasion by

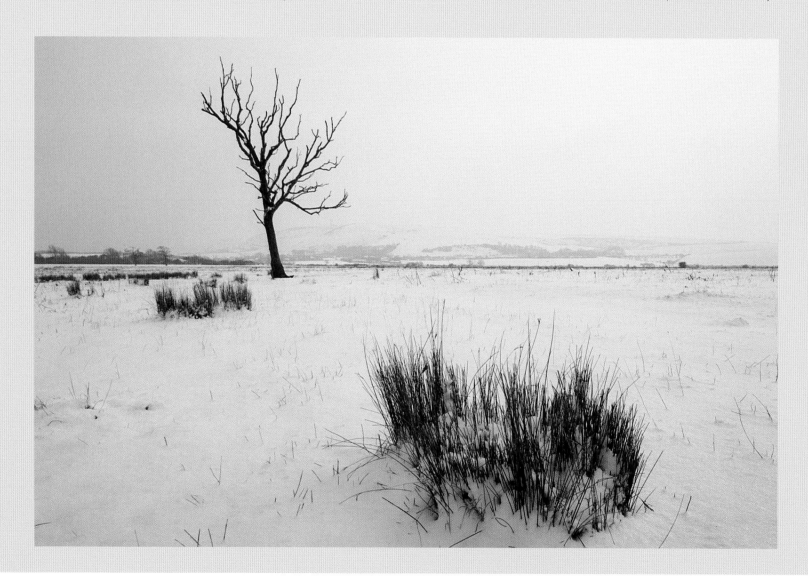

the aircraft trails. Coupled with the line of grasses, they form a strong arrow effect, leading the eyes to the tree and the South Downs beyond.

Britain's changeable weather is legendary. We are located in what mountaineer Martin Moran calls a 'battleground' of air masses, cold Arctic air to the north, warm tropical air to the south, dry continental air to the east and moist Atlantic air to the west (Moran, 1988). These ever-shifting air masses cause dramatic changes, where one day or week can be unrecognizable from the previous one.

24mm wide-angle lens, small aperture for depth of field, polarizing filter, Fuji RF50

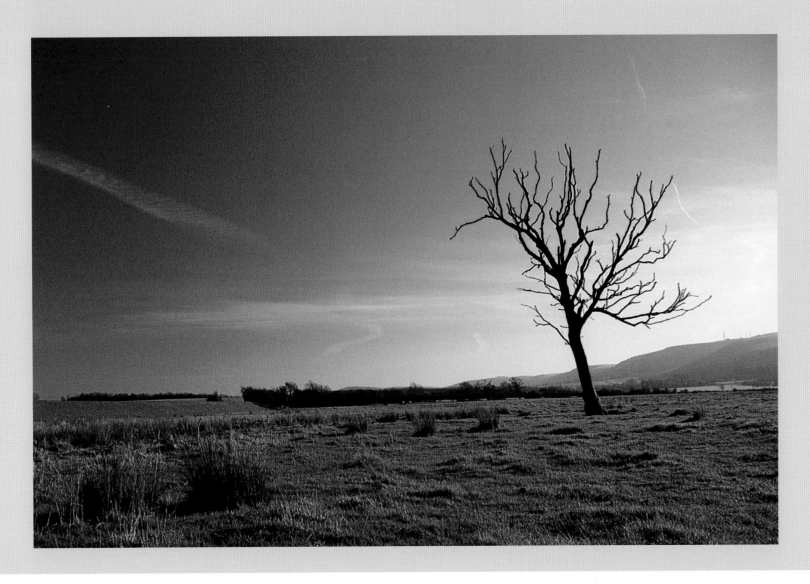

Footprints in the Sand – Coralejo Dunes, Fuerteventura, Canary Islands, 1998

When the skies are clear, there is often a soft, glowing quality to the light just before sunrise or after the sun has dipped below the horizon. These two images, made 20 minutes apart at sunset, illustrate the difference between the strong shadows and contrast of the warm, direct light, and the delicate textures during the afterglow.

The Coralejo dunes are close to a crowded holiday town and popular beaches. It is easy to find peace and solitude in this expanse of sand, but footprints provide evidence of people's daytime explorations.

This captured my imagination. We leave our human mark all over the landscape, yet in the morning these tracks would be gone, erased by Fuerteventura's persistent breeze.

24mm lens, hyperfocused to retain sharpness in the nearest footprint and the dune, Fuji Sensia ISO 100

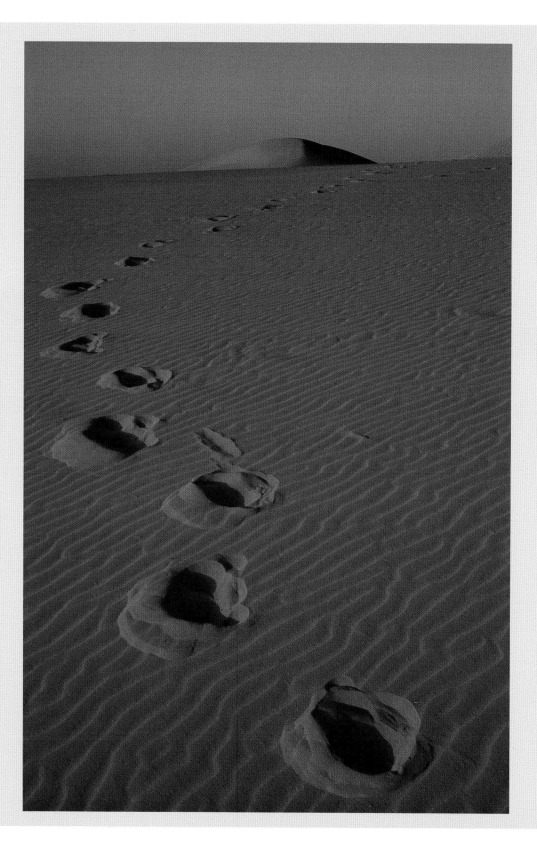

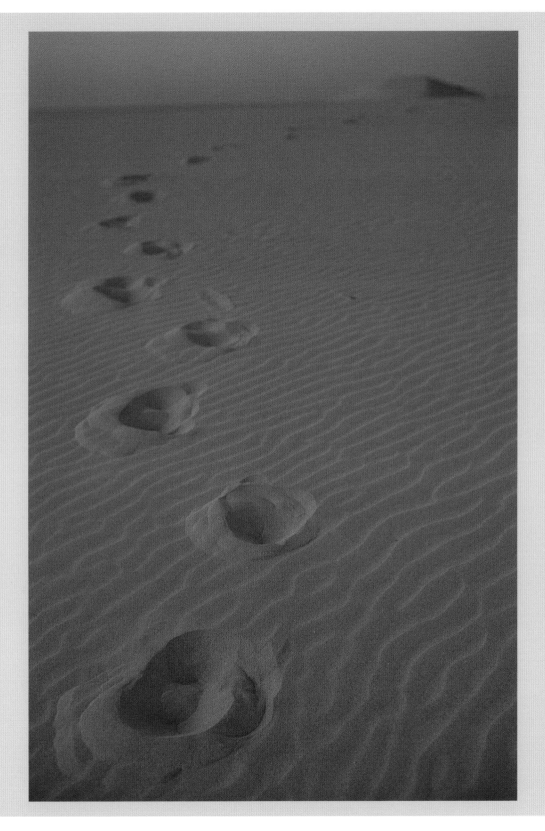

When I passed by the footprints again, I did not consciously vary the composition; I simply responded to what I saw in new light and made the image quickly and intuitively. Darkness falls quickly here, and we were still some way from the car.

Photographers often wait for the light. But how often do we stay to observe and capture what happens when the light is gone?

24mm lens focused on the nearest footprint, wider aperture letting the dune soften out of the plane of focus, Fuji Sensia ISO 100

Ben Alder from Culra Bothy – Scottish Highlands 1995

Dawn in the UK is preceded by a period of twilight. In calm, stable weather with clear skies, this twilight often glows, almost as though light is coming from the ground. Britain has no mountains high enough for a true 'alpenglow' effect, but this is somehow quite similar.

50mm lens, wide aperture to gain shutter speed in low light, Fuji Sensia ISO 100

We had walked the 19km (12 miles) from Dalwhinnie to Ben Alder, a high and remote massif in the Scottish Highlands, for a week's winter walking based at the Culra Bothy.

On the first morning I was woken by first light, and instinctively turned my first thoughts to what the light might be doing outside. The mountain was bathed in a soft, warm light. Light levels, though, were very low, and I had to choose a wide aperture to gain sufficient shutter speed, even when lying down to brace my elbows on the ground.

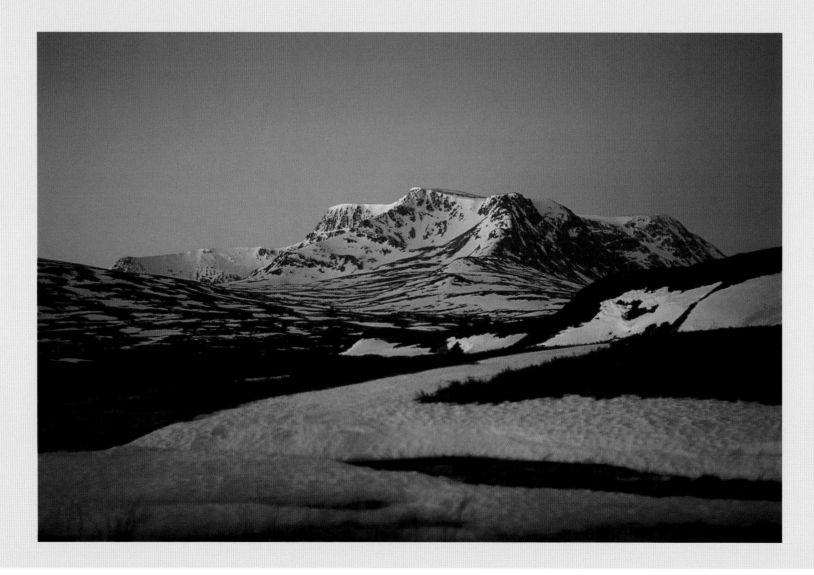

Ten minutes later the sun had risen just above the horizon, fringing the corniced ridge of Ben Alder with golden light. The ethereal glow of pre-dawn vanished, leaving a much cooler but generally brighter scene.

One needs a special kind of motivation to give up a warm bed for the dawn, but the rewards of light are often very special. On this occasion the overnight temperature had fallen to -15˚C (5˚F).

50mm lens, mid-range aperture, Fuji Sensia ISO 100

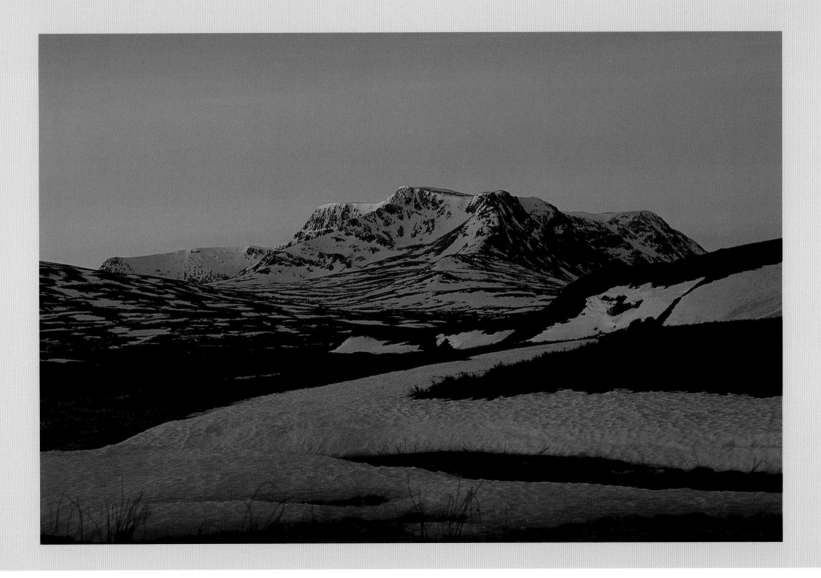

**Dusk and Dawn – Rhinog range, Snowdonia National Park,
North Wales, 1997**

The Rhinog mountains, inland from Harlech on the North Wales coast, are rough and inhospitable. Their modest height means that they are less frequented than the higher hills of Snowdonia. This and their ruggedness make them attractive to seekers of solitude.

200mm lens, Fuji Sensia ISO 100

We had made a camp beside a tiny lake on a rocky bluff to the north of Rhinog Fawr. Here we could look out over the Irish Sea to the west, and eastwards to the Aran mountains near Bala, giving uninterrupted views at dusk and dawn.

In the evening, the colours were rich and deep. This image required no thought, just a steady bracing of the camera to hold the 200mm lens. It was my favourite of a sequence made at a very leisurely pace as the sun dipped into the haze.

If there were one experience I would urge everyone to have just once in a lifetime, it would be to witness the dawn from a high mountain.

The next morning I ensured that I was ready for the sun to appear over the ridge to the east of the mist-filled valley below. Framing the image to include the silhouette seemed to capture the peace of the moment.

50mm lens, small aperture for depth of field, Fuji Sensia ISO 100

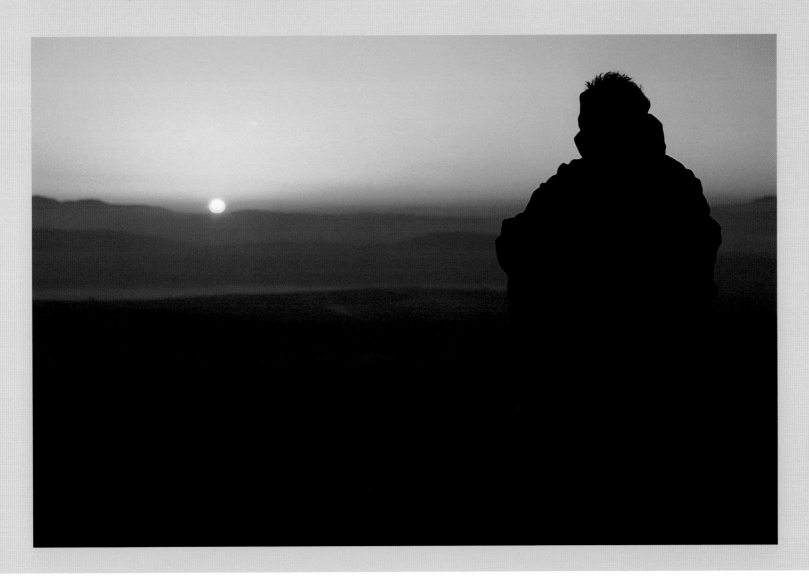

**Moelwyn Mawr from Pont Garreg-Hylldrem –
Snowdonia National Park, North Wales, 2002**

The road from Beddgelert towards Porthmadog is
beautifully scenic, softer and greener than the
rocky confines of higher passes of Snowdonia to
the north. Near Garreg is a picturesque stone
bridge, from which opens up a magnificent view
inland to the statuesque little peak of Cnicht, and
Moelwyn Mawr.

This image was made on a bright and sunny day,
using the obvious line of the stream to complete a
simple composition.

50mm lens, Fuji Velvia ISO 50

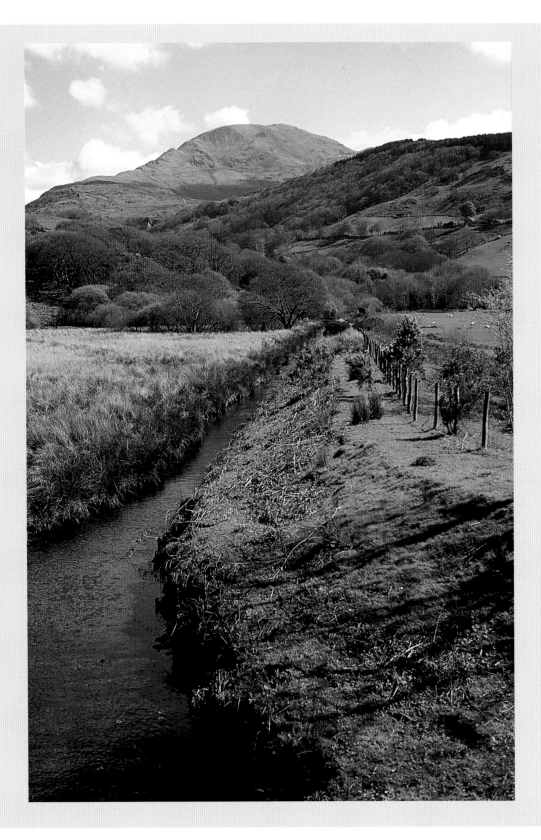

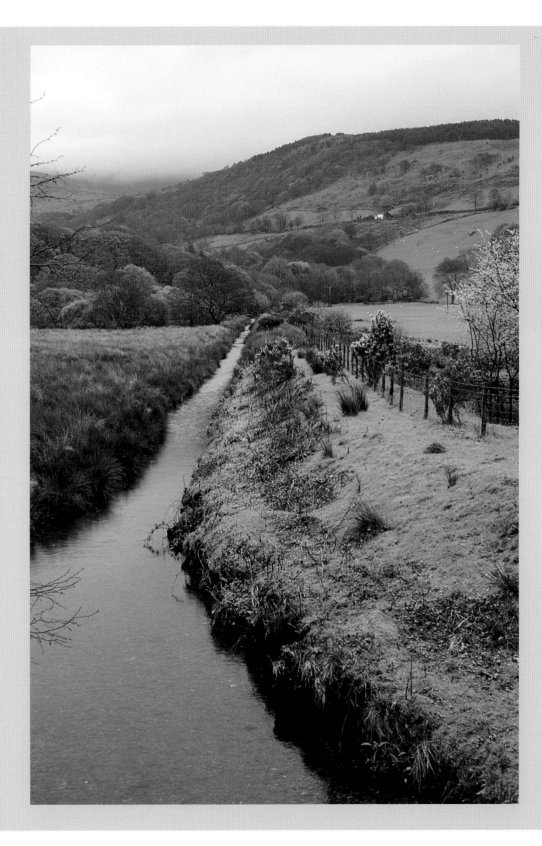

Two days later, it was a dank, wet afternoon. The distant hills were obscured by fog, but the colours seemed to be just as rich – if not richer – in the soft light, as in bright conditions and I repeated the image.

Fuji film has the capacity to reveal rich colours even in flat light, but it is not to everyone's taste.

50mm lens, Fuji Velvia ISO 50

Mitten Buttes and Tree – Monument Valley, Utah, USA, 1989

This style of image from Monument Valley, with fiery red rocks at dusk, has become something of a cliché. Nevertheless, I have included these illustrations because they are a perfect example of the way in which strong light can transform an image.

50mm lens, Fuji RF50

We had arrived at Monument Valley, a Navajo tribal park, in the afternoon, timing our self-drive around the rough roads so that we would be exiting at the time when light should be at its strongest.

Throughout the afternoon the light was flat but bright. Unfortunately, on our travels we are not often able to wait indefinitely for good light, and it is impossible to tell whether it will arrive at all. For this reason it is always good policy to 'bank' a couple of shots, even if at home you might come back another day.

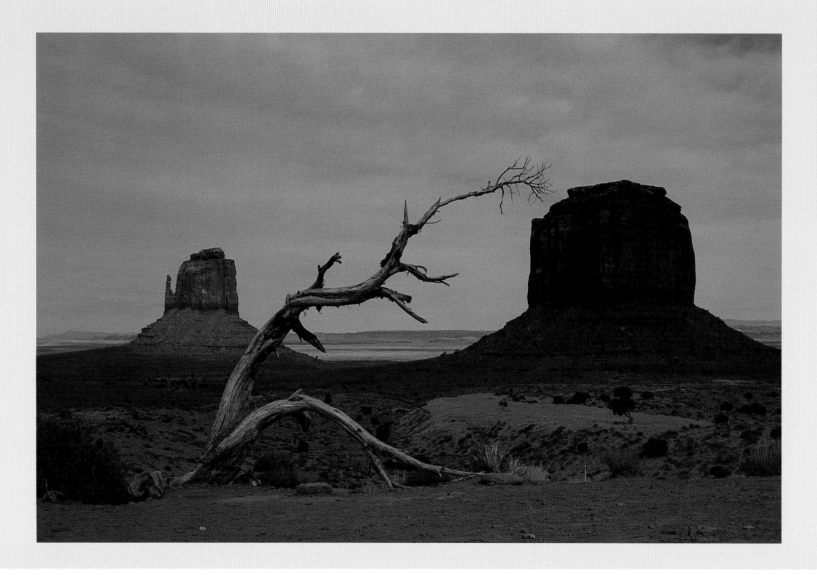

This old tree made an interesting foreground to the buttes and I made a mental note of the location.

The light came suddenly. There were earlier images to be repeated, and new ones to be made where I had earlier passed them by. There was little time and the shadows seemed to be racing up the rock faces. I switched into rapid-response mode: running, crouching, driving on, changing lenses.

In a fast-breaking situation like this, I would have made just one or two images had I used a tripod. This would have been one image, but I would have missed the others (see image on page 94). On another visit, the waiting game might be the right approach. (The choice between fast response and patience is explored more fully in Section 3.)

24mm lens, Fuji RF50

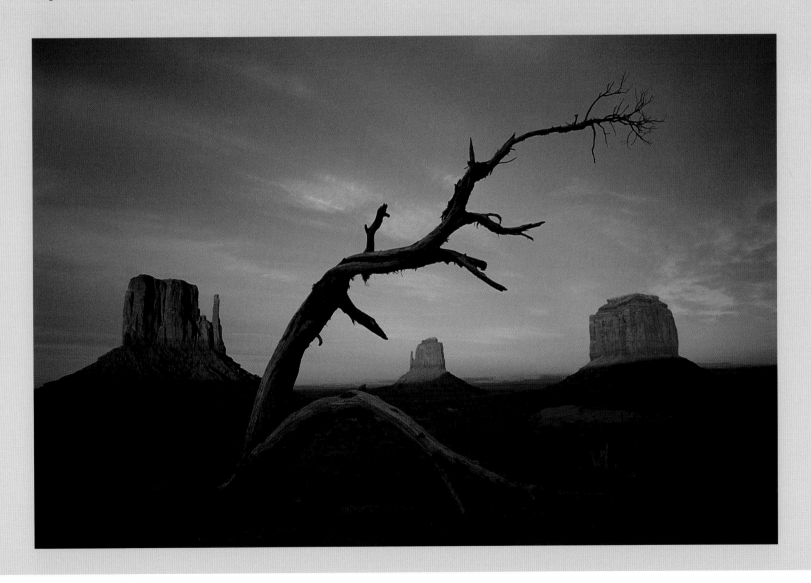

Loudenvieille – Val Louron, French Pyrenees, 1999

This region of south-west France is blessed with beautiful villages, spectacular mountain scenery and some of the best wholesome food to be found anywhere. Loudenvieille is a popular holiday base and a regular finish for mountain stages of Le Tour de France. We had arrived in early afternoon, at the end of a strenuous trek.

50mm lens, polarizing filter, small aperture for depth of field, Fuji Sensia ISO 100

Midday lighting in summer is normally deadly to landscape photography. High sun and haze combine to suppress contrast and colours, and shadows are short. Here though, the air was clean and crisp. This composition from the town bridge was instinctive, with the trees and the river providing an ideal foreground and framing. I was also struck by the rich greens and blue sky.

Sudden storms often provide a great opportunity for rapid-response photography. A violent thunderstorm swept through the mountains the following morning, then came five minutes of brilliant light. I ran back to the

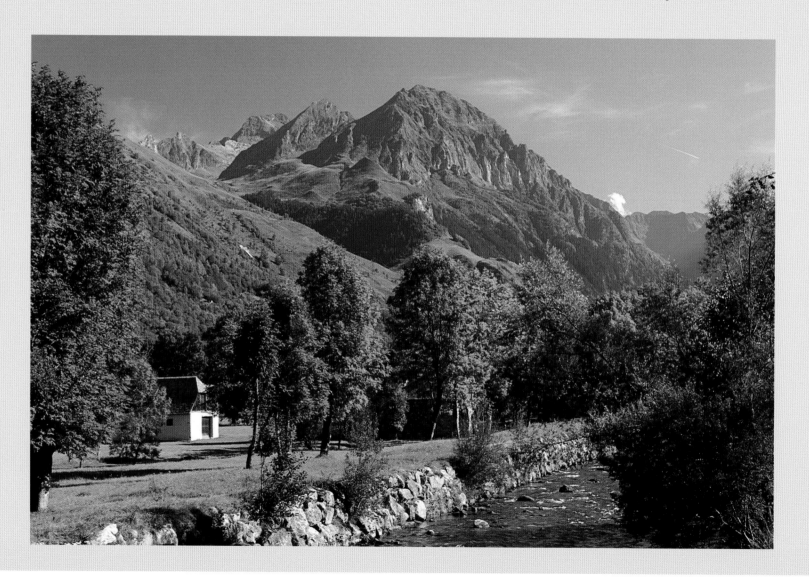

bridge to catch the storm clouds clearing the summits, but I still had to wait for the foreground light. It came and went, and luck had it coincide with a clear mountaintop. I was ready.

A polarizing filter not only enriches colours. Most importantly, it is able to remove the reflections from foliage that are so troublesome in sunlight, causing distracting highlights.

The parapet of the bridge also provided a perfect support for my elbows. Two elbows and two legs make a 'quadrupod'.

50mm lens, small aperture for depth of field, Fuji Sensia ISO 100

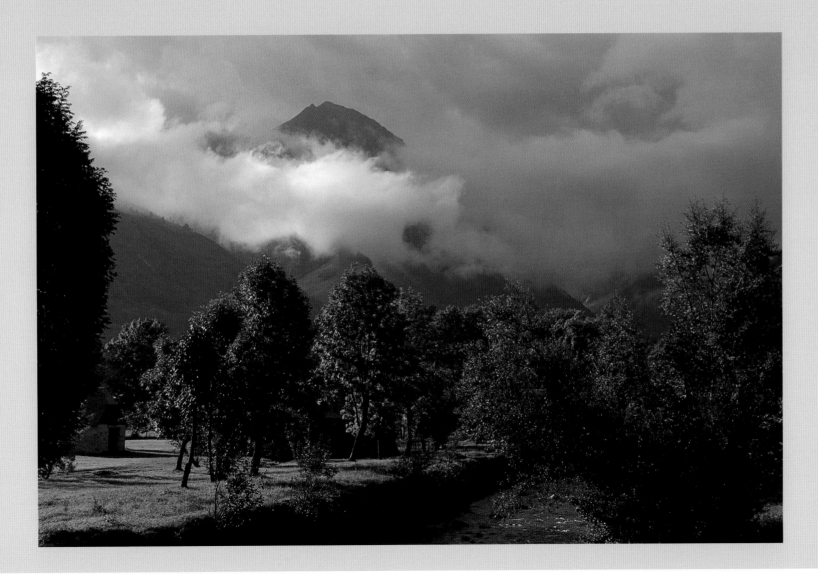

Summit Wall, High Street – Lake District National Park, England, 1994 and 2002

The mountains of England and Wales are still farmed extensively. Sheep roam freely and boundaries are marked by dry-stone walls that often run for miles over the felltops. High Street is the highest top in a fascinating group of hills to the east of the Lake District.

I explored High Street on a cold but calm day in early March. The preceding week had seen heavy snowfall followed by strong gales that had blasted the fells clear of most of the lying snow. Behind the wall, though, I was enthralled to find these fantastic sculptures. As the wall had disrupted the windflow, so eddies and vortices on the lee side had carved out the drifted snow bank.

After some experimentation, I found a balanced arrangement, which includes both the wall and the summit of High Street to give the natural artwork a context.

50mm lens, small aperture, hyperfocused for depth of field, Fuji RF50

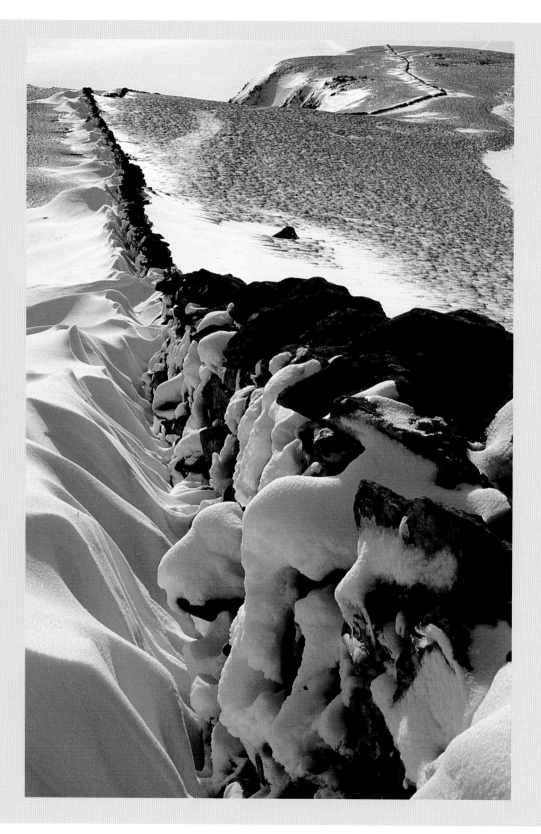

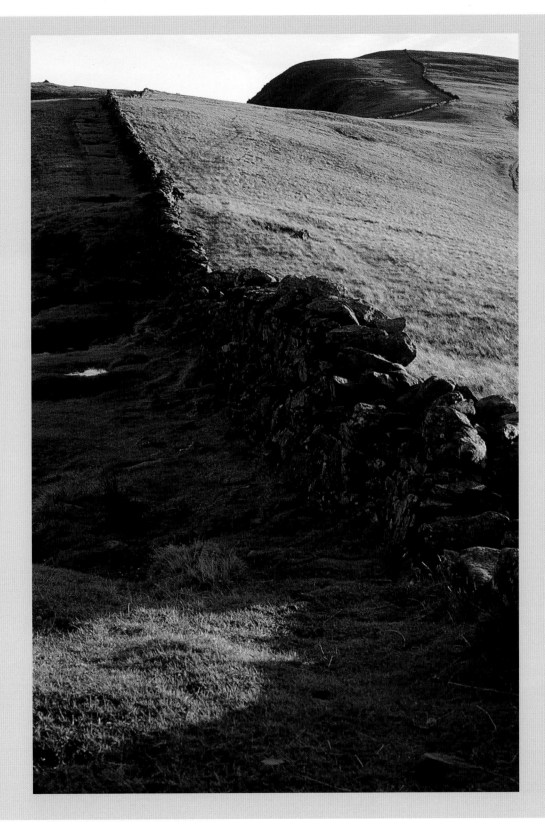

The second image was made deliberately in the knowledge that the first was successful. I reframed the image from memory, but without the snow sculptures I was not drawn so close to the wall. The winter light was crisp, but this image is not striking.

As photographers, we move ourselves around so that we can visually arrange things into an image. But it is not enough. We need the work of nature to help us, and we need the luck to find it.

50mm lens, small aperture for depth of field, Fuji Velvia

Hochwilde from the Ramolhaus – Ötztaler Alps, Austria, 1989

Weather conditions in the mountains can change in an instant, as mountain people know only too well.

For photographers, days when cloud is lingering and swirling around the summits can provide some of the most exciting opportunities.

On this occasion, we had encountered too much cloud on our climb of the Hochwilde; there were no views at all. However, the next day, the persistent blanket that had enveloped everything began to clear, letting sunlight through onto the glacier.

The views from the Ramolhaus, an Austrian Alpine Club hut, are extraordinary. Sitting on the patio, perched over a stupendous drop, I could watch and wait as the light and cloud formed their spontaneous patterns. In this image, I was able to frame the light, the mountain (top left) and the Hochwildehaus (lower left) into a pleasing image.

200mm lens, Fuji RF50

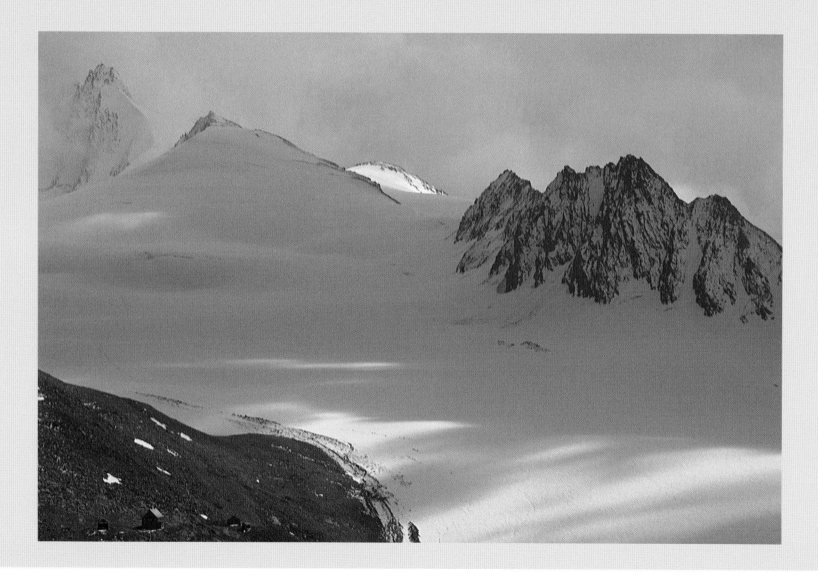

What I desperately wanted, though, was a clear view of Hochwilde itself. Mists frequently boil up in the heat of the day, as warm air rises and condenses. But often, infuriatingly, everything clears overnight when there is a sharp drop in temperature. This weather pattern continued for a few days and it provided the perfect image of Hochwilde in the crystal-clear, cold air of morning.

To be high up when the light is happening is the key to exciting mountain photography, and the best way to achieve this and to enjoy the grandeur of the high mountains in Europe, is to stay in the alpine huts.

200mm lens, Fuji RF50

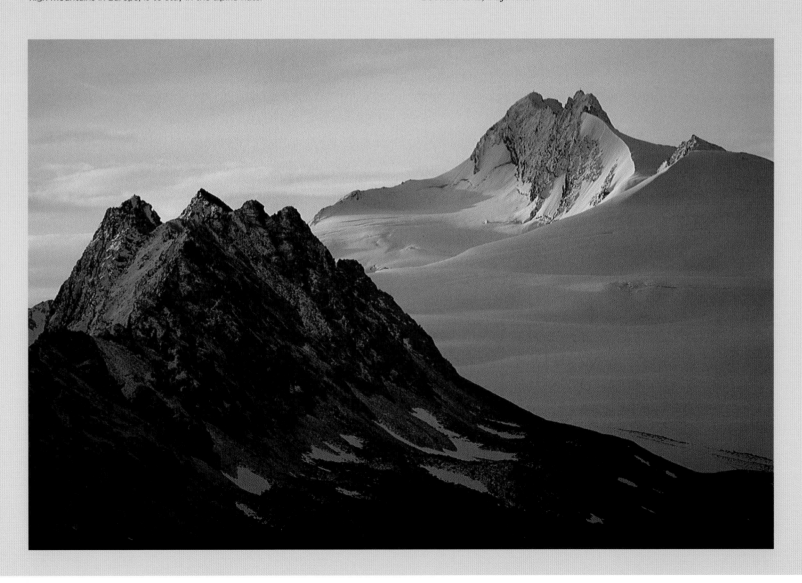

Lenticular Clouds, Goatfell – Isle of Arran, Scotland, 2002

The Isle of Arran lies in the Firth of Clyde and is often described as 'Scotland in miniature'. Its blend of low moorland, craggy mountain ridges and spectacular coasts is everything that the country as a whole can boast. Brodick, the main town is reached in one hour by the Caledonian-MacBrayne ferry running several times each day from Ardrossan on the Ayrshire coast.

50mm lens, Fuji Sensia ISO 100

Our ferry left port at 7am. We had driven overnight from Sussex, so the hour was an ideal opportunity to catch up on some sleep, but I noticed something in the sky as it began to get light: lenticular wave clouds. I watched the sky, as I felt that it would become spectacular if these clouds took on colour once the sun came up.

The light show was glorious yet subtle. I made this and several other photographs of the cloud stacks over Goatfell, switching between my 50mm and a wider lens to cover all angles. In the stiff breeze, I had to brace hard, using the ship's side rails as a support.

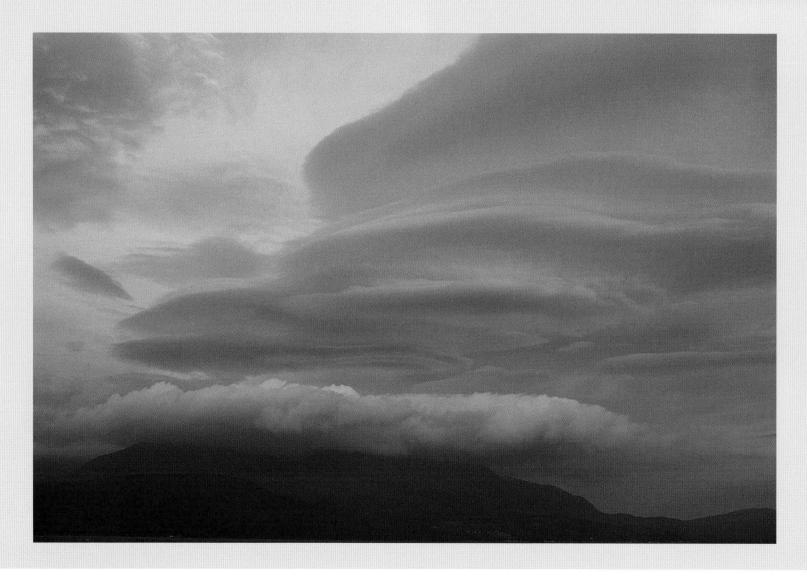

Soon after we docked I made this further image of the lenticular clouds from the beach. The clouds shifted imperceptibly until mid-morning, when they were gone.

Lenticular clouds are one of the most intriguing cloud forms, their lens shape often being associated with UFOs. They form in the lee wave as fast-moving air is forced upwards over the hills into a more stable air mass. The weather is often stable but breezy.

24mm lens, Fuji Sensia ISO 100

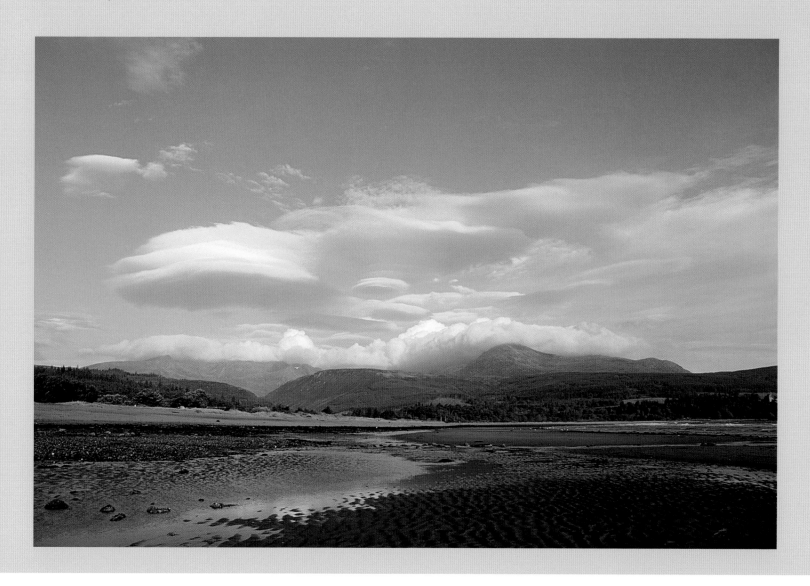

Mountain Road – Fuerteventura, Canary Islands, 1999

Scenic roads the world over frequently have by lay-bys. They are often marked on the map as 'viewpoints', suggesting that there will be something scenically special to behold when we make the obligatory stop there. They also have a practical value, since stopping the car for photography on narrow mountain roads can be dangerous at best.

50mm lens, small aperture for depth of field, Fuji Sensia ISO 100

On our explorations, we stop at them all, alongside everyone else. However, I often feel that I am working in other photographers' tripod-holes. One way to explore in peace is to be up and out early.

The view from this overlook was not special at all, but the road itself, winding its way around the mountainside did have an appeal. The white kerbstones also combined well with the lay of the land to make a well-balanced image.

I knew that we would be returning via the same road later. I had already noticed that an hour before sunset each day the light was consistently warm

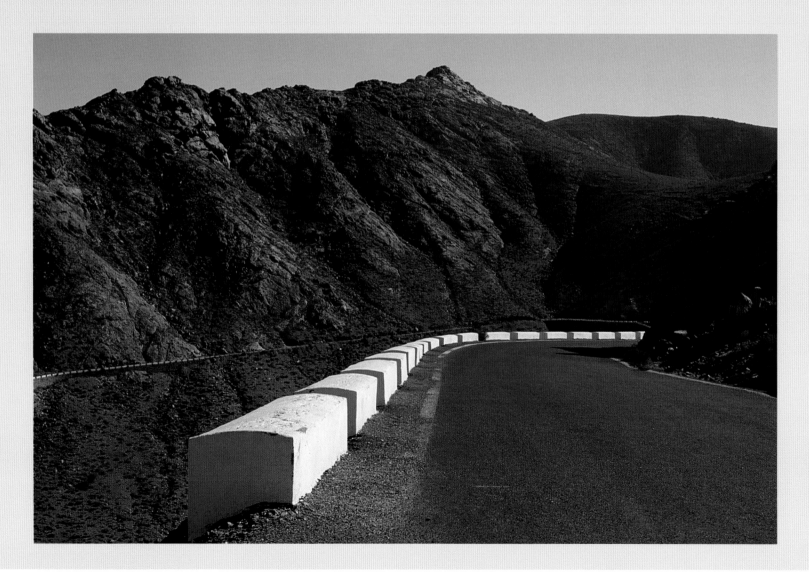

and bright, so we timed this part of the journey to coincide with the light. At the same spot, the mountainside was now bathed in golden colour, but the kerbstones were no longer so prominent against the strong light. So I was pleased to find an alternative that placed them diagonally and opposite to the line of the shadow.

Diagonal lines tend to make dynamic compositions. They lead the eye easily into an image and often create real impact. This image, in addition to the light, is all about diagonals.

50mm lens, small aperture for depth of field, Fuji Sensia ISO 100

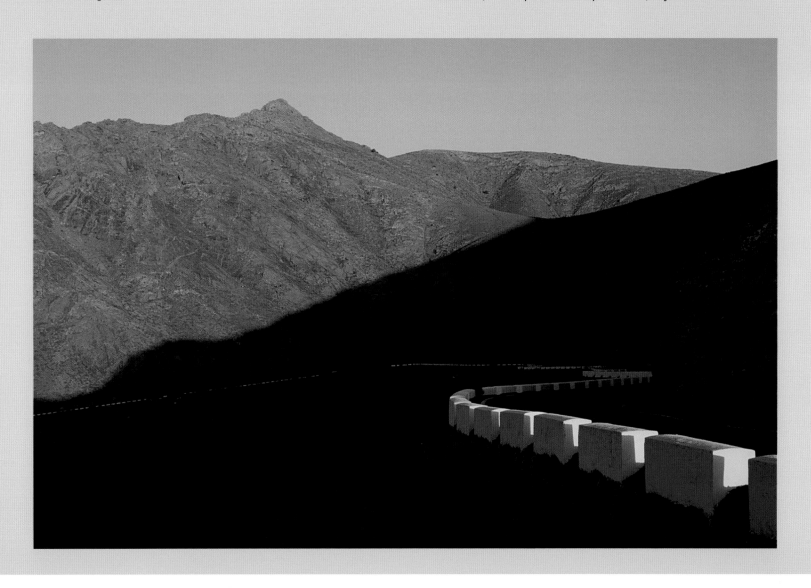

Luinne Bheinn and Gleann an Dubh-Lochan – Knoydart, Scottish Highlands, 1991 and 1997

I guess we all have a favourite walk, in a place that we would happily revisit time and time again. Despite its reputation for being one of the wettest places in the whole of the British Isles, my favourite is Knoydart, a remote tract of land between Loch Nevis and Loch Hourn in the west of Scotland.

50mm lens, Fuji RF50

There are many possibilities for walks and multi-day treks in the area, camping or making use of the bothies at Barrisdale Bay and Sourlies. However, day walkers will also find great beauty and solitude by taking Bruce Watt's ferry from Mallaig to Inverie and exploring inland in Gleann an Dubh-Lochan.

The track from Inverie to Barrisdale Bay runs through here, presenting great views towards the Munro peak of Luinne Bheinn. This image was made on a limpid, spring day with a cloudy-bright sky giving soft light.

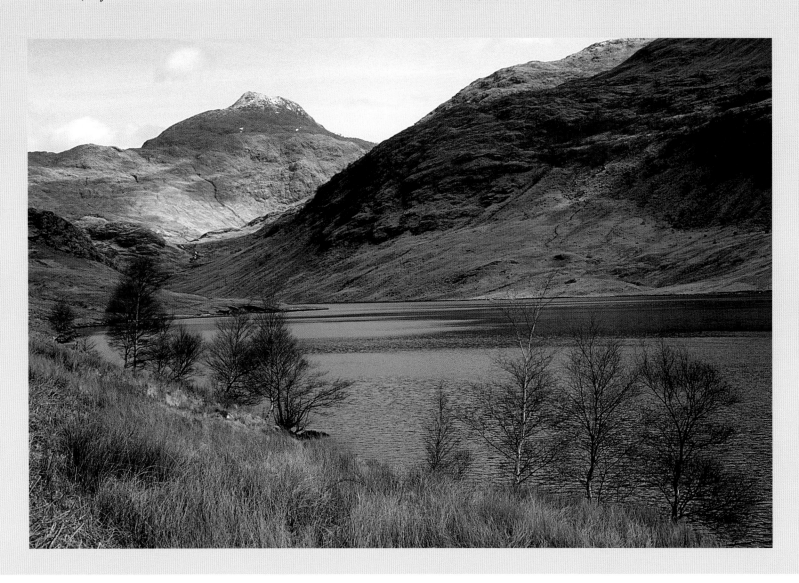

On another visit, this time in the autumn some six years later, clouds over the mountains were looking threatening. Yet to the south and west, breaks were allowing richly coloured light to filter through.

Seeing the possibility, I waited for the drifting light to fall on the middle ground, taking care to expose for the highlights. I was happy to improve my composition too, standing slightly higher to separate the trees and the water. Both these images were made on a natural lunch-stop.

With some exceptions, hazy skies do not make for good distant landscapes. In a mix of dark, stormy cloud and direct sunlight, though, real drama is possible. The showery conditions after the passage of a cold front often yield this kind of fleeting light.

50mm lens, Fuji Sensia RF50

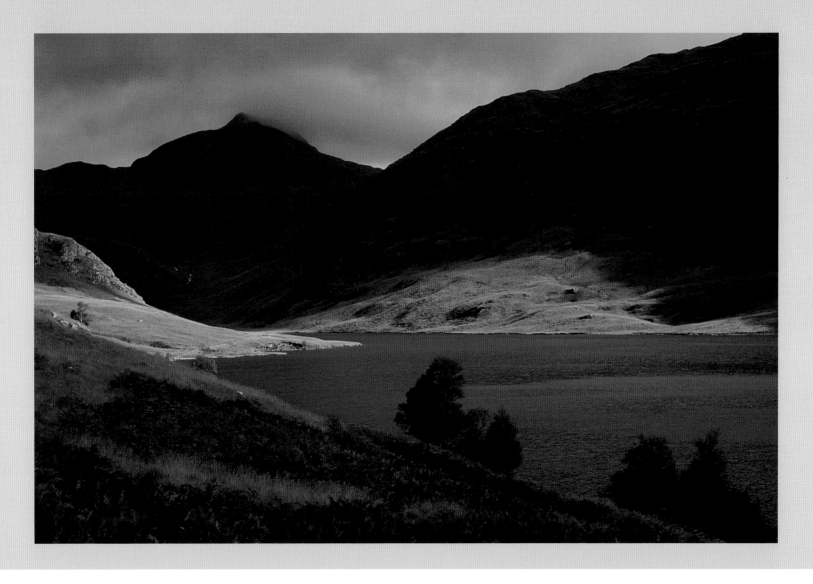

Clearing Storm, Pico Posets – Spanish Pyrenees, 1999

The two highest mountains in the Pyrenees, Pic Aneto and Pico Posets, both lie on the Spanish side of the border with France. Even if you have no intention to climb Posets, wonderful views of the peak can be had from the Viados hut, an easy two-hour walk from the valley. The hut makes a great base for a couple of days, too, and here you will find some of the best rural Spanish cooking.

200mm lens, Fuji Sensia ISO 100

We had arrived at the Viados hut intending to climb Posets the following day. However, the weather was unsettled. We had walked through the afternoon in heavy rain, which began to clear as we arrived at the hut.

Watching clouds lift off a great mountain in a clearance, performing an ever-shifting dance with the sunlight and shadows, is one of the joys of outdoor photography. Notice the airflow across the prominent ridge to the left, with cloud clinging to the lee of the crest. I watched for some while, and exposed when the summit was briefly clear.

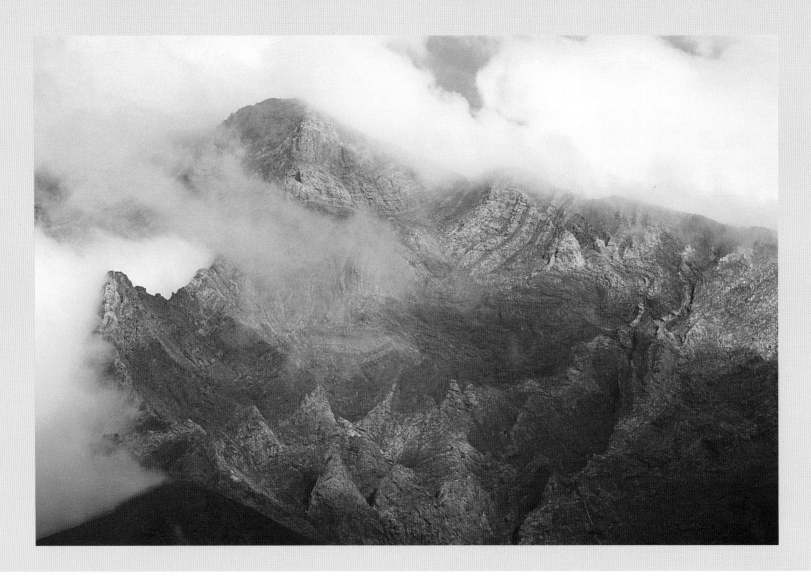

It rained all night, and in the morning it became clear that our climb was not on in such changeable conditions. Snow had fallen on the summit, and in similar cloud to the previous afternoon, I made a further image of Pico Posets; I tried to balance the elements in the frame by including the bright area of cloud, but this composition is not as pleasing as the first.

The edges of weather are often the best for outdoor photography. Watch the weather forecast, particularly for an incoming cold front from the west in late afternoon. Watch the sky, stop what you are doing and position yourself.

200mm lens, Fuji Sensia ISO 100

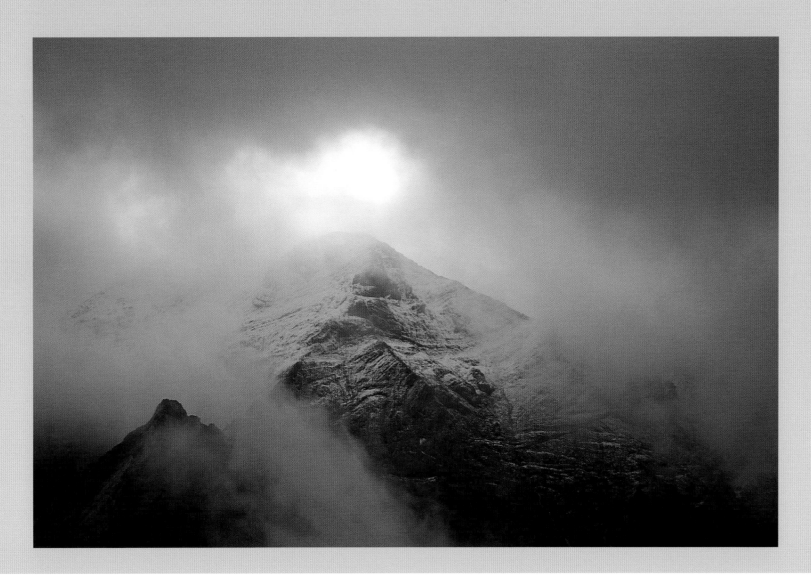

Pont Scethin and Rock – Rhinog range, Snowdonia National Park, North Wales, 1997 and 1999

This picturesque stone bridge offers easy access to the southern end of the Rhinog mountains from the west, and passage from Barmouth in the south to Cwm Nantcol. It is a perfect lunch-stop.

These two images, made in springtime two years apart, again demonstrate vastly different lighting conditions, and choice of lens.

This spring morning was perfect: warm and still with sharp skies. I examined several places from which to photograph the bridge, but the shapely rock also caught my eye.

An upright composition not only allowed this to be a key element, but I was also able to layer the sky to include the light cloud at the top of the frame. However, I did have to lie flat on an adjacent rock in the middle of the stream.

The polarizer cut glare from the water and enriched the sky.

24mm lens, polarizing filter, small aperture for depth of field, Fuji Sensia ISO 100

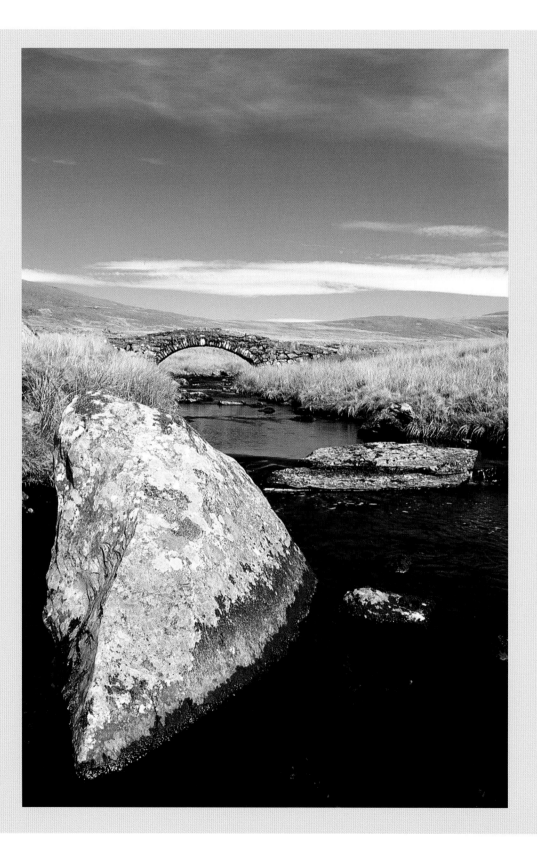

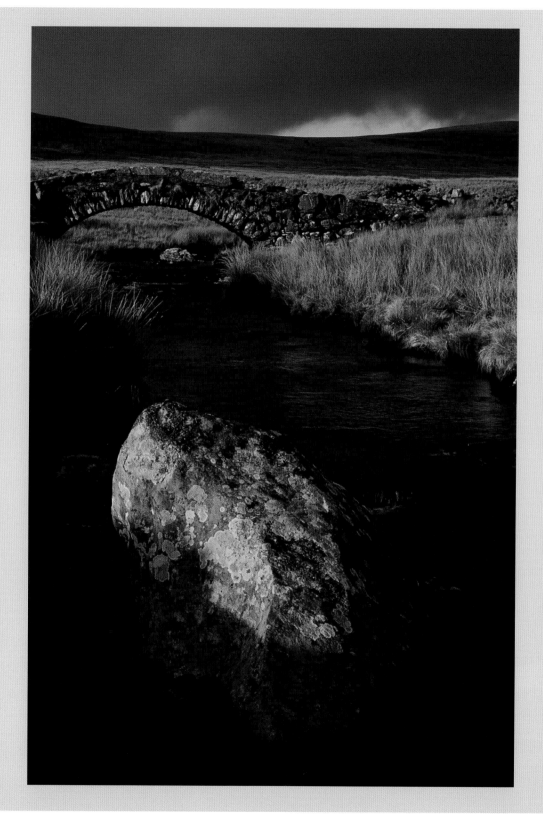

Again in unsettled weather, I was able to take advantage of an evening clearance. In the particular lighting conditions, this composition with the standard lens worked better for me than my original, but it is not a better image.

The physical objects in a photograph are not the only elements to compose. The light influences everything. What works in one light might not work in another. Light is the key.

50mm lens, small aperture for depth of field, Fuji Sensia ISO 100

Weisskugel in Morning Light – Ötztaler Alps, Austria, 1996

The magnificent Weisskugel stands proud and remote at a height of over 3,700m (12,100ft) in the Ötztaler Alps.

My viewpoint for these images was the 3,200m (10,500ft) high Brandenburger Haus, a hut perched on a rocky spur in a huge icefield at the head of several glaciers. During another spell of patio-photography in the early morning, I watched from the first light.

50mm lens, Fuji Sensia ISO 100

Alpenglow is the beautiful effect seen just before dawn and after sunset in the high mountains. As the sun rises and sets, light travels obliquely for a much greater distance through the atmosphere, and short wavelengths of blue light are scattered in the air, leaving longer reds to warm up the land.

In this case, the summit of the Weisskugel was bathed in red light long before the sun cleared the ridges surrounding the hut to illuminate the glacier. I loved the contrast between the delicate, pink hues on the mountain and the blue shadows of the glacial ice. Cropping the image brings attention to the light.

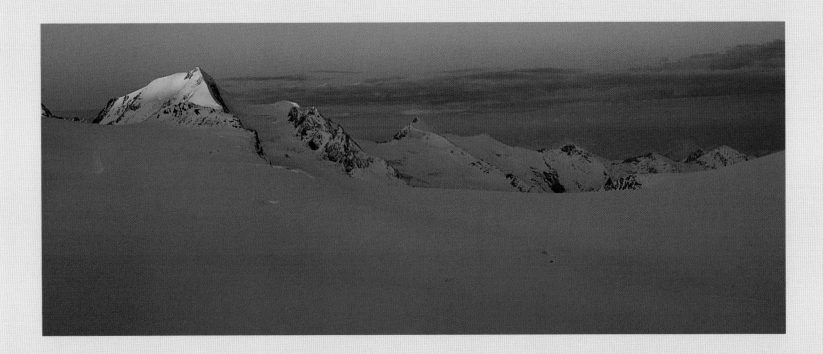

Only minutes later, a much brighter light had spilled through. The change in colour is dramatic, yet I hardly noticed the changing. I felt no need to crop this image, as clouds and light on the glacier now provided added interest.

I would like to challenge an old myth: snow is not white. Snow can be white in bright sunlight, but, like the sea, it takes on the colour of the light falling on it. It can be pink or golden. It is always blue or grey in the shadows. Snow can also be yellow, but that is another story! We are comfortable with the changing colours of the sea. Why not of snow?

50mm lens, Fuji Sensia ISO 100

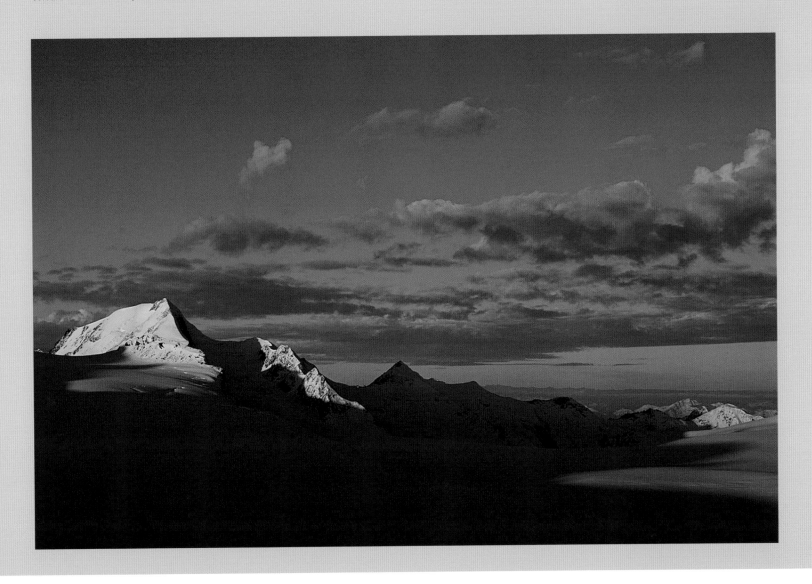

Wild Camp below Esk Pike – Lake District National Park, England, 1999

We have now moved from the comfort of an alpine hut to the confines of a tent in the Lake District.

Our long drives north from Sussex have to be arranged. Unfortunately, dropping everything to run to the hills when the weather looks great is not a practical proposition when you have a family.

50mm lens, Fuji Sensia ISO 100

On this occasion our arrival in Cumbria coincided with foul weather. However, a clearance was forecast for later that day, with the promise of fine weather tomorrow. We set out at lunchtime in persistent drizzle to set up camp at Angle Tarn below Esk Pike.

It was already light when I unzipped the tent. Snow from the previous day capped Esk Pike but there was no light (in a photographic sense). The wind was also biting cold, so I made just one image.

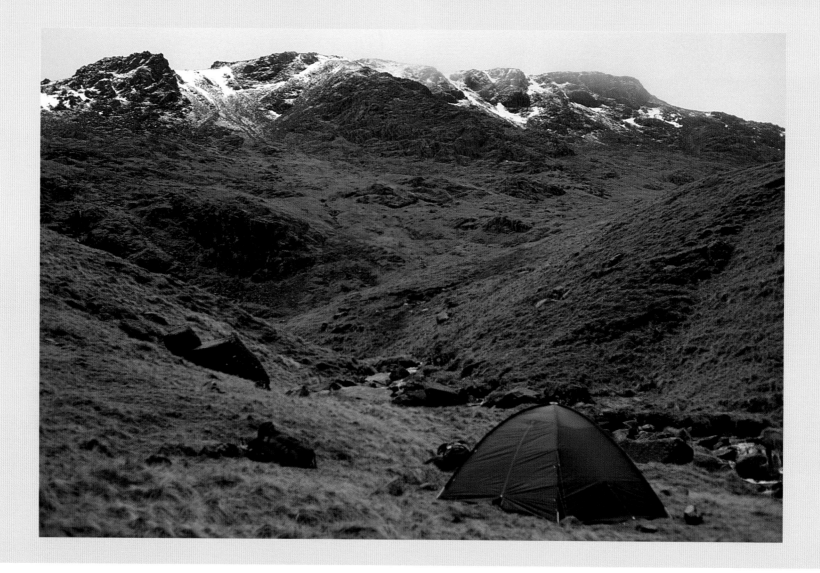

The change was sudden and completely unexpected. The sky gave no clue, but the clouds began to break, and light poured through. I grabbed the camera and ran.

I repeated the image of the camp, with red light on Esk Pike, and then embarked on a fantastic half-hour that yielded at least three other images that you will find in this book. The pace of change was incredible, and the photography was totally exhilarating and instinctive, despite the chill and the physical problem of operating the camera with watery eyes and layered gloves. Sometimes the light comes when you least expect it and our hunch to chase a weather clearance had come off. We had made our own luck

50mm lens, Fuji Sensia ISO 100

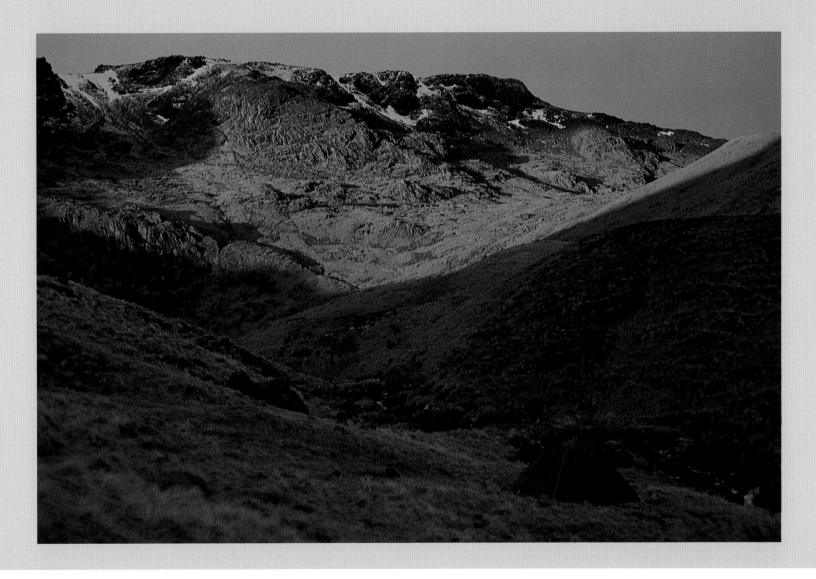

Mitten Buttes and Clouds – Monument Valley, Utah, USA, 1989

This view of Monument Valley is the classic first view from the overlook at the entrance to the park. I had already made my images of the rocks glowing a fiery red, and now the action was in the sky. There were two other photographers there too; I heard one of them remark "It will be better in a few minutes".

24mm lens, Fuji RF50

Any high level clouds in the eastern sky are likely to pick up colour as the sun sets. The colour in the cloud first shifted from white through cream to a delicate orange. Although the best arrangement of the rocks in the frame came with my trusty standard lens, I could not include the clouds, so I switched to my wide-angle. I made several images, exposing for the brighter sky.

Over ten minutes or so, the colours continued to shift. Orange changed to pink and red, the blues intensified, and the rust-coloured desert floor began to take on the familiar afterglow. I continued to shoot.

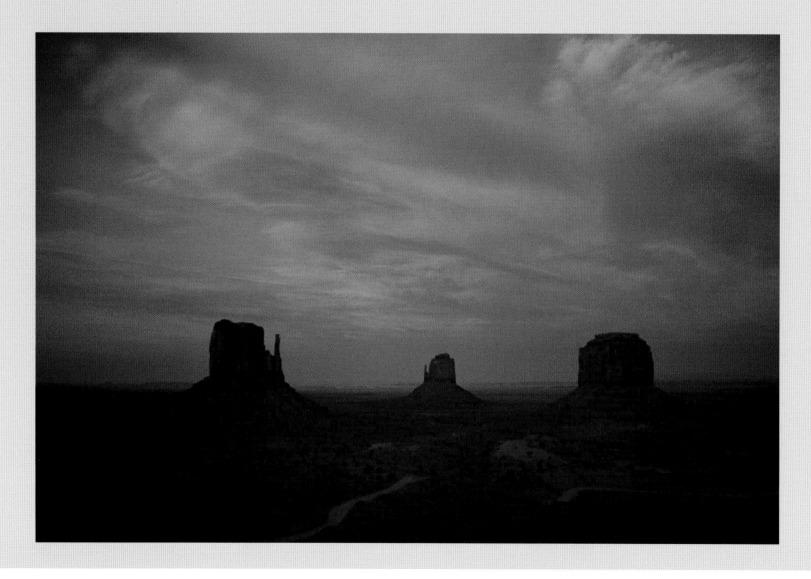

The light did not 'get better'; it just changed. The other photographers chatted idly, hardly observing or reflecting on the scene. Their approach seemed routine and lacking in energy, in passion. This upset me. Perhaps they were there to do a job. Perhaps they had seen it all before. The light that day might well have been ordinary, but it did not excuse their taking it for granted.

Don't limit yourself by thinking that you have the definitive image (even though that may be the case). A collection of images for an article in *National Geographic* magazine may have been selected from hundreds of rolls of film.

We don't have their budgets, but we can capture changing light by shooting all the subtle changes as they happen. How often do we only know what we have when we see the finished photograph? Maximize your chances.

24mm lens, Fuji RF50

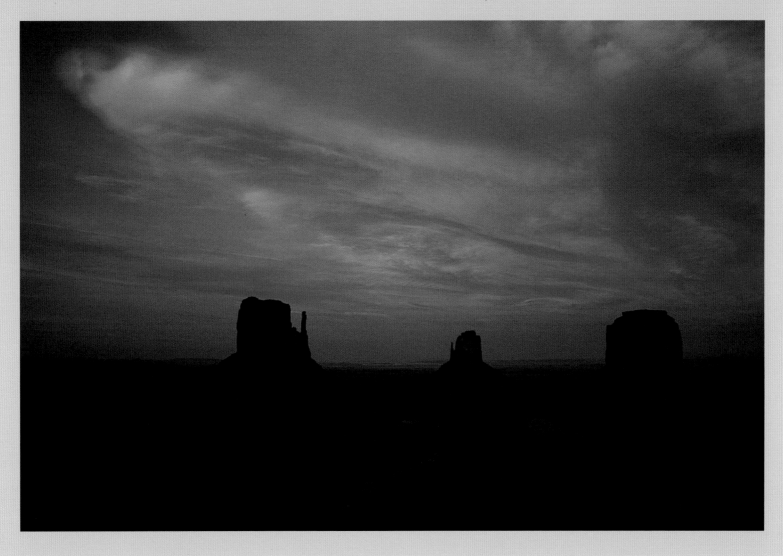

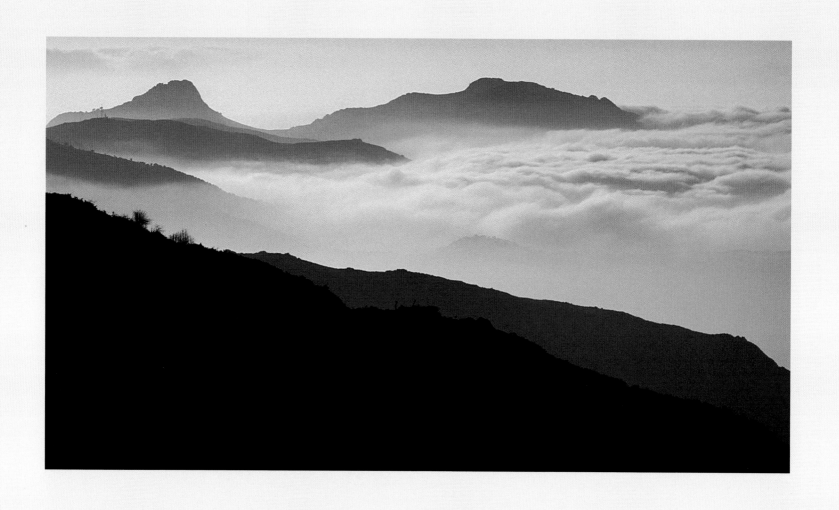

Section ② **Immersion** in the landscape

The Light of Experience

Have you ever heard the silence, or felt that you could touch the distance? Have you felt the air on your face, even when everything is still? This is immersion. Immersion is about being present, experiencing fully every new moment. We have all experienced immersion. Sometimes, what we are doing feels effortless and natural; we don't want to stop, and we give it our total attention. We can choose to immerse ourselves in listening to music, enjoying a meal, watching a sport, walking in inspiring country. When we do this, nothing else matters. We are here, now.

However, in the pace of daily life, our attention is diverted by rushing to the next task, worrying about what will happen when we get there, or the consequences of what we have just done. We do not notice the present moment.

Thought invasions get in our way: they hinder, interrupt concentration, and stifle enjoyment. If the task is a creative one, then we feel blocked. Who has not had the feeling of wanting or needing to be creative, but nothing will flow? And so we try harder. Sometimes, the harder we try, the less we achieve.

In photographic terms, this means that the more we look, the less we are likely to see.

I am often aware that I see images naturally whilst doing other things, like driving. When I am relaxed and my mind is quiet, I see relationships between fields and trees, colours and shapes, light and land. It is as though I have tuned in to a certain wavelength.

Quiet and solitude help too, for they are antidotes to the noise of everyday life. When we take time out, we stop achieving for a while. We can simply be. We can watch and listen, empty our minds and give ourselves up to experience. Everything we observe flows into the subconscious, ready to be received when needed.

Immersion is seeing. Photography is just a natural extension of seeing.

The message is simple. My photography comes from the heart. It is about feeling my way rather than thinking. The images in this section required no special techniques, nor speed of response. I did not seek them out; they simply presented themselves at times when I felt at one with the landscape.

Exercises

1. Take yourself on a photoshoot without your camera. Go to a special place: a mountain, a city park, a seashore, a building. Sit quietly for an hour with no agenda. Just watch, listen, and feel. If daily thoughts encroach, acknowledge them and let them disappear. Write down anything that you have never noticed before.

2. Go out with your camera, but simply go for a walk. Feel your way; listen, but do not search. Forget the camera is there, and resist any temptation to use it until something 'speaks' to you.

Sunrise, Monument Valley – Utah, USA, 1989

There is no image in my collection that could better start this section on being engaged and at one with the landscape. I was not even outside. We had stayed overnight at a motel near Monument Valley in Utah and were very fortunate to find ourselves in a room that overlooked the land, rather than the car park.

I got up early and just watched from the balcony. The glow in the sky suggested where the sun would appear, so I set up the tripod and waited for the scene to present itself. There was no sound in this drama, no sound at all.

200mm lens, wide open at f/4, tripod mounted, Fuji RF50

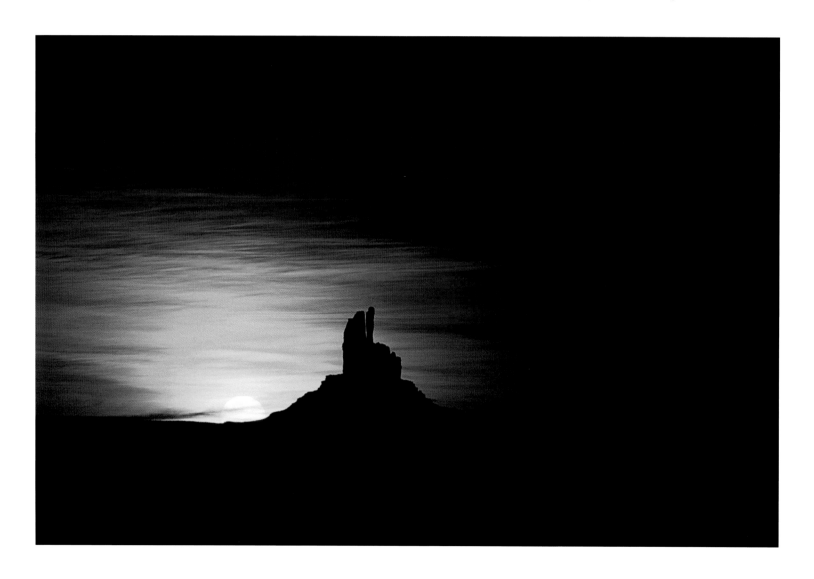

Rocks and Colours, Loch Morar – Scottish Highlands, 1991

This peaceful image of Loch Morar in the west of Scotland, by way of contrast, was not dramatic, but the silence and colour were equally compelling.

It was a warm evening and there was hardly a breath of wind, but there was the musical sound of the smallest ripples lapping the rocks, and a spring cuckoo somewhere on the far shore over a mile away, echoing.

The change in soft colours from daylight to dusk was so gentle it was imperceptible. I made this simple image when the colour seemed strongest, moving just enough to separate the dark shape of the rocks from the shadows of the bank.

A key to this tranquil image is the horizon; including just a sliver of the horizon in the distance provides a context for the abstract rocks and the patterns and colours in the water..

50mm lens, Fuji RF50

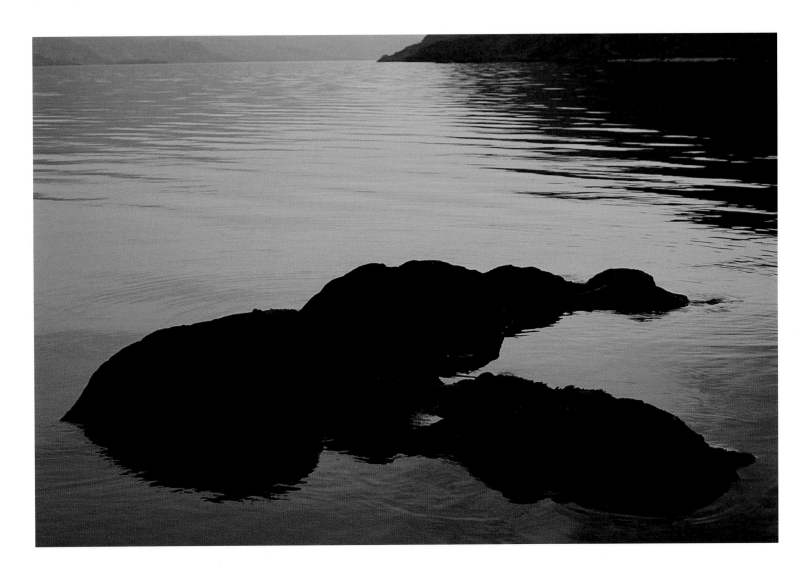

Langdale from Crinkle Crags – Lake District National Park, England, 1983

When we are starting out with photography, results are often unpredictable. I view this image very fondly, because only on taking it from the box of processed transparencies did I realize that there was something different about it. It was the first time I realized that I had photographed the light.

I recall the walk that day, but not making the image. This kind of posed shot of walking companions was common for me in the early days. The painterly light was a bonus, but one that I noticed only after the event. It started me on a journey.

The dappled light on a day with broken cloud reveals a new scene at every turn and can yield beautiful images. There is always a choice: to see the potential and wait, or to respond when it happens.

Rollei 35LED, 40mm lens, Kodak Ektachrome ISO 64

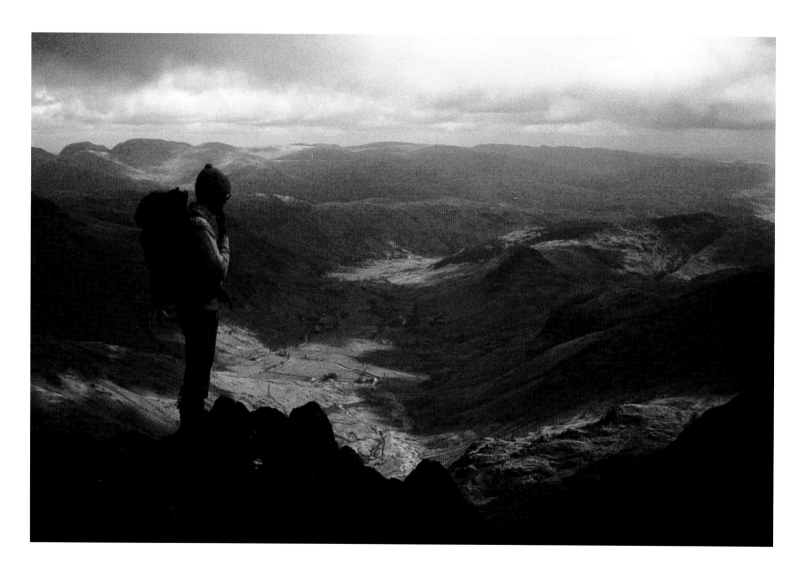

**Threatening Clouds, Steyning Round Hill – South Downs near Steyning,
West Sussex, England, 1988**

On this occasion threatening clouds in the spring afternoon drew me to
Steyning Round Hill.

For some time I just walked around, then formations of cloud and light
began to lift the soft and rounded shapes of the South Downs into exciting
images. I underexposed the film very slightly to saturate the colours and to
emphasize the dark sky.

The triangulation pillar is an essential element in the image. Next to the track, it
provides balance, breaking the horizon line on the eye's line through the scene,
and it had eluded me until I had relaxed out of my everyday thinking.

50mm lens, Fuji RF50

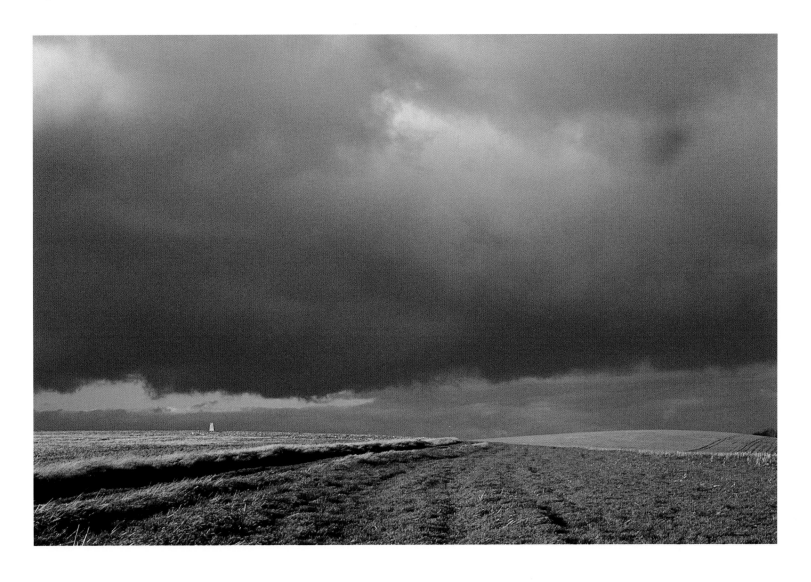

Skyscape, Glenridding – Lake District National Park, England, 1991

We were walking to the pub after a day on Helvellyn, when I became aware of a slight change in the light of the evening sky. I took a moment to stop, to listen and to expand my gaze as widely as possible. The white clouds seemed to be glowing. The only sound was birdsong.

Expanding the gaze means becoming aware of your peripheral vision. Sit and notice that you can be aware of almost 180˚ around you. Do this when you preview a scene, and defocus slightly. Patterns of highlight and shadows will suddenly become much more apparent.

The 24mm lens was ideal for this image, enabling me to frame the clouds in a strong pattern and to keep the shadowy ridge as a base. The glow lasted just a few minutes.

24mm lens, Fuji RF50

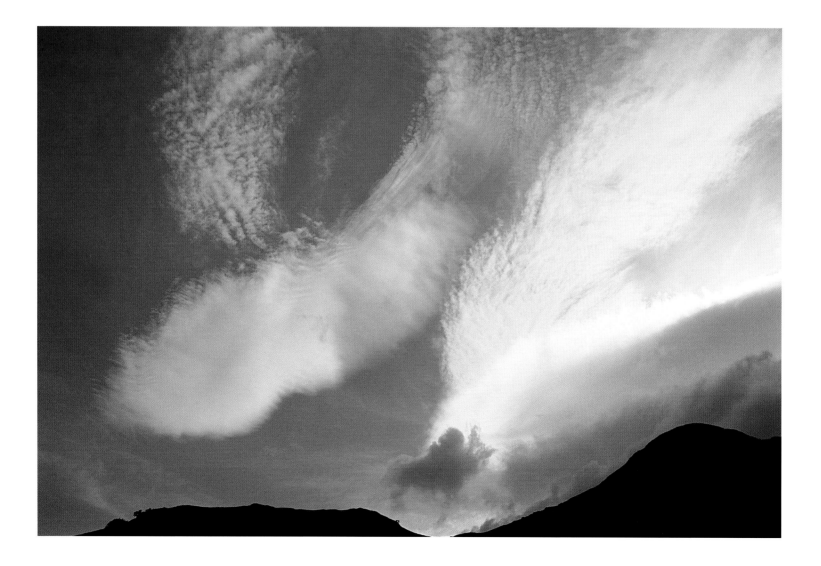

Morning Mists – Lake District National Park, England, 1988

There is no better way to immerse yourself in wild country than to spend a night out in it. Here we had camped on a knoll just beneath Crinkle Crags overlooking Langdale and Pike o'Blisco. Dawn comes early in the Lakeland summer. I was awake in the first light and we were bathed in sunlight on the fell long before the valleys escaped the shadows.

Mists lingered across the lower fells to the east, and gave relief to this soft recession of interlocking ridges in the distance. I lay prone, bracing my elbows into the ground for stability. As the sun rose, the light flattened, and the scene dispersed.

Telephoto lenses compress the distance, and distant elements in the landscape become progressively more blue as light is scattered in the atmosphere. Look for opportunities to capture a recession with a longer lens and draw yourself into the far reaches of an image.

200mm lens, elbows braced, Fuji RF50

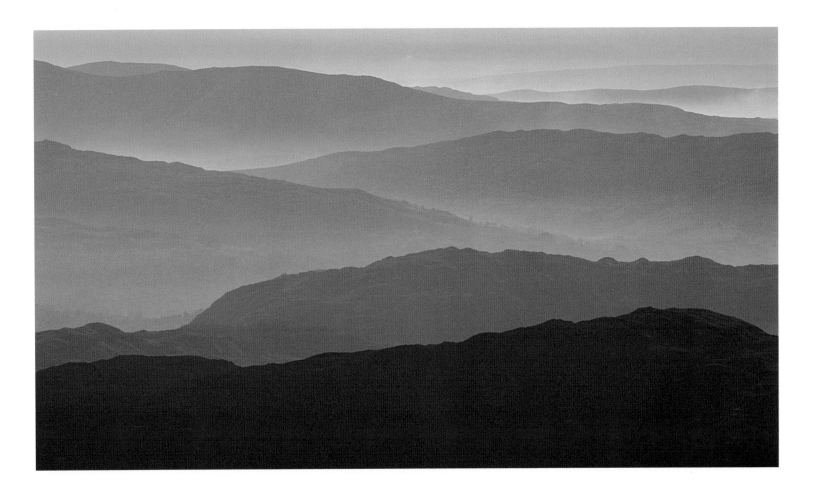

**Evening Glow on Striped Butte – Death Valley National Park, California,
USA, 1989**

At dawn and dusk in Death Valley there is a pilgrimage to Zabriskie Point to
watch the light. It is not so easy to become immersed when people around
are chattering idly. I moved away from the crowd to a spot where I could look
away from the sunset and see the effects of the light clearly on the Striped
Butte. It glowed, almost eerily. I made one image, and it was enough.

In any scene of breaking light, look all around you. Try not to let yourself
be captivated by just one scene. Drink it all in, quietly.

50mm lens, Fuji RF50

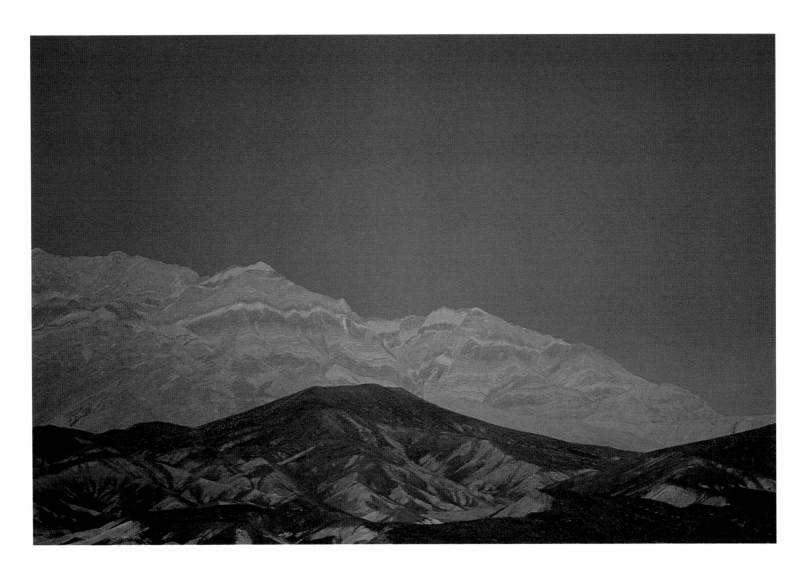

Javea at Dawn – Costa Blanca, Spain, 1996

The Costa Blanca is blessed with some wonderful mountains, not least of which is Montgo, which rises out of the sea near the resort of Javea.

I rose before dawn to climb the hill. Near the top of the ascent a vista opened out over the town, revealing a lovely mix of natural blue and pink light in contrast with the town lights. In my desire to reach the summit before dawn, it would have been easy to hurry, and not to stop and look occasionally.

Photographs of town lights at night always look best before dawn and after dusk, when there is colour in the sky; when the sky is black, the excitement goes.

50mm lens, elbows braced on rocks, Fuji Sensia ISO 100

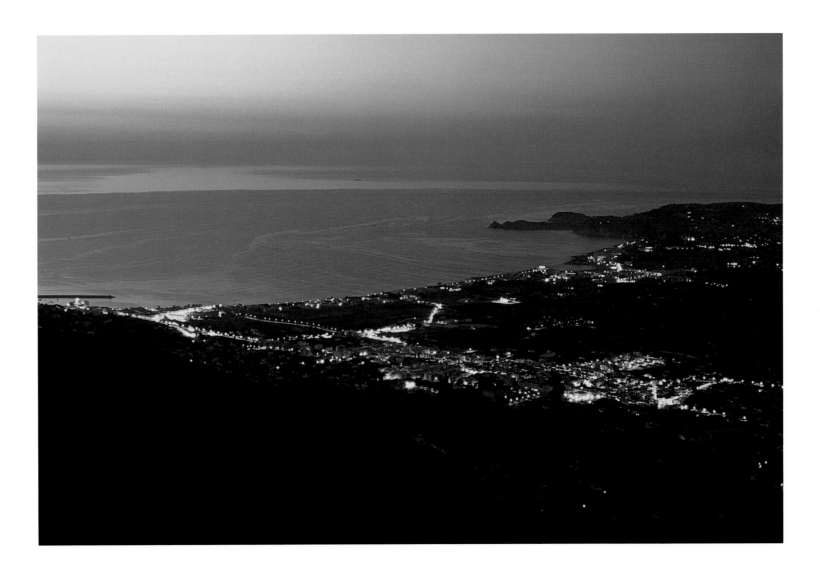

**Sunlit Tower, Bryce Canyon – Bryce Canyon
National Park, Utah, USA, 1989**

Bryce Canyon is one of the most difficult places to
photograph that I have visited. Images of this
masterpiece of erosion in Utah are becoming very
common, yet I have seen few that evoke the
ethereal quiet that seems to haunt the deep gullies.

Our first exploration of the overlooks revealed
little except standard views, so we decided to
explore the network of paths taking us deep into
the confines of the red clefts. I then felt able to
appreciate much more the delicacy of the rock
spires and the fleeting moments of light.

This tower and tiny tree came out of an
instinct to seek out more intimate studies. The
side lighting and the sliver of light along the crest
help it stand out from the shadowy recesses.
Since the area of highlight is so small, I checked
the exposure carefully on another sunlit rock so as
not to overexpose the image.

Even with a wide choice of lenses available, it
is not always possible to frame an image perfectly.
Do not be afraid to crop transparencies if
unwanted detail is unavoidable.

*200mm lens, elbows braced on the overlook,
Fuji RF50*

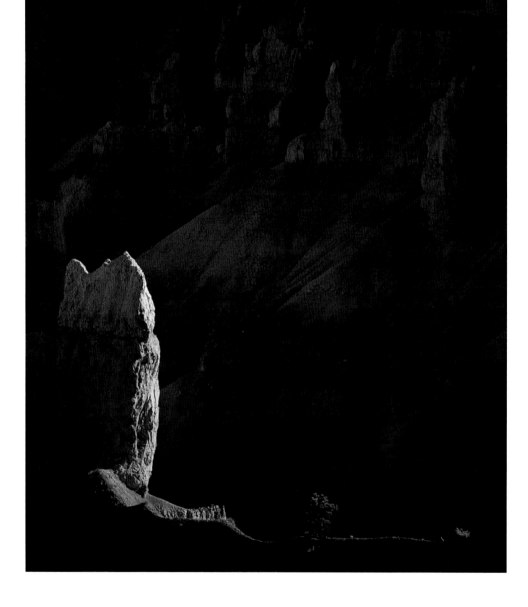

Sunlit Rock, Rossett Pike – Lake District National Park, England, 1999

This image was the last I made in that same freezing half-hour as yielded the Images on pages 44 and 45 The very first light of morning shone with rich colour from beneath the clouds. As always, though, the tones began to cool as we moved into full daylight, and I prepared to stop photographing.

Descending back from Rossett Pike, I noticed a number of brightly illuminated boulders. It seemed chaotic until this beautiful shape appeared lit in isolation. Placing it off-centre in the frame linked it with the dappled light on Glaramara in the background for a naturally balanced composition.

Several minutes later, the whole fellside was lit. I metered closely from the rock itself, as the large shadow area in the scene would have caused my centre-weighted meter to overestimate the exposure. Modern multi-segment meter patterns might have coped well here, but I always compare a meter reading from the key highlights with the general reading, opting for slight underexposure with transparency film.

50mm lens, Fuji Sensia ISO 100

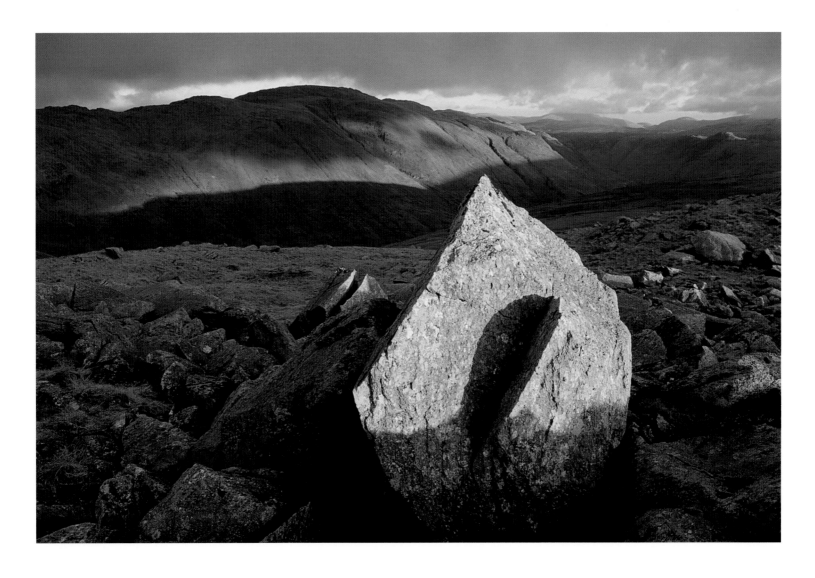

Moonrise, Telgruc-sur-Mer – Brittany, France, 1993

For several days I had a clear view over this open coastland of western Brittany. The scene was pleasant enough, but nothing spoke to me until the evening of the full moon, which rose just after sunset.

 The moon hung low and large on the horizon, glowing a soft pink-orange. I made several images, but only when it had risen higher was I happy with this composition, with the buildings and the lights providing a balance to the left of the frame. I made several bracketed exposures, favouring a darker image with just sufficient deep blue light in the scene to maintain detail in the background and a hint of colour in the moon.

The big moon on the horizon is an illusion. It is no bigger than when it is overhead, but seen in relation to the land it always seems larger than life. Although our eyes are deceived, a lens of at least 200mm is needed to make the moon look even a normal size on film.

200mm lens, tripod mounted, Fuji Sensia ISO 100

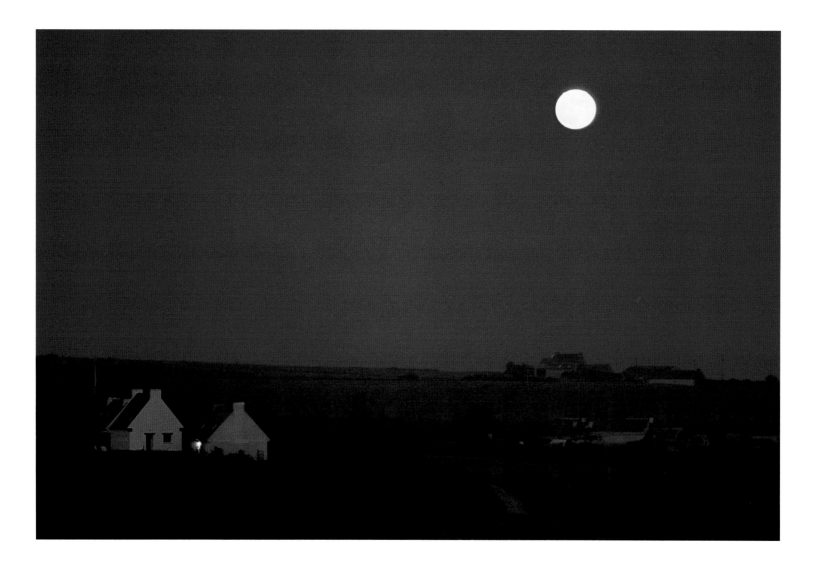

Moonrise, Cortijo Romero – Alpujarra hills, Orgiva, Spain, 2001

Cortijo Romero is an alternative holiday centre in the foothills of the Sierra Nevada mountains of Andalusia. A holiday here is a time for genuine rest and renewal; the strong spiritual atmosphere is perfect for feeling at one with the landscape. On the roof of the farmstead is a terrace used for singing, dancing and stargazing.

One perfect evening, the moon rose over the hills. This wide-angle view makes use of the small building and tree for balance. Also, the terracotta floor tiles add light to the scene, and the encroaching cloud adds a little drama to an otherwise clear sky.

The moon itself has similar exposure values to daylight. What is not easy, however, is to compromise between a moonlit scene that includes ground detail and an overexposed and blurred moon, and one which captures the moon's detail in a black sky.

The timing of the Brittany image on the facing page, and the reflective foreground surface here, have kept overall light levels in balance.

24mm lens, tripod mounted, Fuji Sensia ISO 100

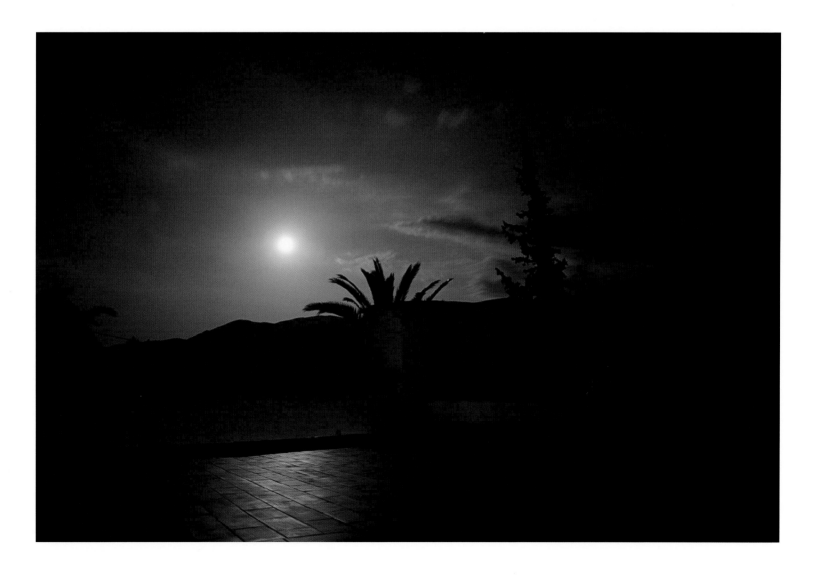

Sunset over la Revellata – Calvi, Corsica, 1988

Late evenings and early mornings are the times when those who love the landscape should be out and about, for this is when the colour of light changes fastest and the drama is at its height. But it is often the quietest scenes that are the most elusive.

As this scene unfolded, the colours intensified a little. The sun seemed to be dropping straight into the notch at the end of the peninsula, and I noticed a solitary cactus tree that would provide a balance in the empty space of the water, and, by chance, two people were also clambering on the rocks.

The sun often drops into a layer of haze near the horizon. When it does so, its intensity drops and it takes on a gradation of colour from yellow to red. This is often the best time to photograph the sun and the surrounding scene, as light levels are more balanced.

200mm lens, elbows braced on rocks, Fuji RF50

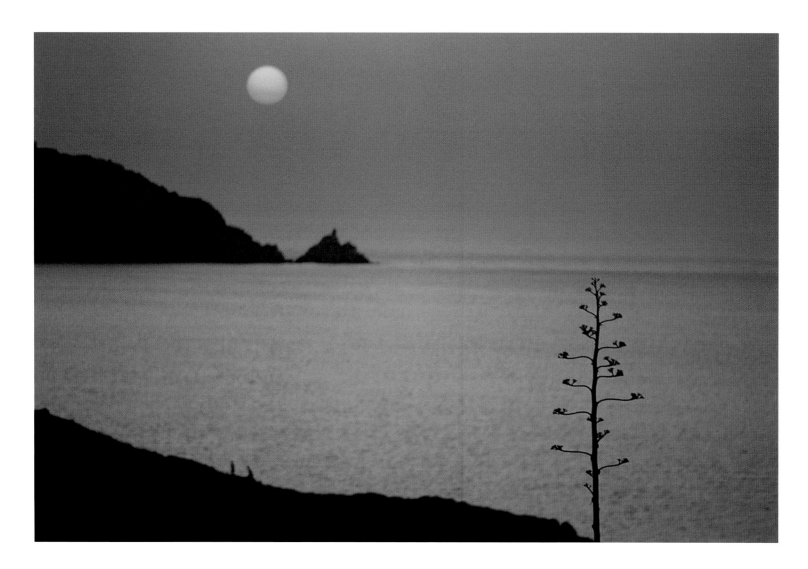

**Layered Reflections, Llyn Llydaw – Snowdonia National Park,
North Wales, 1989**

Llyn Llydaw is the second and largest of the three lakes one passes on the Miners' Path to the summit of Snowdon, Yr Wyddfa, the highest peak in Wales. The classic and most challenging route on the mountain is the 'horseshoe', the ring of peaks and airy ridges from Crib Goch via Yr Wyddfa to Lliwedd.

For many reasons, we often walk this route by starting on Lliwedd, and climbing up from the lake I was suddenly struck by the sunlit ridge of Crib Goch reflected in the still water.

Having checked my exposure on the bright ground, I made this image at a point where the crest of the ridge was reflected clearly and separated from the shoreline, creating a fascinating layered effect.

When I am well attuned, it is often the more abstract compositions that appear to me unexpectedly. Sometimes, as here, they require no searching out.

50mm lens, Fuji RF50

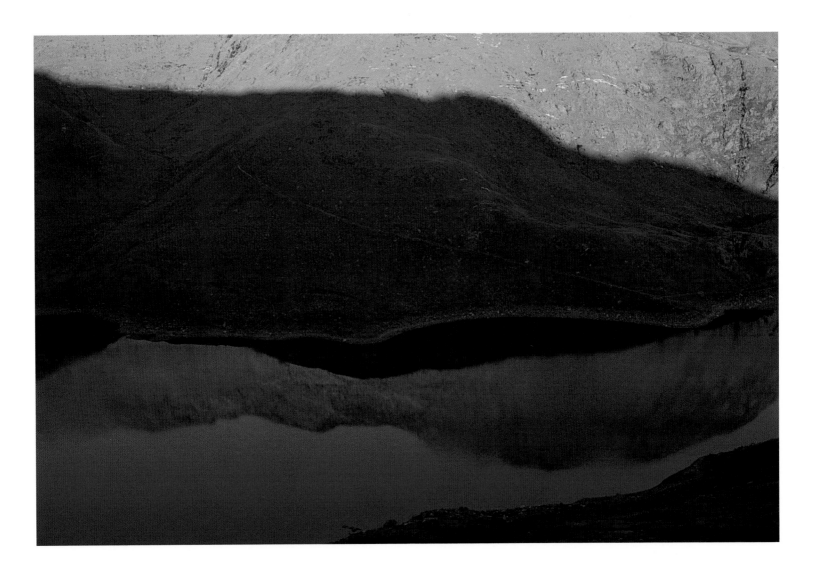

**Buncton Church and Rapefield – near Steyning, West Sussex,
England, 1995**

The little church at Buncton is one that I pass daily, often not noticing it at all in my switched-off state of driving for work. In the springtime, though, my awareness begins to return, like a new zest for life in the brightening light.

Sussex in the spring is a sea of yellow oil seed rape fields. This particular morning was bathed in a delicate light through a slight haze; the scene seemed particularly fresh and the light picked out the end wall and the small bell tower of the church.

The open landscape here looked too wide at first. Walking a little way along the road, I was able to place a tree in such a way as to prevent the field lines leading my eye out of the frame.

200mm lens, beanbag on a fence for support, Fuji RF50

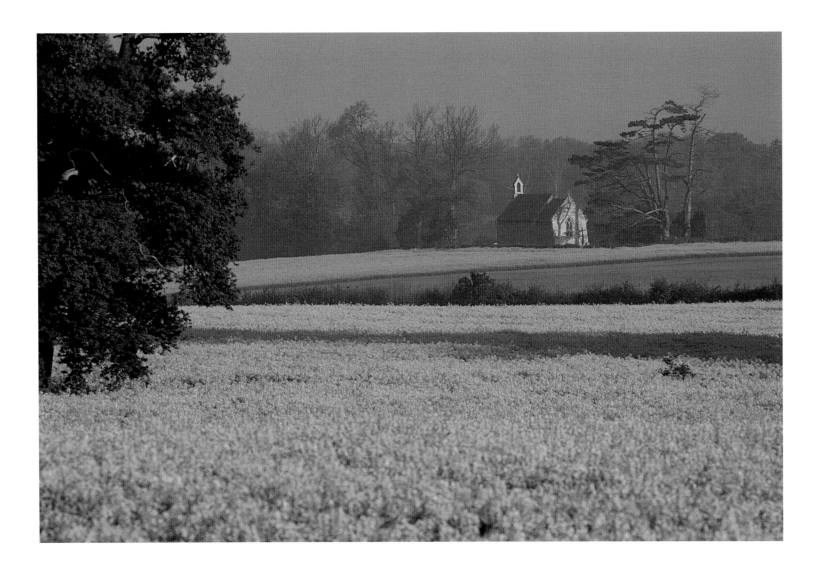

Autumn Leaves – Wakehurst Place, West Sussex, 1995

There was a very hazy light on this still, autumn morning, making wider landscapes rather flat. But I was noticing how individual leaves were shining under the woodland canopy.

I used a tripod here to frame a composition with the 200mm lens. I was drawn to place the leaves in the corner of the frame, creating an empty space, which I diffused by breathing on the filter to give just a hint of softness.

I discovered the breathing technique by accident when I took a lens out of a warm pouch into the cold air and it steamed up. Watching through the viewfinder as the mist clears, it is possible to release the shutter when the effect is exactly right. The effect seems natural, a product of the environment.

Otherwise, apart from an ever-present skylight or a polarizer, I do not use any filters to enhance colours or create artificial effects. I would prefer to return on another occasion.

200mm lens, wide aperture for background diffusion, tripod mounted, Fuji Sensia ISO 100

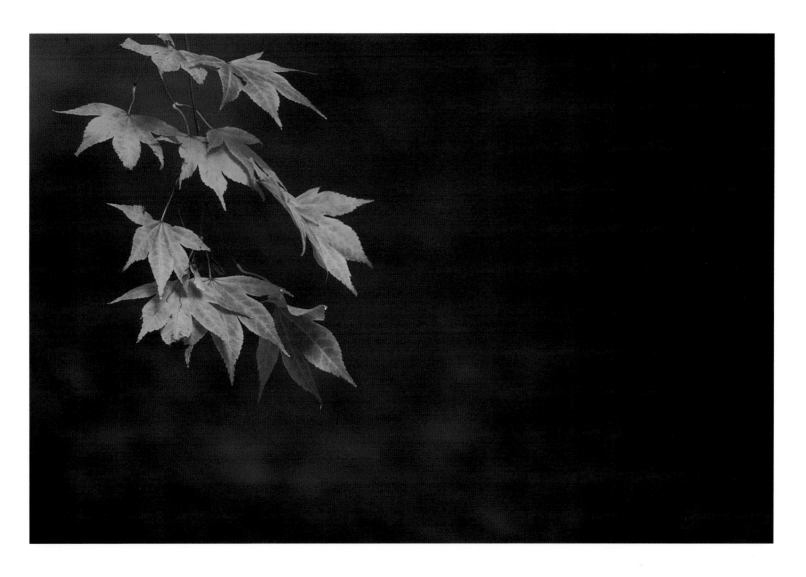

Recession, Bidean nam Bian – Glencoe, Scottish Highlands, 1987

The intimacy of a scene is not always close by. Sometimes, just a hint of light in the distance will catch my eye. Although our brains are able to interpret a distant scene, allowing us to close off peripheral detail and concentrate, to capture this requires a telephoto lens.

This photograph came at the end of a bright April day in which I had climbed both Buachaille Etive Mor and Bidean nam Bian. On the westward descent towards Glencoe village, I saw this small brightness in the distance out to the south-west, where the peaks were receding in a hazy, blue light,

combining beautifully to make an ethereal image. I suspect that the brightness comes from sunlight reflecting on the sea. I cannot be sure, but it does not concern me; it is the light and its interaction with the land that matters.

I have since wondered whether my receptiveness was enhanced by my feeling close to my physical limits after 2,400m (8,000ft) of ascent.

200mm lens, Fuji RF50

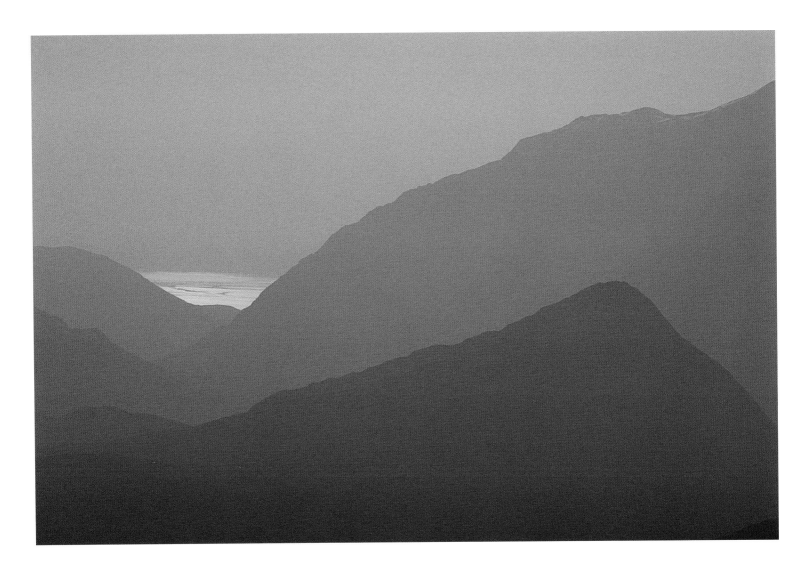

Sunlight on Bridalveil – Yosemite National Park, California, USA, 1989

Another spot where photographers gather in hordes is the Wawona Tunnel road in Yosemite Valley. The overlook provides the classic view back to El Capitan and the Half Dome, which was made famous by Ansel Adams among others. The previous evening at sunset was no exception, being packed with people by the roadside. On this beautiful, atmospheric morning, though, it was deserted.

Sunlight filtering through the morning haze was catching just the very top of the Bridalveil waterfall, creating a bright shine in the blue air. I composed to frame the surrounding peaks and maintain the context and scale of the scene.

I made the classic images from the overlook too, but they seemed too obvious. I knew they had been done before. This one felt like my own image; I am sure that you have felt that sense of satisfaction at least once.

200mm lens, elbows braced on a wall, Fuji RF50

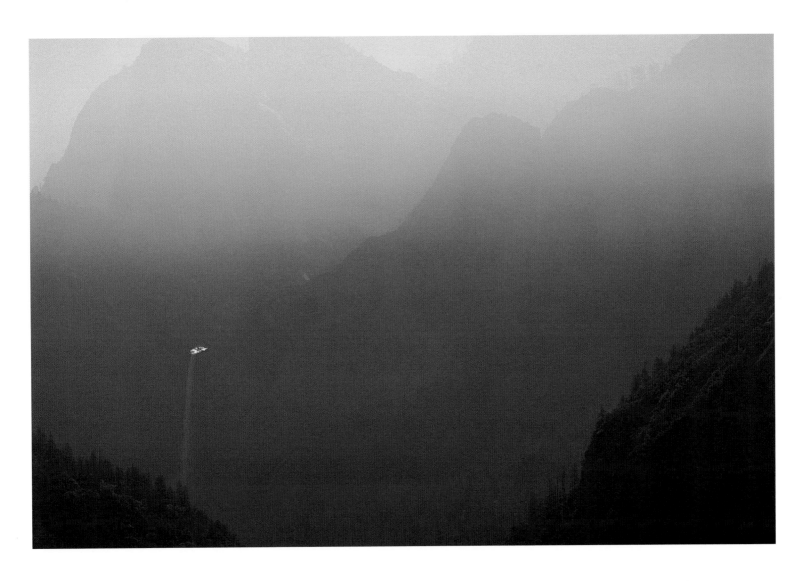

Evening Inversion, Speloncato – Corsica, 1988

One of the most exciting moments for a landscape photographer is when cloud or mists become blocked in the valleys, usually by a temperature inversion. Whenever there is fog on the ground in fair weather, it is worth getting to higher ground.

Here in the Balagne region of northern Corsica, a sea mist had risen in the afternoon, only to be blocked by a high mountain ridge inland. As we crossed the ridge in the car via a high pass, we found this wonderful ocean of cloud lapping the slopes away to the north-west. A series of images flowed in a steady stream.

There is a sense of detachment from the ground when clouds are below your feet, and only the tops around you reaching into a clear sky. It would be hard to be disengaged.

The important feature of this image is the framing of the scene to include the sweep of hills away in the distance. Exposure for the highlights has also revealed the textures in the cloud tops.

50mm lens, Fuji RF50

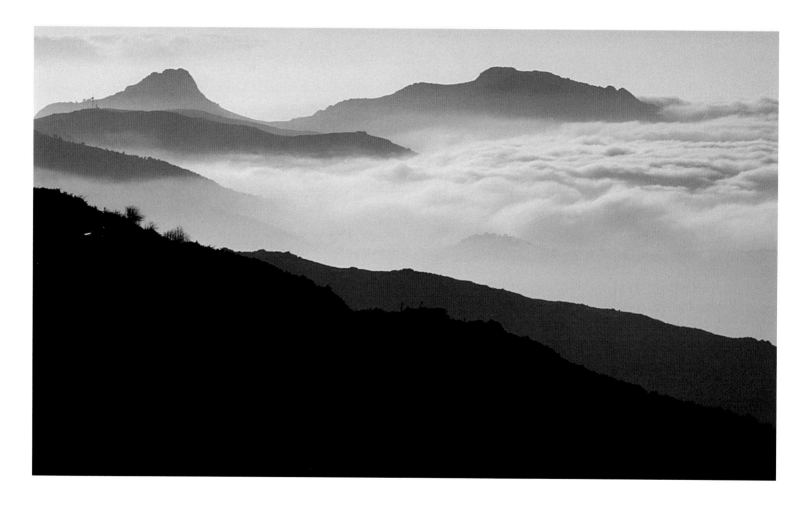

Contemplation, Tryfan – Snowdonia National Park, North Wales, 1989

Temperature inversions are common in North Wales. Whenever an excursion coincides with mist in the valleys and good weather, the experience is memorable. On Tryfan, though, a popular mountain year round, it is difficult to find a little peace in which to enjoy it.

In my own pursuit of some space of my own to take in the scenes from Tryfan's summit, I noticed another walker who had the same idea. He stood quietly and motionless on a rocky rise for 15 minutes. His own immersion in the scene seemed a perfect subject for my photograph. The rock and the man formed a strong silhouette against the mists, so I was happy to let them go black in my exposure by metering from the background.

Including people in a landscape image often brings scale and a sense of participation. Purists sometimes object, but our own involvement in the landscape is unavoidable. From a compositional perspective, a strategically placed person is an ideal prop.

50mm lens, Fuji RF50

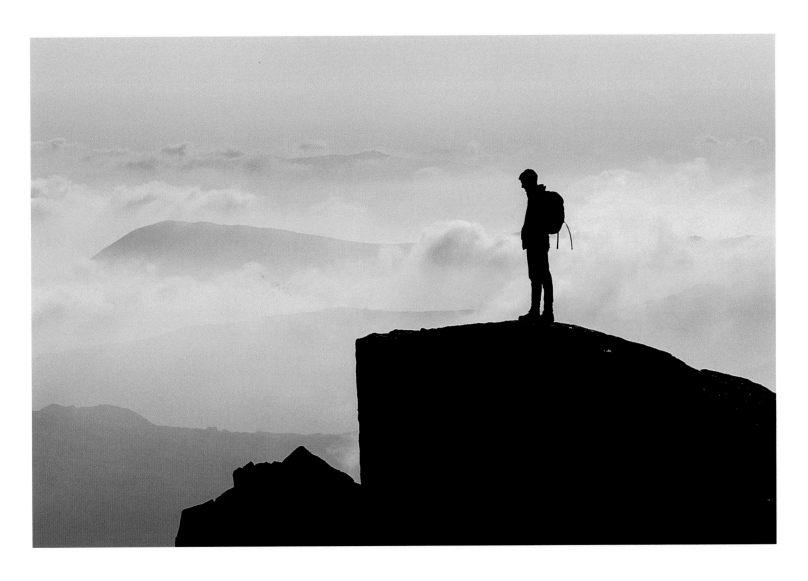

Grand Canyon

The sheer scale of the Grand Canyon leaves you overwhelmed for a time. It is 1,600m (nearly a mile) deep, and 32km (20 miles) across. The silence and space are tangible, even on the crowded South Rim.

We sat every evening for four days, watching the changing patterns of light, tracing the shadows as they created new shapes. Trying to capture the scale and grandeur proved difficult and elusive. wide-angle compositions were not working for me but, by letting my gaze fall on selected areas of light and shadow, I began to see smaller, detailed aspects of the whole that had meaning in a wider context.

Stacked Ridges – Grand Canyon National Park, Arizona, USA, 1989

This image uses a telephoto lens to compress the distance, stacking the ridges in a succession of golden light and ink-black shadows. Like widening the gaze, narrowing our vision selectively to pre-visualize distant scenes is an important technique. Scanning with the telephoto lens in place can then confirm what we have seen.

200mm lens, elbows braced for support, Fuji RF50

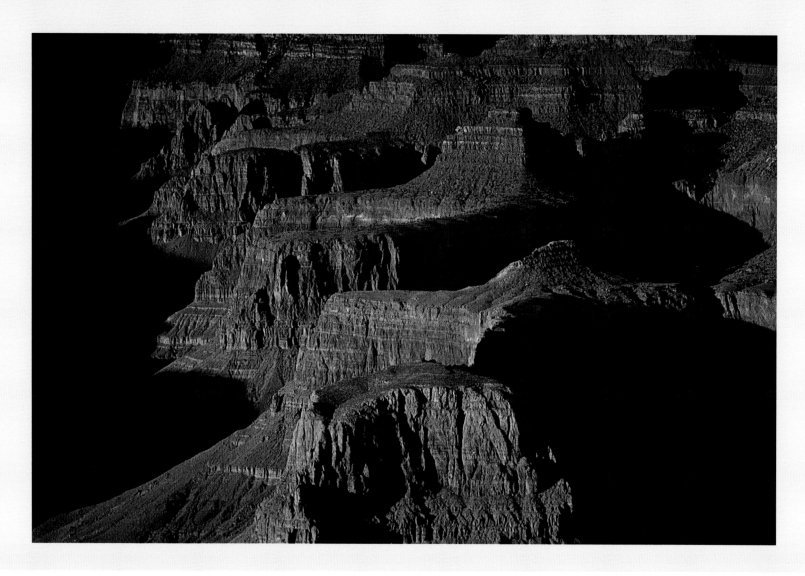

Window of Light – Grand Canyon National Park, Arizona, USA, 1989

This image came about in a similar way. It is not a window of light at all, but the prow of a buttress catching the light before it dips below the plateau.

The range of tones in this scene is too great for transparency film to hold, even though we are able to perceive shadow detail with our eyes. I am perfectly happy to let shadows disappear totally to black, provided that they do not overwhelm the image and they form pleasing shapes.

Defocusing your gaze, or using the depth-preview on the camera, helps to pre-visualize patterns of light and shade.

200mm lens, elbows braced for support, Fuji RF50

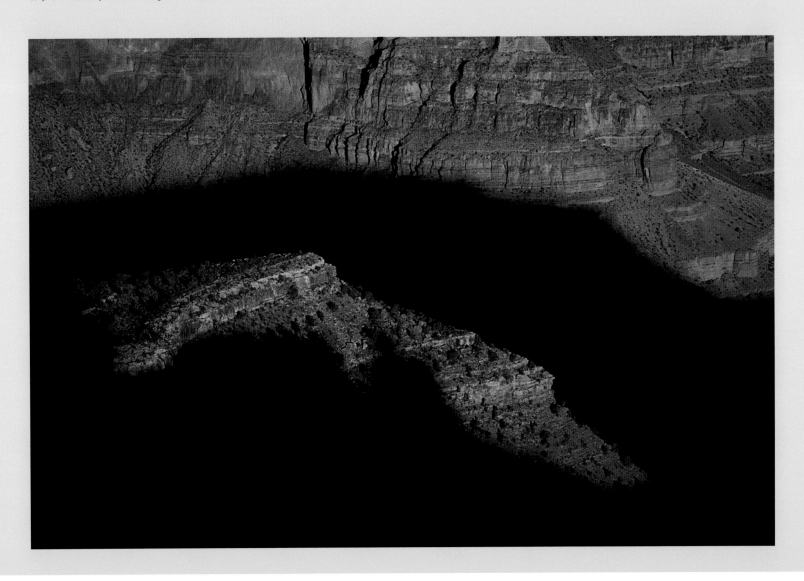

The Knott and High Raise – Lake District National Park, England, 2002

The Knott is an outlying fell just to the north-west of High Street in England's Lake District. We had spent the night in a high camp nearby, and were basking in brilliant sunlight on the top whilst the valleys still sat heavy with frost from the cold night.

The characteristic dry-stone wall was catching the full glare of the light, in contrast to the shadowy fellside. This was the subject of the image. The key, though, was balancing this with the light on the upper slopes of High Raise in the background.

The background light was a stroke of luck. Positioning the wall so that the right-hand end remained just open was deliberate, to allow the eye to wander freely.

Fences and walls often block the way into an image. This can make a bold statement if intentional. Including an open gate as a 'way through' invites the eye further into the picture space.

50mm lens, small aperture for depth of field, Fuji Velvia

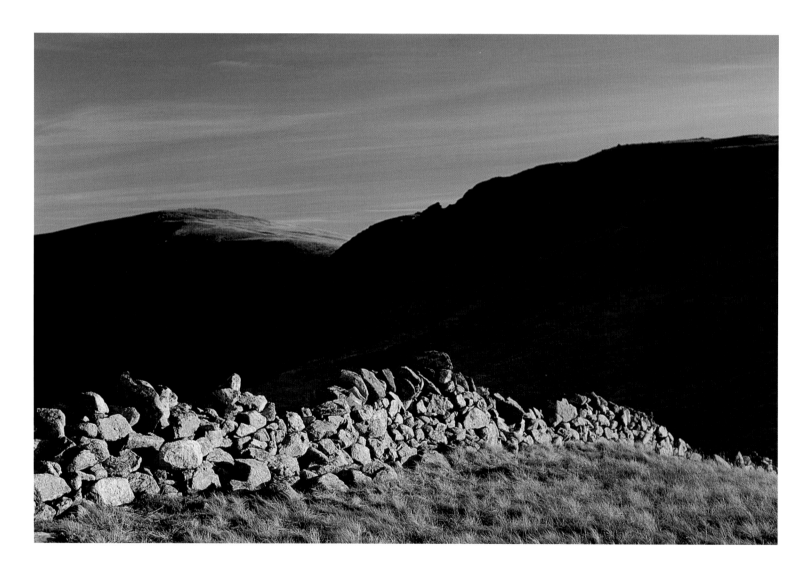

Last Light, Ogwen – Snowdonia National Park, North Wales, 1990

I thought I had made my final image for the day. The north-eastern side of Y Garn is dark in winter, and drops sharply down to Ogwen. We were already well out of the sunlight.

Suddenly, the distant tops took on colour, as light flooded across the lower fells at the eastern end of the Glyders range. With the valley full of fog, an instant image presented itself, and I asked my friend to stand on the edge to balance the scene. The light came and went quickly, leaving us to descend into the dank, freezing fog of the valley floor.

The light is the feature of this critical image. But, again, use of a person provides essential balance and scale, allowing the large space of the foreground to be used, and providing a sense of participation for the viewer.

50mm lens, small aperture for depth of field, Fuji RF50

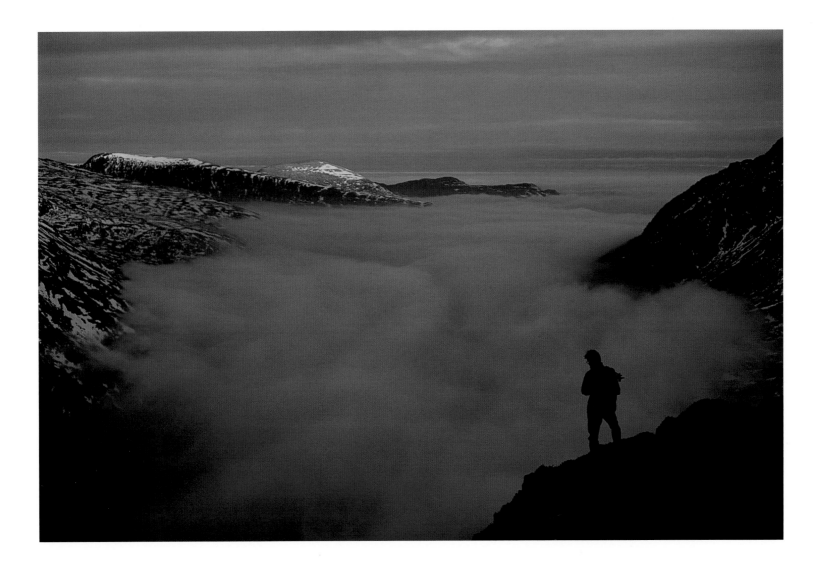

Glacier Shadows – near Brandenburger Haus, Ötztaler Alps, Austria, 1996

Staying in the Brandenburger Haus had already provided an evening and morning of wonderful light (see images on pages 42 and 43).

That same crisp, sharp morning, we left the hut to traverse the Hintereisspitzen, three peaks rimming the icefield. In truth we were too late; the sun was warm, and what should have been a pleasant stroll over the glacier became a toil as we broke through the soft-crusted snow. It was a great relief to reach the shadows, as the snow was once again icy and hard. Also, a whole new range of photography opportunities appeared as we moved from light to shade along the foot of the peaks.

It was the pattern and the diagonal that seemed to make a strong statement. I was not concerned to capture bright white snow; rather it was the textures in the shadows, particularly on the twilight edge, that caught my attention.

50mm lens, Fuji Sensia ISO 100

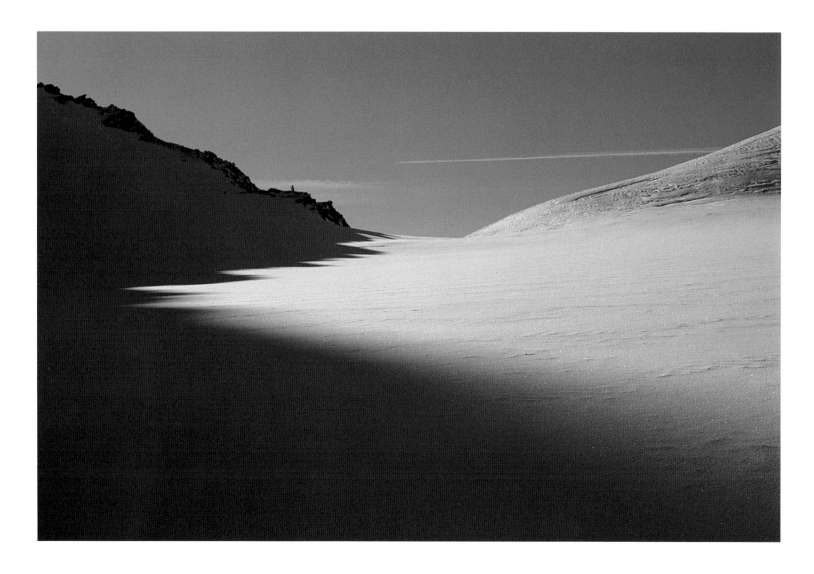

Light Bands, Blencathra – Lake District National Park, England, 1995

Here is another example of simple pattern-work. The image came to me as I wandered slowly around on the upper slopes of Blencathra, a prominent peak in the north of the Lake District. We had already decided to camp high, and I was anticipating great light later in the evening (see image on page 109).

Broken cloud meant that light was intermittent, never in the same place twice and never still. There were three distinct bands: shadow from the hill, the sunlit snow slope, and the dark sky beyond. Strong diagonals seemed to be working in harmony with one another. One image was all it took.

I used the 200mm lens to compress the scene and exclude the peripheral detail, bringing attention only to the detail I had observed.

Like many others in the book, this shot could never have been planned. It came from an awareness of light, and a desire to photograph light, rather than things or places. It is what I often call 'light for light's sake'.

200mm lens, Fuji Sensia ISO 100

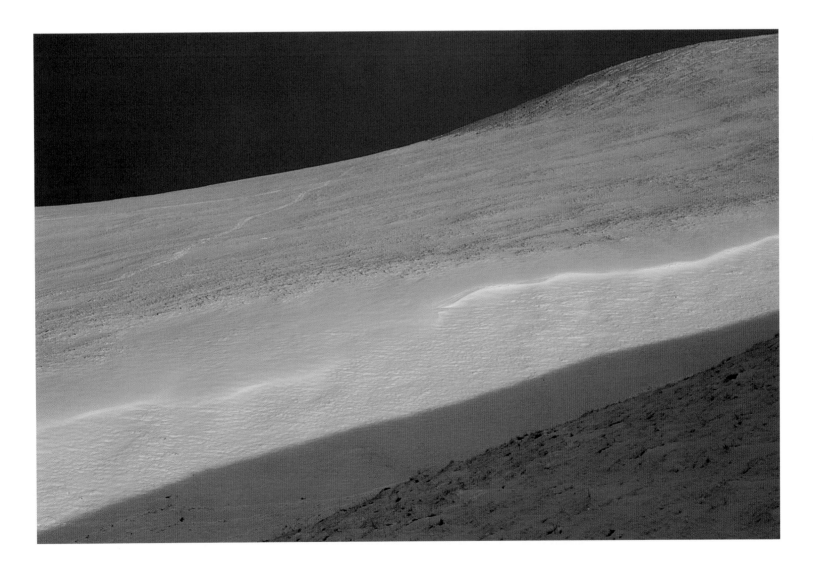

Devoke Water – Lake District National Park, England, 1993

Places often have an air about them, a mood, an atmosphere that we can sense but cannot identify. Devoke Water is such a place for me. It sits in the quiet south-western moorlands of Lakeland. It has stillness, almost a haunted foreboding.

I made a small detour from the moorland road across to the water, mindful that there were some dark clouds to the west and strong morning light, so often perfect conditions for image making (the same is true in the evening with dark cloud in the east).

I made this image almost immediately the lake came into view. The light and the rich autumn colours made the scene feel alive. There were more pictures, but the first image was the definitive one, as is often the case.

50mm lens, Fuji Sensia ISO 100

Buttermere Shore – Lake District National Park, England, 1993

Buttermere is one of the most photographed parts of the Lake District, not surprisingly. It is accessible, with easy footpaths and a picturesque village. Promontories of land decked with gorgeous pine trees provide natural stopping points all around the shore of the lake.

I was walking high on the High Stile ridge this winter day in spring-like conditions. Towards the south-eastern end, as we descended, the fiery red brackens on the opposite fells began to be reflected in the still water. We did not stop; the view was changing constantly as the path dropped. But then light came onto the shore of Buttermere and a picture was there. I was able to brace my elbows onto a stile and to frame an image with the 200mm lens.

The exact positioning of the light was important, as was my height. Here, I was able to keep the shoreline separate from the reflection of the crag. A shadow in the lower right corner also tightens the composition.

200mm lens, elbows braced on rock for support, Fuji RF50

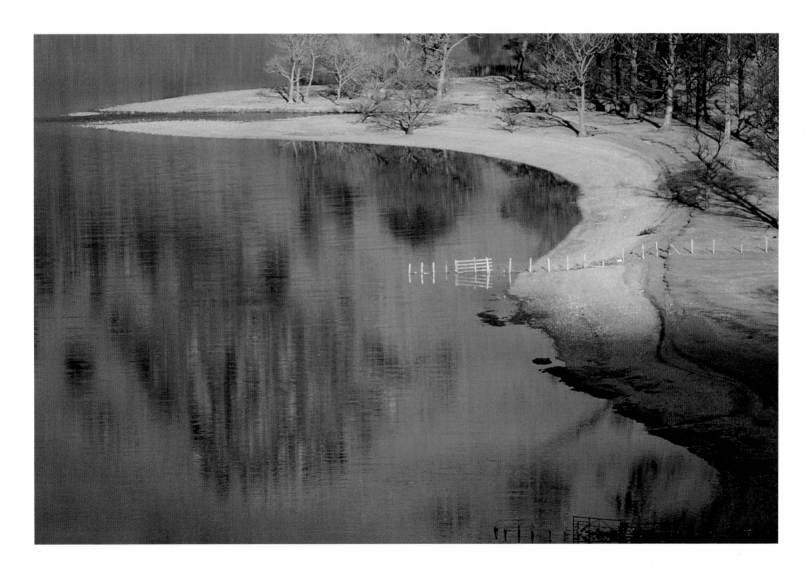

**Snow on Sail Fell – Lake District National
Park, England, 1999**

This walk in the Derwent Fells was another
speculative raid. We had delayed leaving the valley
until lunchtime, due to heavy sleet and snow, but
there was the promise of an evening clearance.
Sure enough, the brighter weather came late,
when the hills were deserted (see also the images
on pages 88 and 89).

We paused to watch; the low-angled light
became intense for a while, yet it was delicate in
hue. The snow behind us was lit beautifully, but
the scene was also enhanced by the contrast of
the distant shadowed ridges and the darker clouds.
I crouched down intuitively to let the grasses make
a dominant foreground, moving just sufficiently
to arrange them as I wanted them.

The natural fusion of warm and cool tones at
the beginning and end of the day usually makes
for a pleasing image.

*50mm lens, small aperture for depth of field,
hyperfocused for the nearest grasses, Fuji
Sensia ISO 100*

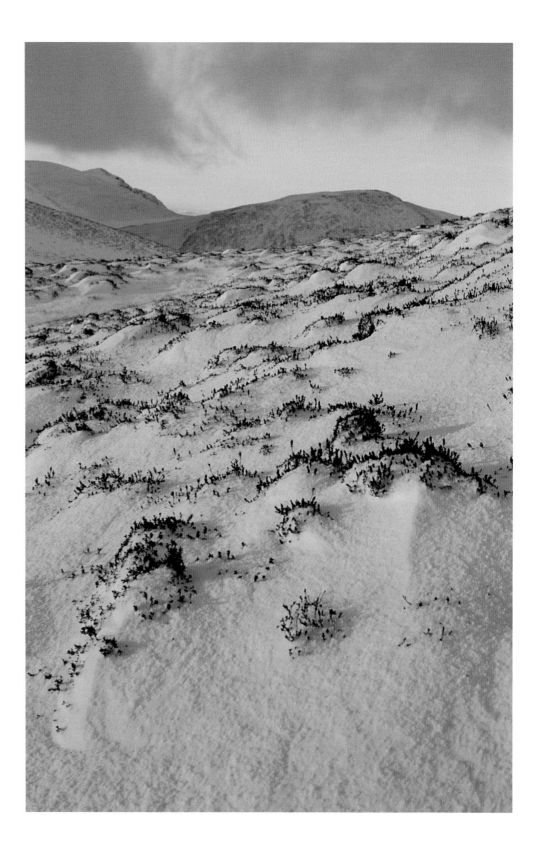

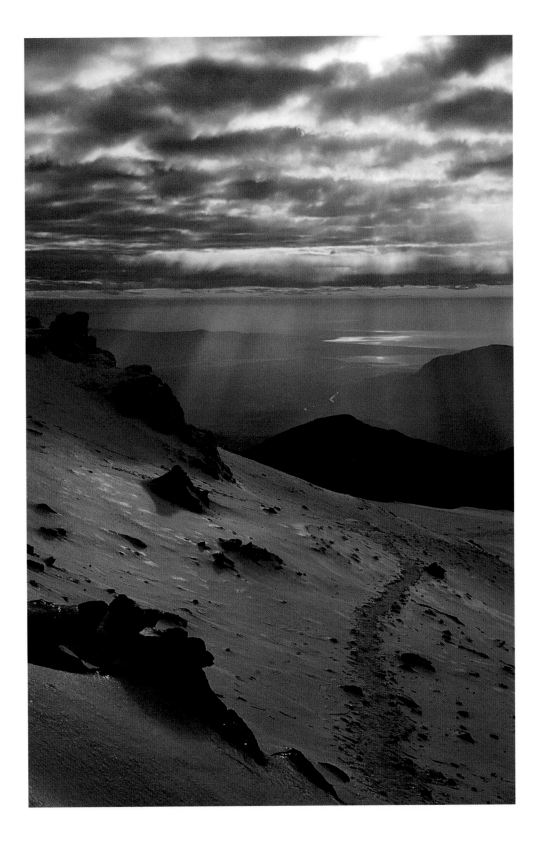

Skyburst – Snowdonia National Park, North Wales, 1987

There are days, just occasionally, when conditions contrive to bring the most magical scenes together. This December day on Snowdon began brightly but clouded up to leave a broken sky, and there it stayed. All day, until the last light at 4pm, sunbursts poured downwards through the heavy air. The scene shifted almost unnoticed, but every corner we turned presented a different aspect. In every way, we were immersed for the entire walk.

On the final pull up to Snowdon's summit, I saw everything converge into a wondrous fusion of elements for a photograph. The snowy ridge behind us was silvery. Tracks in the snow led off to the dark shadows of a peak in the mid-ground and the air was full of rays of light. In the distance, the coast shimmered golden, and a red base seemed to hold up the layered sky.

It felt as if I had to do nothing to secure the image other than bring the elements together within the frame and press the button. Images such as this one defy the imagination and can be explained only by the term 'serendipity'. A great many frames were exposed that day, but this one said everything.

50mm lens, small aperture for depth of field, Fuji RF50

Rock Sculptures, Bryce Canyon Rim – Bryce Canyon National Park, Utah, USA, 1989

Many times I have watched the busloads of people turn up at national parks. I know that the trippers have a half-hour to wander about, to look, and to take a few pictures before being herded back onto the bus and away. It is not possible to engage with the landscape under the pressure of an itinerary. Staying overnight, you can explore when the crowds are gone. On the rim of the Bryce Canyon amphitheatres are some towers of rock that remain largely unseen behind the trees of the campground.

I went out in the warm light of the evening. The towers were perfectly placed to catch the sunlight, which emphasized the rich reds of the rock, and I was able to make the image I first saw, simply by losing a little height to lift them up against the sky.

24mm lens, Fuji RF50

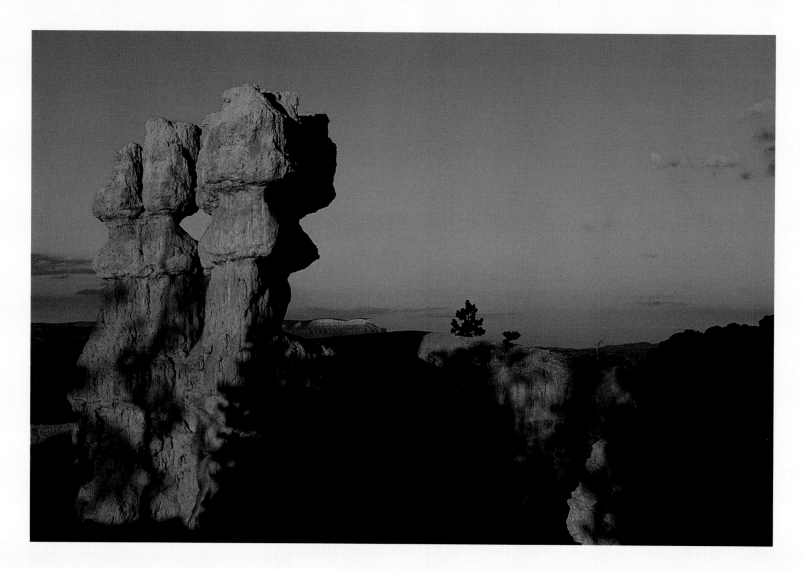

Closer observation began to reveal shapes and delicate sculptures. I was fascinated, and took several shots in some surreal light. A wide aperture helped me to maintain focus just on the rocks themselves.

A great tip for your holiday: even if you travel independently, find out when the tour buses go to the various attractions, then go there on a different day. Better still, arrange to stay there until dusk when you can really 'see it in its best light'.

50mm lens, wide aperture, Fuji RF50

Snowdonia Ridges – Snowdonia National Park, North Wales, 1990

In the mountains, or wherever you may be, if there is morning fog on an otherwise fine, stable day, then go high. Do so particularly if the mist appears thin. If you break out above the mist, you have won. If not, then nothing is lost, but sooner or later you will get lucky.

We set out onto the Glyders range in Snowdonia in freezing fog, but emerged from the gloom, after just half an hour's climbing, into a crystal-clear sky.

Towards the end of the day, the low sunlight illuminated the mists still trapped in the valleys to the south-west of Y Garn. Two photographs I made in that final hour of light required only minimal framing, but did require that I pre-visualize the distant scenes for the 200mm telephoto lens.

This first image looks along the Nantlle Ridge. The bright mist in the valley is framed at the base by the low point in the foreground ridge, which gives it emphasis.

200mm lens, Fuji Velvia

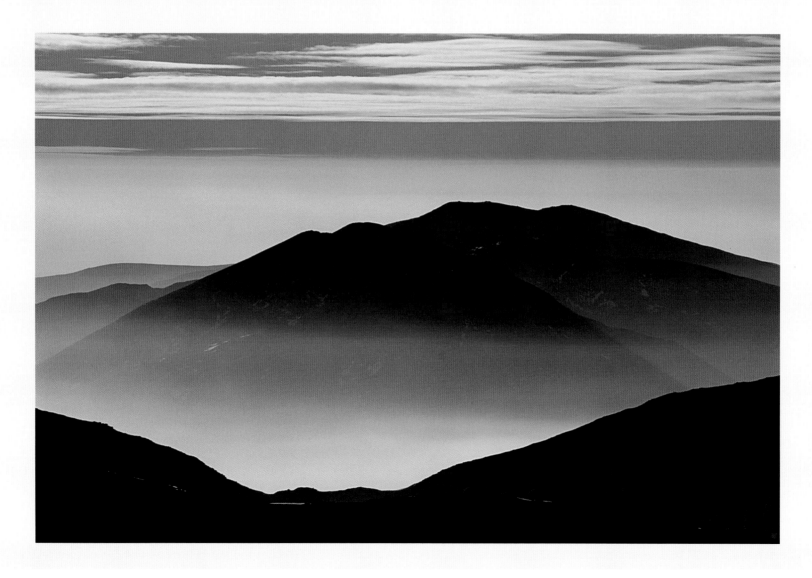

In this longer view, we take in the Yr Eifl range of hills on the Lleyn peninsula. The image is made by the succession of ridges, which are separated by the veils of mist between them.

There is an exhilaration that I feel whenever I have been immersed, an excitement in having seen something remarkable and captured it on film.

200mm lens, Fuji Velvia

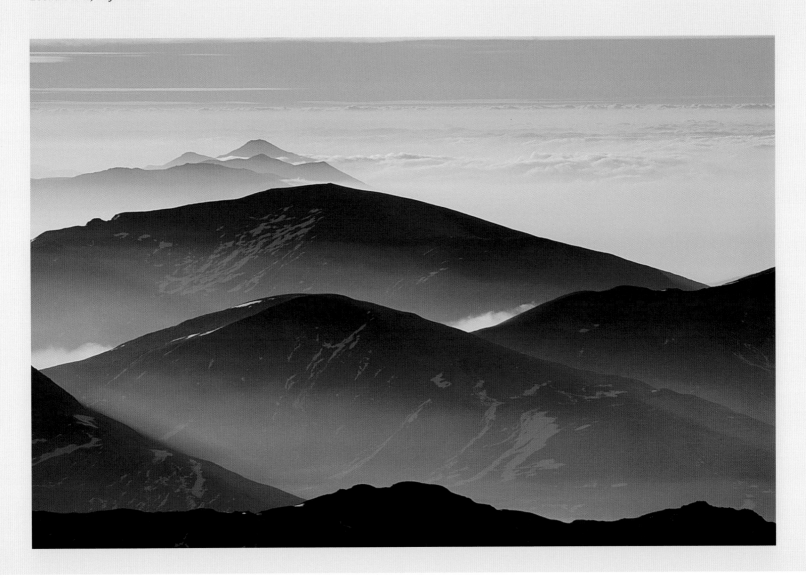

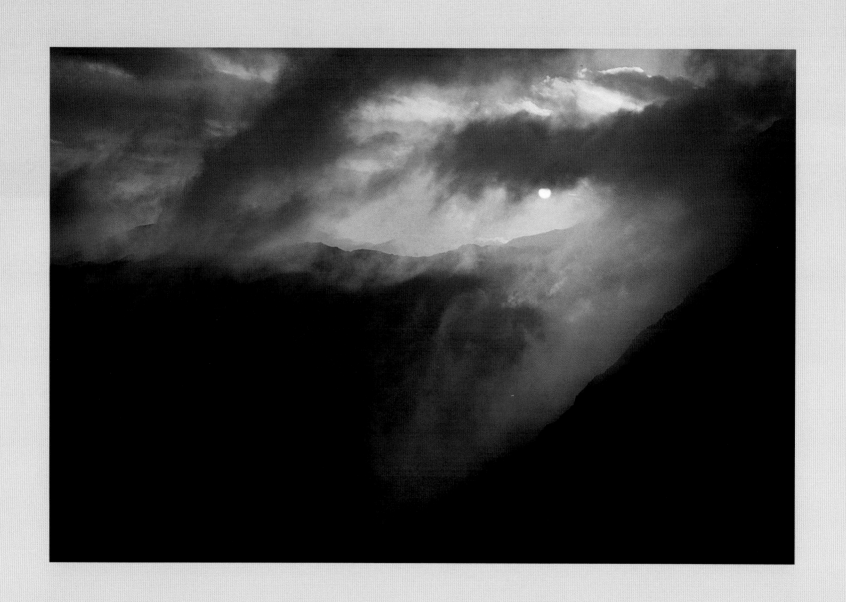

Section 3 **Rapid** response

Working at the Speed of Light

The images in Section 2 came about mostly through a process of immersion: a conscious decision to let go and to be at one with the landscape. None of the scenes was especially fast moving, nor did they require seeking out; each is a moment in the cycle of changing light.

What, though, when that moment breaks so fast that there is no time for thought? Sometimes, no thought is needed, we just do what is right instinctively, and we find it difficult afterwards to explain how we did it. It feels effortless and natural. This state of flow is often called 'being in the zone'. When we are in the zone as photographers, we can respond to a fast-breaking situation whilst retaining full control of the camera. We might go somewhere on a hunch, sensing that something good might happen, and so it does; photojournalists work in this way. At other times, the first thing we see is the image. It seems as if the process of seeing and making the photograph are all melded into one.

The more we can train ourselves to let go, to stop thinking, and to become immersed, the more likely it is we can experience this state of flow. (Another form of flow, familiar to artists and writers, is considered in Section 4.) When we try to make a rational decision, however, spontaneity becomes blocked; we talk ourselves out of it, we worry about getting it right, we miss the moment.

The rule of thumb I use is, if it looks good now, shoot it; if it looks like it could be good, follow your instincts, watch, be patient. Applying this rule, a stream of images can result, so long as the light lasts. As to what looks good, that is up to you. Take inspiration from other photographs, by all means, but follow your own heart.

There are some practical considerations, though. For a fast response we must be totally conversant with the controls of the camera, and have a sound knowledge of simple techniques that can be applied quickly. Obviously, the simpler the camera, and the simpler the techniques we employ, the more likely we are to retain control. (More on this in Appendices 1 and 2.)

All of the situations of light in this section were dynamic. The light or another element was moving, sometimes rapidly. I either acted instinctively and immediately, or I waited, relying on selecting the 'right' moment; I was working at the speed of light, but I never felt hurried.

Exercises

1. Take the time to read the camera manual, especially for the important techniques of how to control depth of field, how to meter from selected parts of a scene, and how to make minor adjustments to exposure. Work out which modes allow you to work most flexibly and instinctively.

2. Then go out on a shoot with no film. Treat the session like practising your golf swing. Look at meter readings, respond, and repeat your moves until the camera holds no more mystery for you.

Cloudscape, Crib Goch – Snowdonia National Park, North Wales, 1989

This day on the Crib Goch ridge of Snowdon provided the fastest photography I have ever encountered. I knew that sometimes, a breaking scene gave me very little time in which to respond, but here I had no leeway to move either, as Crib Goch ridge falls away sharply on both sides of its knife-edged crest for 300m (1,000ft).

For most of the day clouds had kept us enveloped in gloom. However, as afternoon drew on, clearances became more frequent, often leaving bright sunlight and clear skies for a few seconds. As we crossed the pinnacles of rock on the ridge, the cloud suddenly cleared and Yr Wyddfa, the summit of Snowdon, was revealed. I grabbed my camera and made two images that seemed well balanced in the viewfinder. There was no time for thought or consideration of 'rules'; ten seconds later, it was gone, and we were returned to the gloom. The next time a judge at your camera club suggests moving 2m (6ft) to the left, remember this picture!

You cannot make an instant response if the camera is in the rucksack; it must be ready and, in this instance, mine was in my waistpouch. I keep my camera set on an autoexposure mode at an aperture of f/8 or f/11, which allows me to hyperfocus quickly and shoot. I have made it my business to know my camera intimately, so that I can respond intuitively to the light.

500mm lens, Fuji RF50

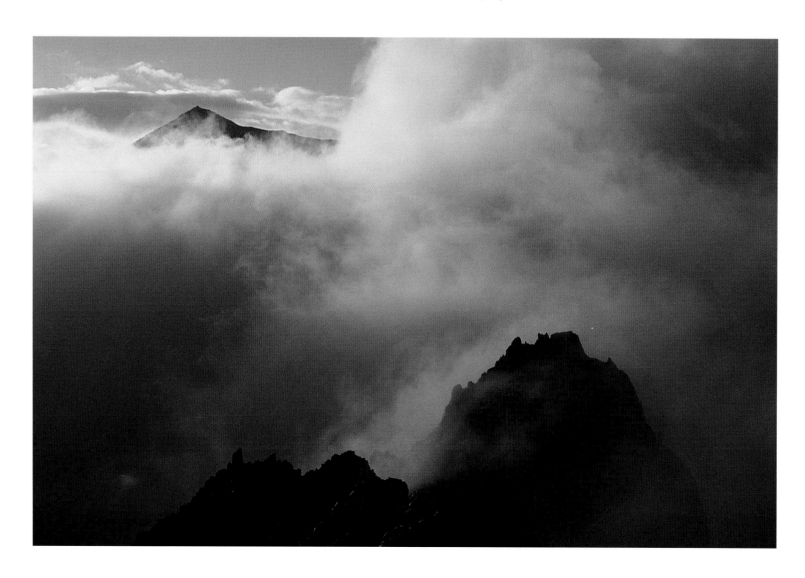

Brocken Spectre, Crib Goch – Snowdonia National Park, North Wales, 1989

You are picking your way along a mountain ridge in shrouding mists and cloud. Suddenly the sun breaks through brightly and a large shadow looms before you, floating, ethereal, surrounded by a mystical halo of coloured rings. You stand, enthralled. The shadow is, of course, your own, cast onto mist that is lingering close below in the corrie, or on the lee of the crest. It is a Brocken Spectre (named after the mountain in Germany where it was first observed) and Glory ring, a common but highly sought-after optical phenomenon among walkers and photographers. Backward scattering of light in the water droplets causes the Glory rings.

Narrow ridges like Crib Goch offer great opportunities for seeing them, especially on winter days with low sunlight and lingering clouds. We were lucky enough to see dozens on this afternoon and each time they lasted just long enough for an image. I liked this one particularly because of its proximity to the brightly lit rocks. They are easy to photograph: simply meter straight from the mist as a little underexposure emphasizes the shadow.

When you are aware of the conditions for seeing Spectres, you can position yourself in the right place, which is between the sun and any mist lingering close below. If it happens, you can claim to have made our own luck. (See also the image on page 102.)

50mm lens, Fuji RF50

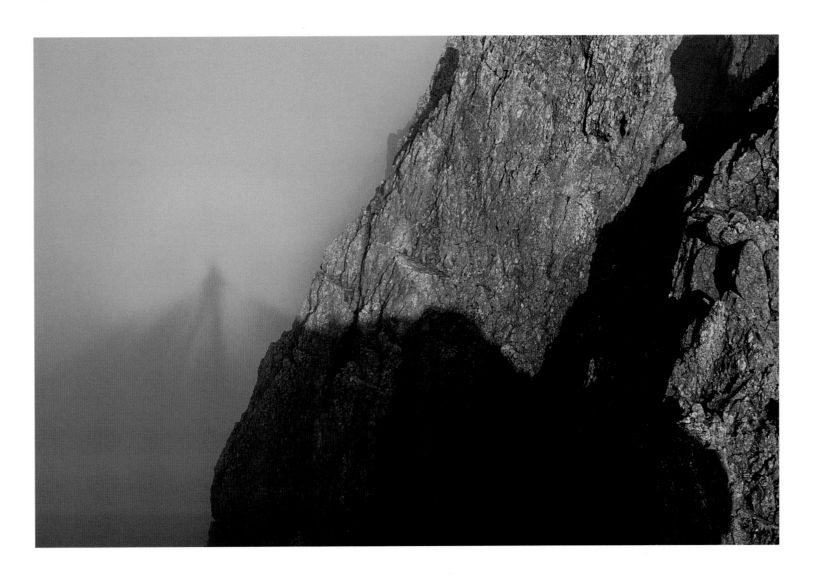

Sunlight on Sail Beck – Lake District National Park, England, 1999

Just a short distance from where I made the 'Snow on Sail Fell' image on page 78, I could see that the light was about to disappear. Heavier clouds were moving in quickly to obscure the sun, but curtains of light were still drifting across the opposite fellside. On this occasion I was not in the right place at the right time, so I ran, looking all the time for the balance between the shadowed ground and the valley.

When this is happening, my instinct is telling me whether the composition looks good or not. The last thing on my mind is any notion of rules or guidelines.

I reached a good position nearby, and waited just a few seconds then for the light to drift across in a pleasing way. Those few seconds were sufficient for me to compose myself as well as the image.

Had I been using a zoom lens, I might well have been tempted to shoot from the position where I first saw a possible image. My 50mm lens compels me to move around to seek the best position; it stops me becoming complacent.

50mm lens, Fuji Sensia ISO 100

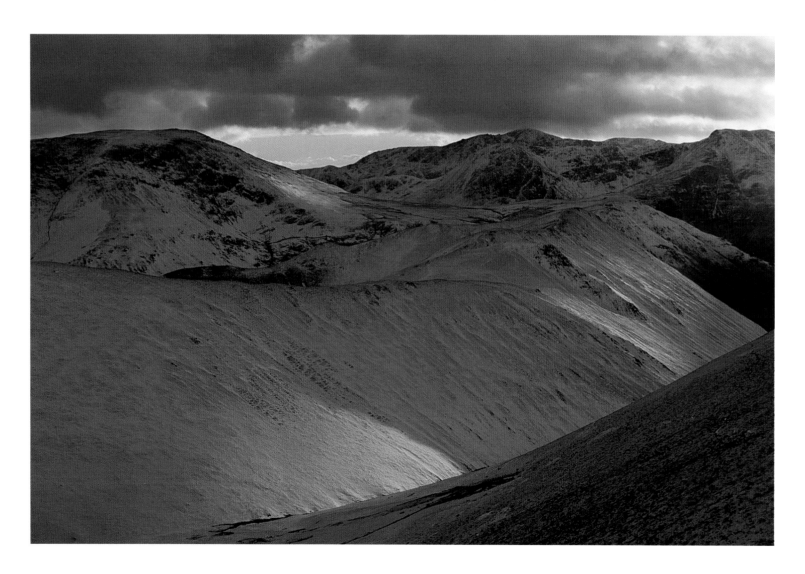

Dawn Light, Skiddaw – Lake District National Park, England, 1999

After making the image on the facing page, we descended a little and made camp in a position that gave us a clear view north to Skiddaw.

I am always awake at first light in the hills. Stepping out into the cold from a warm sleeping bag sometimes demands more effort than it is worth, but it has to be done if there is the remotest chance of any light.

The sky was a uniform grey, but then a touch of colour appeared to the east of Skiddaw's peak. I had the hunch to find a place that would give me a good image if the light developed.

For just a few seconds, a glow came to illuminate the mountain. In low light, I worked with as slow a shutter speed as I could manage to hold, so as to give me a smaller aperture and some depth of field. The image was in.

My concern in finding a place to make this image was to fill the space in the lower left corner without blocking off the view into the picture. The grasses again gave me the perfect prop.

50mm lens, Fuji Sensia ISO 100

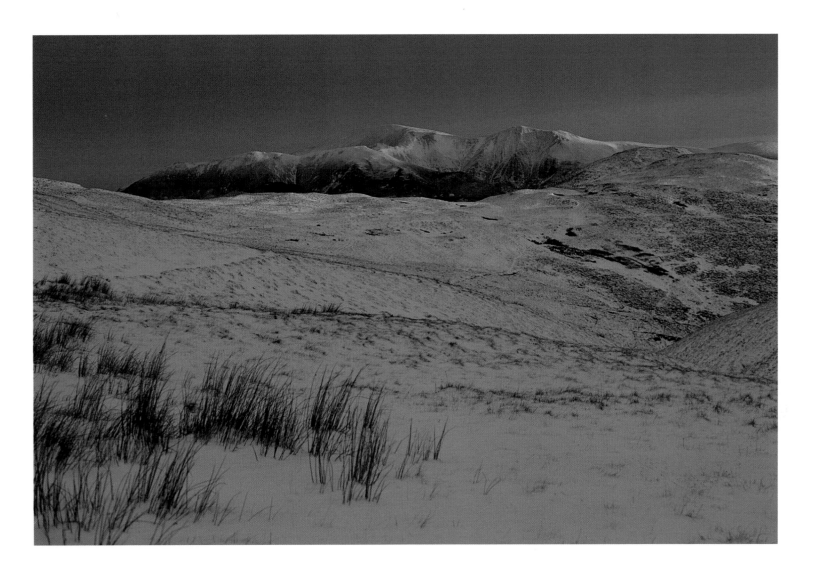

Horse on Truleigh Hill – South Downs near Edburton, West Sussex, England, 1994

Truleigh Hill is my local hill and is close enough for me to walk over it weekly in the summer months. With a group of friends one evening, I was heading over the hill to the pub at Edburton, when the sky became ablaze with colour.

I am not usually tempted to photograph sunsets that are composed principally of sky and a black horizon, so I set about looking for a tree, or something to provide a breaking silhouette. This horse was that something. I framed a shot, but I was not happy that the horse was facing out of the frame.

For what seemed like an age it stood there, just eating, as they do. Then it turned its head, and I had my image.

The sunlight lingered here. Working at the speed of light was about timing, choosing my moment to release the shutter. By watching the sky, I knew I could afford to wait for that moment; then it was instant.

50mm lens, Fuji RF50

Downland Riders – Steyning Round Hill, South Downs near Steyning, West Sussex, England, 1994

The best light for photography on the Sussex downland is frequently in the winter months, when low-angled lighting picks out the gentle undulations which in summer are lost for most of the day.

This image was another chance happening, timing being a key element. I had made a number of images elsewhere when I saw two riders on the track, on the crest of the sunlit rise. With my 200mm lens, I exposed for the sunlit grass and waited for a small distance to open up between them before releasing the shutter.

Photographers are often too hasty in dismissing midday lighting. In the winter, strong lighting can remain for the whole day, the low angles giving texture and interesting shadows.

200mm lens, elbows braced on a fence, Fuji RF50

Cloudfall, South Downs – Devil's Dyke, East Sussex, England, 1986

At the time I made this image I was relatively inexperienced, but I was tuning in regularly to interesting light.

Sea mists are common on the coastal strip below the South Downs, but they mostly become blocked by the hills, leaving the Sussex Weald clear. Just occasionally, though, mostly in the autumn months, they rise up as far as the scarp, and tumble over the steep, northern slopes like a series of vaporous waterfalls onto the villages below. I had seen this coming and made a dash to Devil's Dyke, where I was able to photograph the falls in rapidly diminishing light with my miniature camera. I have seen this phenomenon on just a couple of occasions since then, though we are often fogbound at home in the river valley.

Knowing local conditions can help you to respond quickly as a photographer. Keeping a camera with you is essential too. A compact camera in the car or briefcase means that you can be ready if a situation breaks.

Rollei 35 LED, 40mm lens, Kodachrome 25

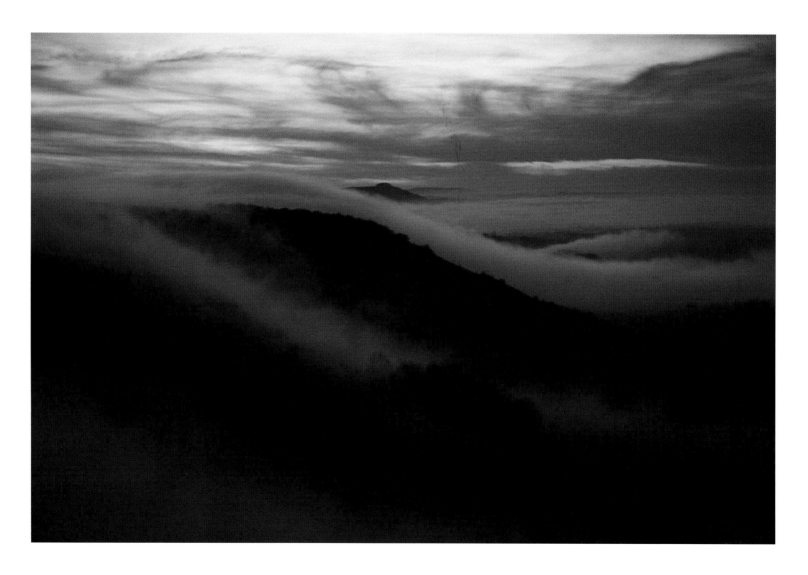

Cloudfall, Bannau Sir Gaer – Black Mountains, South Wales, 1995

I saw the cloudfalls again in the Black Mountains of South Wales, where our group had set up camp by a lake under the northern scarp.

The weather was hot in July, and as usual I was up with the light. For some while, I just sat and watched in the warmth of the morning. There was some mist, but I was mostly enjoying the birds over the lake. In an instant, mist billowed up and over the scarp, completely unpredictably. It lingered for a few minutes and was then gone, by which time I had been able to make a few images with my 200mm lens.

The key to this image, other than preparedness, is the timing. The others I made had neither the balance, nor the light on the cloudfall. The small faint clouds are a stroke of luck, just adding interest to the blue sky.

200mm lens, elbows braced on rocks, Fuji Sensia ISO 100

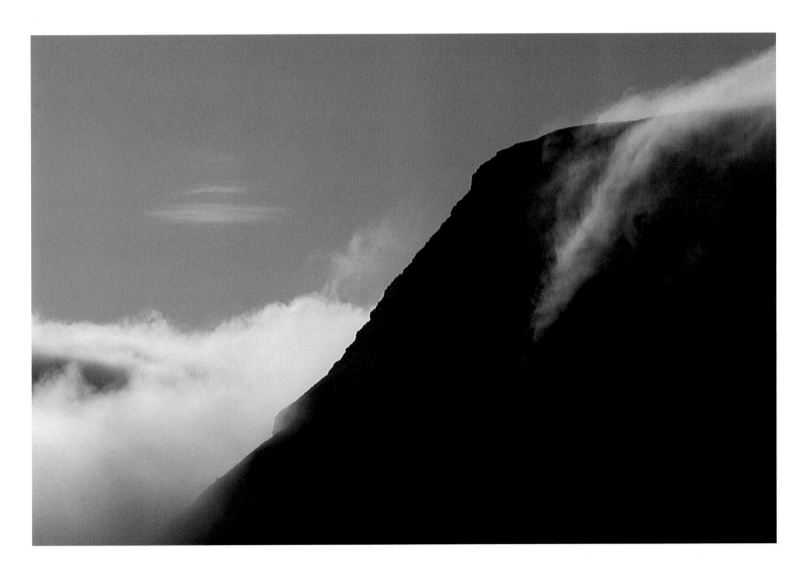

Mitten Buttes – Monument Valley, Utah, USA, 1989

Two earlier images, on pages 24 and 25, illustrated the dramatic difference in lighting on the rocks of Monument Valley when the evening light shone.

I was very aware during this time of just how fast I was moving. I could see the shadows moving up the rock faces, and I wanted to capture as many angles as I could. It was quite an exciting chase.

In some ways, I am more satisfied with this image than the one on page 25, which is probably the definitive image from the shoot. I would have made that photograph had I found the location and waited for the light, tripod prepared.

But I would not have had the time to get this one, nor any of the two dozen others that made the shoot so satisfying.

It was a test of observation, but also a test of my technique to be able to work fast. Journalists and sports photographers are accustomed to working at speed, but it is an approach that scenic photographers often frown upon. When the pace of change is fast, it feels a natural approach to me.

50mm lens, Fuji RF50

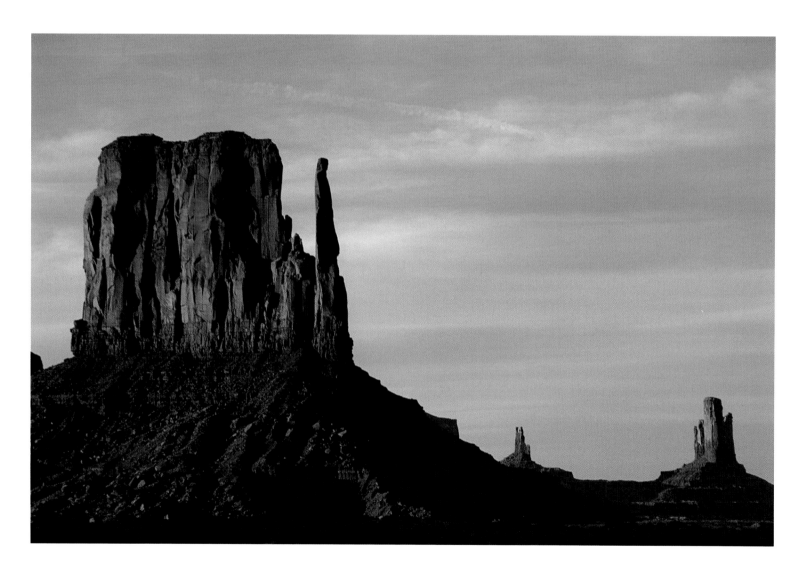

Alpenglow and Cloud Swirl – Ötztaler Alps, Austria, 1989

Unless the light is fleeting, alpenglow is an effect that is fairly long lasting. Although the colours of the light change rapidly over the course of a few minutes, there is usually time to consider and frame an ideal shot.

In this image, taken from the Breslauer Hut, I was composing a shot of the glow on this shapely, distant peak. I was watching the colour, checking my exposure and waiting, but I nearly missed the layers of darker cloud for looking at just one part of the scene. The moment was chosen for me when the cloud formed a beautiful breaking wave, and in the perfect place in the sky too.

It is important to maintain an awareness of the whole scene. When the scene is breaking, things can take us by surprise. I have sometimes moved totally away from my original intentions as a new situation develops.

200mm lens, elbows braced on wall, Fuji RF50

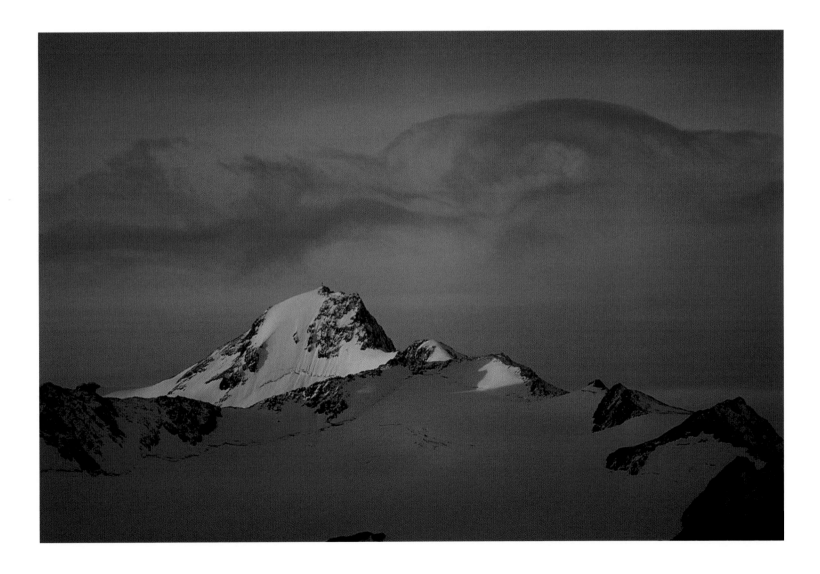

Cloud on Great End – Lake District National Park, England, 1999

This shot was further proof of how exciting working with fast-changing light could be, if I needed convincing after so long. I knew instantly that I had something dramatic, and that I had witnessed one of those moments of sheer unpredictable luck.

I saw the clouds – they were everywhere – but a big one was looming over Great End. As I saw it, the cloud and the mountain both picked up some colour. I made one image with my 50mm lens before it dimmed, and the whole process had taken just a few seconds from awareness to completion.

The sky, the weather and the clouds are almost wholly responsible for changing light, and a changing sky with interesting clouds will almost always produce a worthy landscape photograph.

50mm lens, Fuji Sensia ISO 100

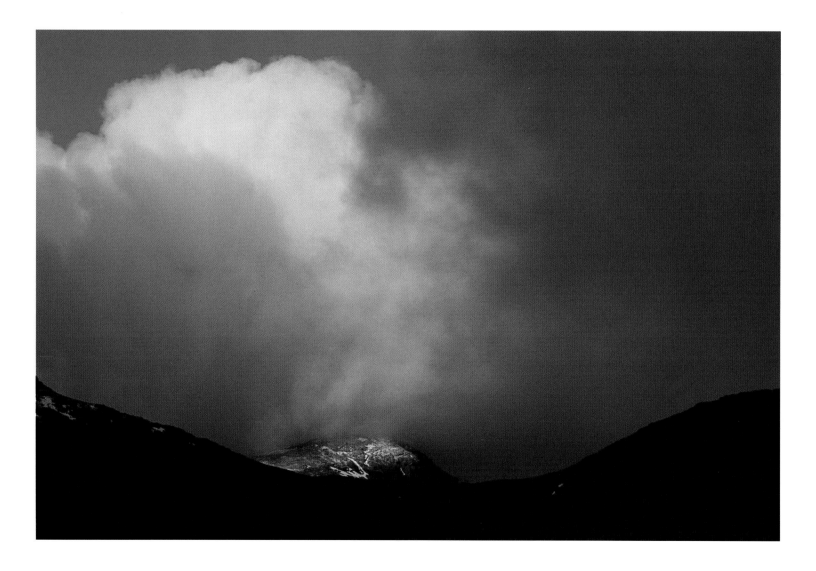

Storm Clouds, Glen Rosa – Isle of Arran, Scotland, 2002

Continuous rain for 36 hours is not unheard of in Scotland, but the edges of weather frequently bring magnificent conditions for photography. Several hours after the rain had finally ceased, the sky brightened and numerous showers passed through.

These dramatic storm clouds appeared quite suddenly whilst we were eating dinner at the campsite. There was nowhere I could run to make an interesting foreground, so I framed them where I stood, using the treetops as a small base. They were too good to miss.

The mix of colours here is extraordinary: a warm yellowish-orange and an ice blue, side-by-side in two separate cloud formations. As with the pinks and blues of low sunlight, I am no longer surprised by what is possible. I know that natural light is infinitely variable; I refuse to create artificial colours with filters.

50mm lens, Fuji Velvia

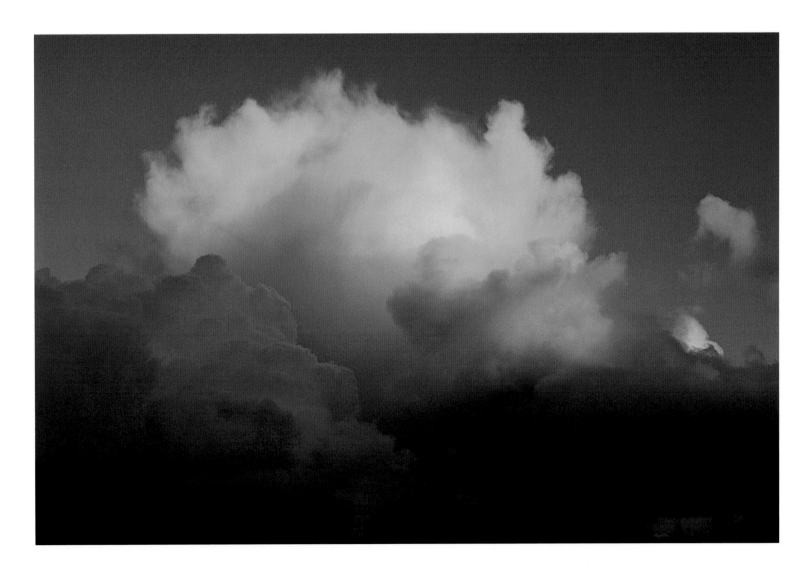

Light Bands, Esk Hause – Lake District National Park, England, 1999

These facing photographs look as though they could have been made in situations of patient waiting. The reality was very different. Light was moving fast across this landscape near Esk Hause in the Lake District. There is no subject to the scene, except for the light. I would not have made the image at all, were it not for the light, but with the bright band across the foreground, the parabolic shape of the col becomes graphically pleasing.

This was an instant image, made without thought. I framed it quickly, and metered from the brighter ground. In just a few seconds the opportunity was gone. I waited for several more minutes in the hope that light might return, but it did not. I was pleased that I went with my instinct. Again I was intrigued afterwards by the importance of the darker ridge in the top left. It has an importance in the frame, giving a further layer of relief.

50mm lens, Fuji Sensia ISO 100

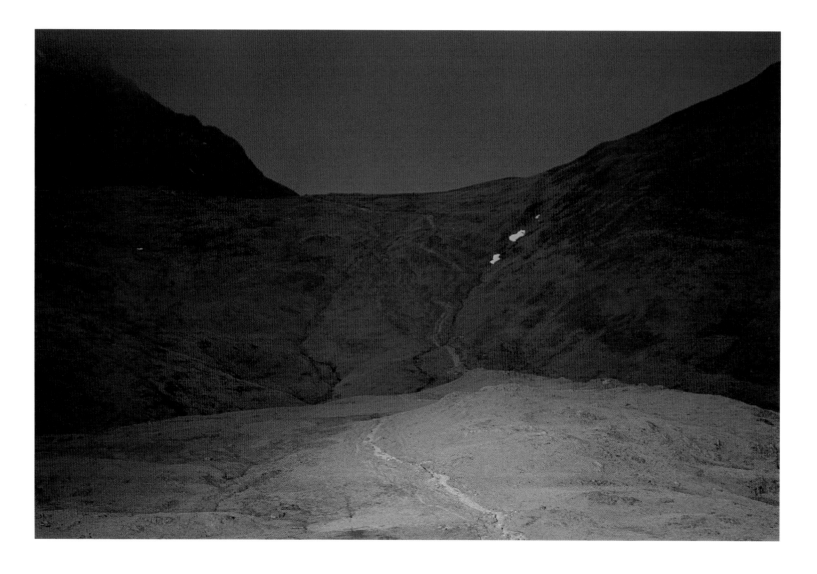

**Light on the Causeway – Llyn Llydaw, Snowdonia National Park,
North Wales, 1989**

This photograph was made just a few minutes before the layered reflections featured in the image on page 63. In many situations of dappled light such as this one, I might have sat to watch for a time, either choosing my moment or making a number of images as the light moved through the scene.

Again, things worked in reverse here. I turned my head, saw that the light was perfectly placed over Llyn Llydaw's causeway, and made two or three exposures before it moved off. Then I sat and waited; what came was not as good.

I can see in this image now that there are possibilities for different framing. A longer focus would have removed the sky, drawing attention to the coloured light and the undulations in the land. Had the light come after a period of waiting, I might have made such a choice. Hindsight is all very well ...

50mm lens, Fuji RF50

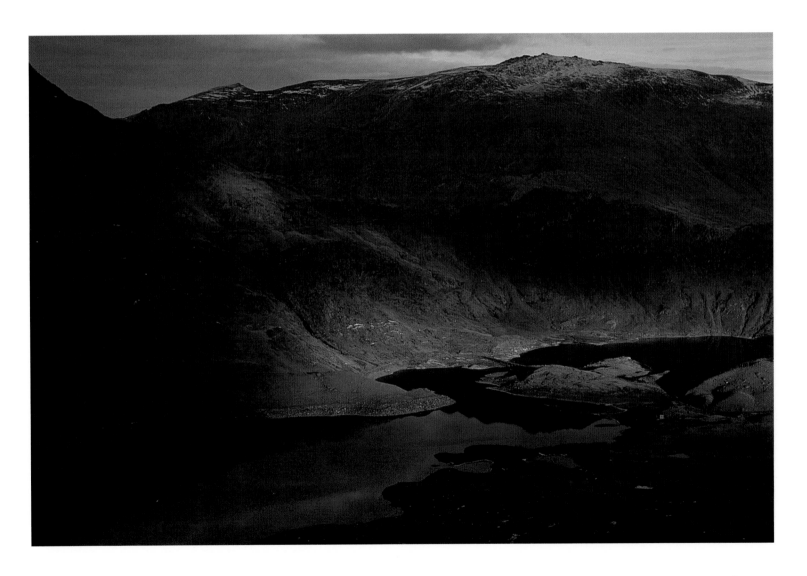

**Storm Clouds, Truleigh Hill – South Downs near Edburton,
West Sussex, 1991**

I have already mentioned the importance of changing weather to photographers hoping to capture changing light. The two almost go hand in hand.

On this day of torrential rain, the lunchtime forecast suggested clearer weather by late evening. It was getting late, and still it rained lightly, but I took a chance and walked up to Truleigh Hill. Sure enough, the clearance came through, but nobody could have predicted the way that the clouds broke up. A great swirl above my head took on colour from the low light, and it felt incredibly close and threatening. The only way to frame it was to lay flat on my back with a 24mm lens, keeping a thin layer of dark ground as a base. The small sunburst was a bonus.

The onset of bad weather is often slow, but clearances arrive suddenly; if you are not out in the bad weather in the first place, then the chances of being able to respond to the clearance are slim.

24mm lens, Fuji RF50

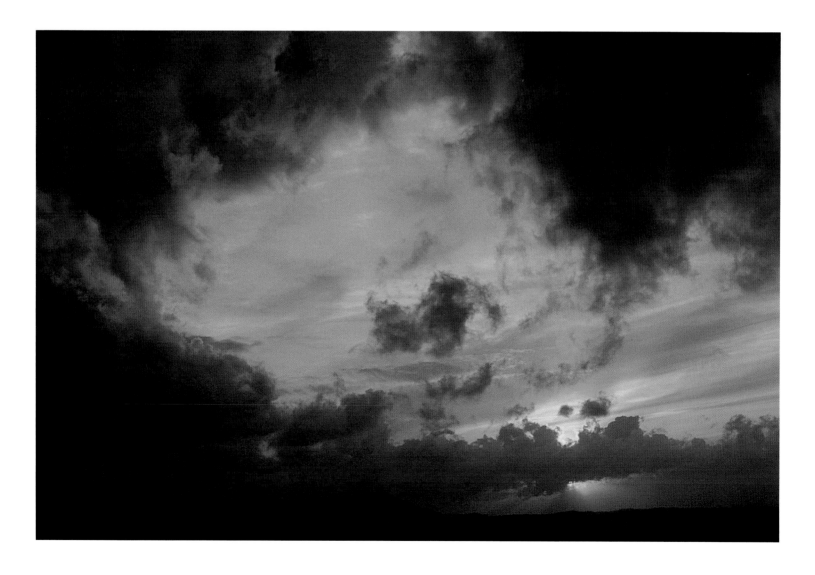

Sunburst over the Isle of Wight – southern England, 1995

At sea, as over the land, I am usually reluctant to make compositions with a simple, straight horizon unless the clouds and light are interacting in an unusual way.

The sky was offering some possibilities for a while before I made this photograph from a ferry returning into Portsmouth. However, earlier with the Isle of Wight to the west, the scene lacked sparkle. Clear pockets of blue became more numerous as we neared harbour, but still I waited for something. When these rays of light burst out of the cloud, I knew this was the moment.

I also picked on a perfect chance – a tiny sunstar appeared through the cloud, placing a patch of light on the water. This was the extra ingredient that I had hoped for since the sky began to change. Unusually for me, the waiting game was right this time.

35–105mm zoom lens, Fuji RF50

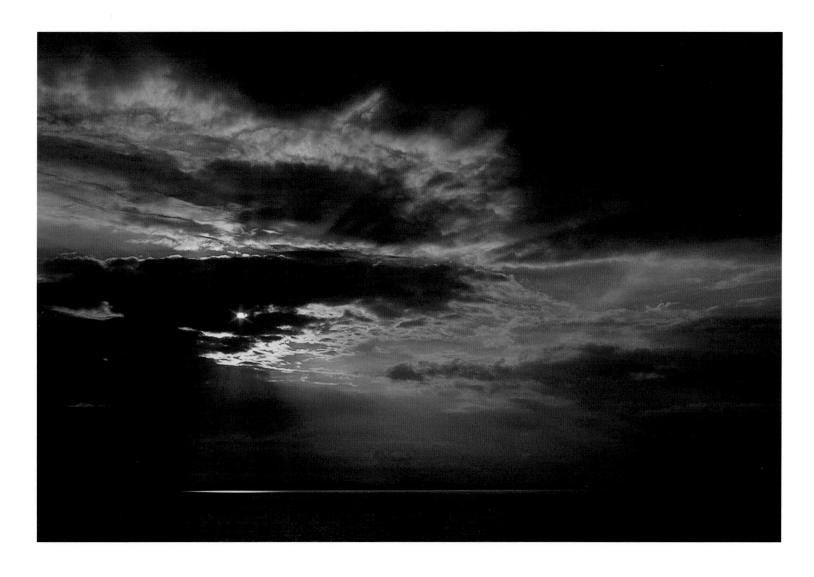

Brocken Spectre, Yr Aran – Snowdonia National Park, North Wales, 1994

In my description of the Brocken Spectre image on page 87 I suggest that knowledge of the Spectres can help us to put ourselves into the right place to see them. I have become accustomed to the possibility, and so I am usually ready.

This morning on Yr Aran, a satellite peak of Snowdon, I was aware that the weather was changing quickly. The sun was rapidly becoming obscured, and a cloudbank was approaching fast. My concern was to retreat from the hill.

Imagine my amazement to see my Spectre below me when I was only vaguely aware of any mist. The landscape was still visible through the thin veil when the shadow appeared in the sunlight. I had the time for only two images. Within half an hour it was raining heavily.

This is an unusual Spectre, seen against solid ground. Three glory rings are apparent, indicating mist with a very even and unusually small droplet size, hence its translucence.

50mm lens, Fuji Sensia ISO 100

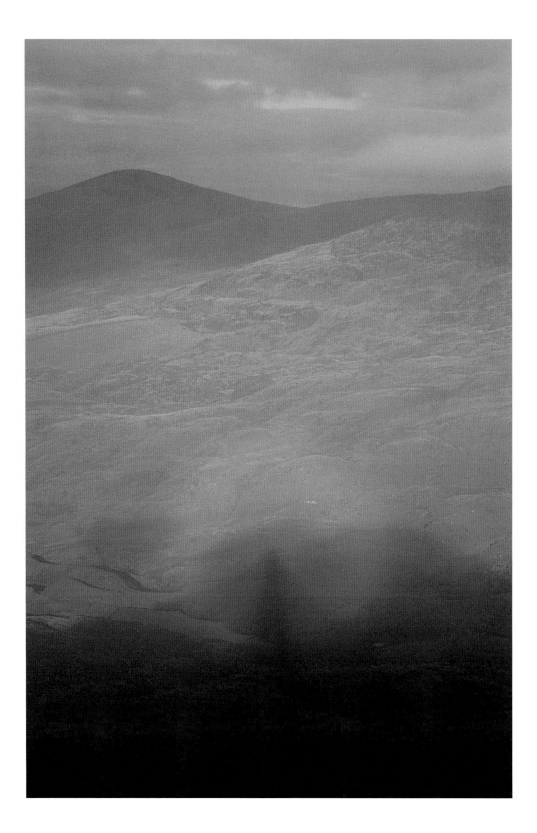

Arnisdale and Beinn Sgritheall – Scottish Highlands, 1991

As we walked around the headland from Barisdale Bay in Knoydart to climb the peak of Ladhar Bheinn, I was struck by the tiny hamlet of Arnisdale on the shore of Loch Hourn. I framed an image in my 200mm lens, but without light the scene appeared flat, and suggested nothing of the scale I perceived. Then, without warning, the shore became bathed in sunlight for a few seconds. I was surprised, because the weather showed no signs of brightness at all. Such is Scotland.

With the light in place, the drainage basin from the slopes of Beinn Sgritheall behind the hamlet took on some relief, and slopes totally dwarfed the houses. The image I made suggests something of our vulnerability to the elements. Scale is a relative measure. The houses looked small from a distance, but only when I compressed the image with a telephoto lens did they appear so in relation to the mountain.

200mm lens, Fuji RF50

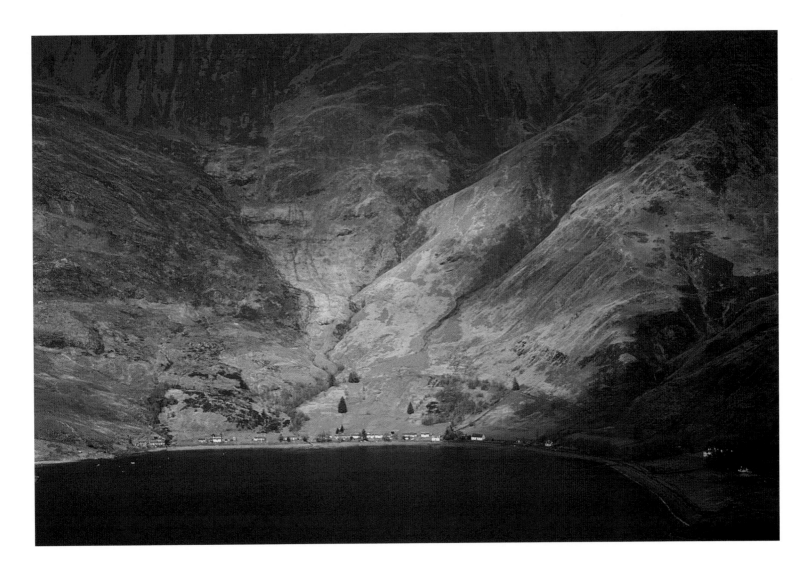

Cliff Walks – Seven Sisters, East Sussex, England, 1995

The Seven Sisters range of chalk cliffs is probably the most photographed spot in Sussex. I have resisted the temptation to include a 'classic' image here, simply because so many have gone before me.

My own favourite is one that does not boast dramatic light, but does continue the theme of scale and timing. I was searching for a photograph for some time, but did not feel well tuned in until I began to see people walking along the shingle beach. They looked small against the high cliffs, and there was a pleasant light giving good textures on the rock.

When the people had walked into the 'right' place, I released the shutter. The timing was crucial, providing balance, scale and movement on the left of the frame.

The image had taken time to come together in my mind, which suggested to me that I should be patient. If I see something immediately, I often act on the impulse.

200mm lens, elbows braced into the beach, Fuji Sensia ISO 100

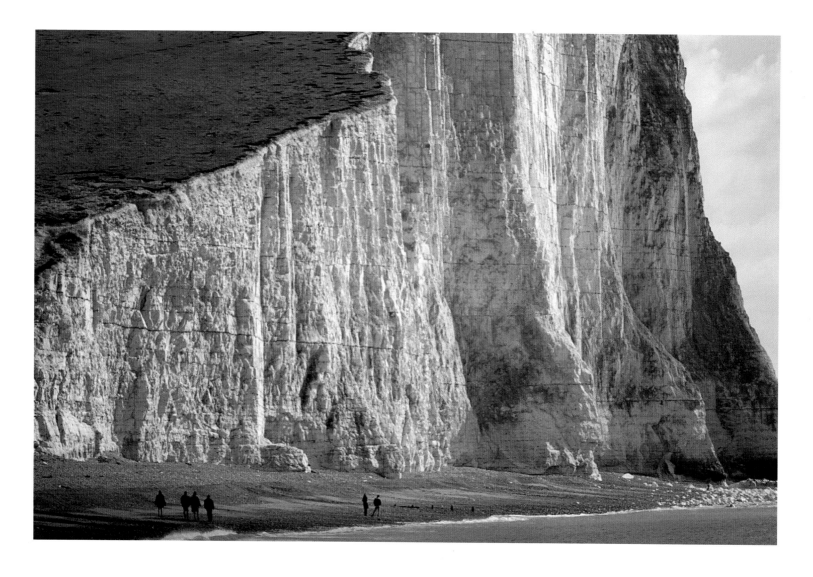

Walker on Froswick – Lake District National Park, England, 1994

By way of contrast, I saw this walker as the scene appeared. Had he not been there, I might have returned the camera to its case. I had been attracted initially by the strong diagonal line of the mountain slope, and Lake Windermere receding into the distance. The sky was pleasant too, but the scene lacked a spark, and I almost left it. Since the composition was already made, I only had to make the exposure. The crucial moment might last only a second or two.

Working quickly with distant scenes can be accomplished easily in the camera. If all of the elements of the scene are within the same plane of focus, in this case infinity, then depth of field is no longer a priority. I was able to open the aperture to gain a shutter speed fast enough for hand-holding. Normally, with a 200mm lens this would be at least 1/250sec.

200mm lens, Fuji Sensia ISO 100

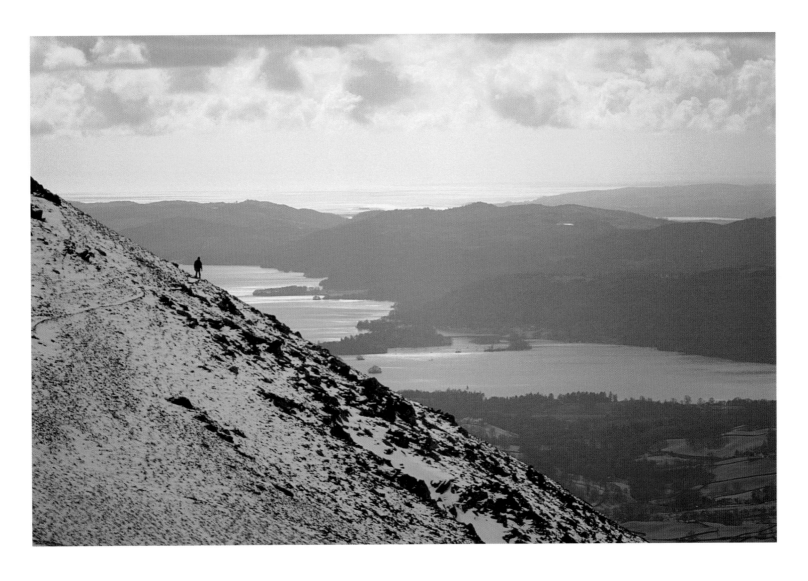

Mist on Thornthwaite Beacon – Lake District National Park, England, 2001

Throughout the morning, as we climbed towards High Street, the mist had been thick, and several times cleared only momentarily. Each time it did so, I was able to make one or two photographs before it closed in again.

During a clearance, I spotted mist clinging seductively to the north ridge of Thornthwaite Beacon, but I missed it. Just in case, I switched to my telephoto lens. When another window came, I grabbed the shot, intuitively positioning the mist with a pattern of ridges leading into the distance. The sunlight and the textures combined beautifully. I feared that the window would close again,

but it remained clear all day from that point. I had been moved to action by the fear of missing the moment.

Although it was the mist that I observed here, the composition depends on the intersection of the background ridges to form a graphic design. It is too easy, having seen a key element, to place it centrally in the frame. Looking beyond the subject is essential.

200mm lens, Fuji Velvia

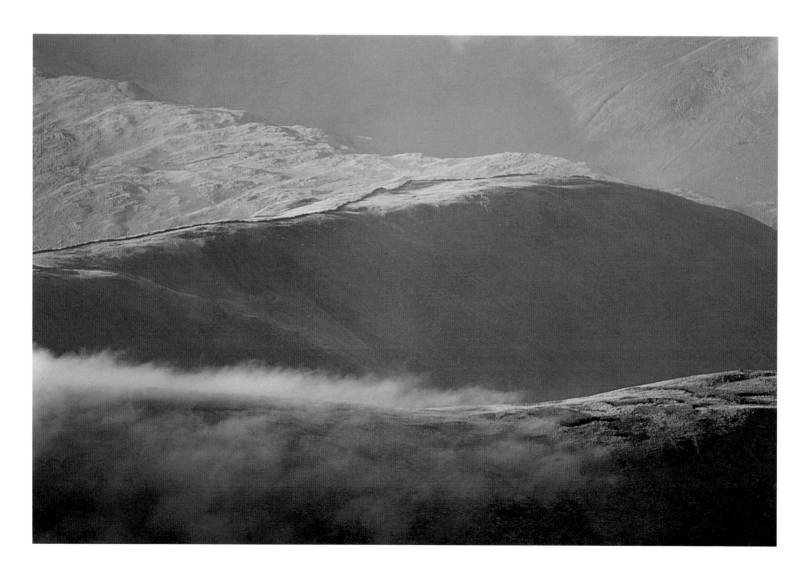

Atmospherics, Derwent Fells – Lake District National Park, England, 1995

This opportunity to photograph air required patience. I knew when I saw the sun's rays breaking through the clouds that I needed to reposition myself to gain a good composition. However, the scene was not breaking fast; I had time to take it in without rushing.

We were returning to the valley from Blencathra, and the further we headed south, the more of the scene opened up. At the point where the ridge to Skiddaw would give the composition a base, I stopped for the photograph. Light makes it possible to photograph air.

Even with a 200mm lens, I could not frame the image perfectly; some of the bright clouds in the top of the frame were too strong, so the final version was cropped for projection.

200mm lens, Fuji Sensia ISO 100

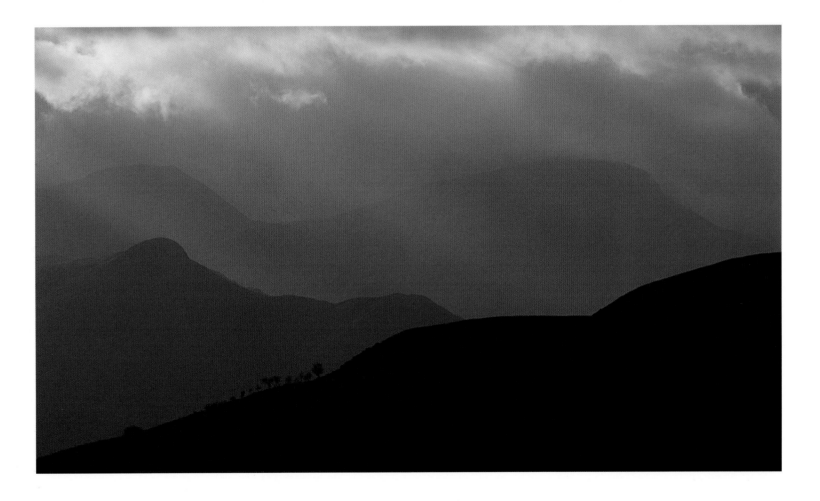

Red Screes – Lake District National Park, England, 1993

I had high hopes when we pitched camp at Sykeside under a bright moon. The morning, though, brought persistent sleet, and we didn't emerge from the tent until 1pm when everything brightened. There were three hours of daylight in which to do something. On unpacking my rucksack I found I had forgotten to bring any film. Thankfully, the campsite shop had a couple of rolls of Agfa slide film, but it wasted time and it doesn't help to be disorganized.

The summit of Red Screes was an incredibly wild place. Snow had been blasted from the surface in freezing, gale-force winds, leaving an icy residue.

Heavy, black clouds hung just above our heads, and the brief window of light contrasted strongly with everything around it. Finding a balanced composition was straightforward, but It was all I could do to release the shutter in the gale.

The wind chill on Red Screes was probably equivalent to a temperature of -30˚C (-22˚F). Three layers of gloves, watery eyes, cold batteries and strong winds make this a candidate for the most trying photograph I have yet made.

50mm lens, Agfa ISO 100 reversal film

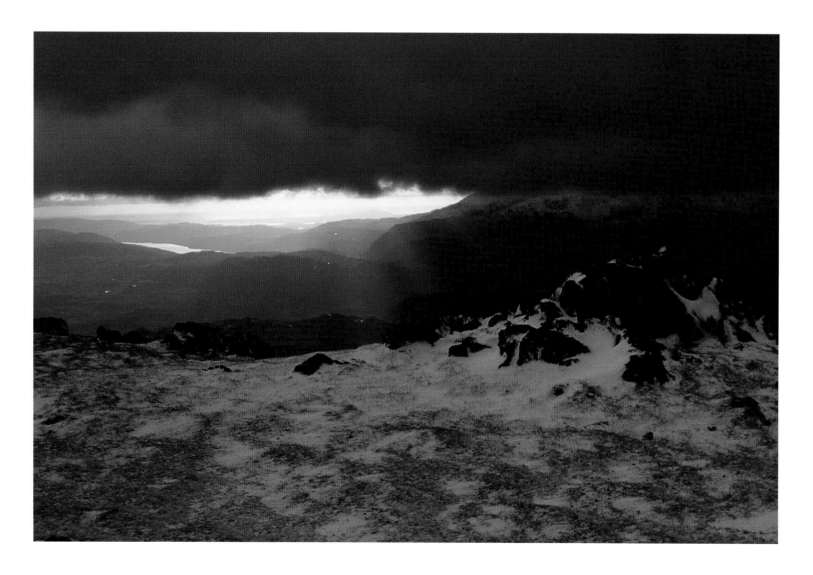

Roughten Beck – Lake District National Park, England, 1995

Every image takes just a split second to take, but often considerably longer to make. This scene was photographed with more patience than any other in the book, but it came about on a hunch.

I had intended to camp further on, but on descending to the north of Blencathra spotted a sheepfold next to a small stream that ran away to the south-west. There was just the possibility that it would coincide with good light later, so we pitched up early. Several good scenes came and went, but I got very cold waiting and retreated to the tent. All was not as it seemed though.

I had deliberately oriented the tent door so that I had a clear view down the beck. When the light came I leaned out, the perfect shot pre-framed from my sleeping bag.

The light was stunning, but the shot is made by the catchlight in the water. However, much we might plan and anticipate in our photography, we still rely on luck to provide the light and the moment of magic.

50mm lens, elbows braced on ground in low light, Fuji Sensia ISO 100

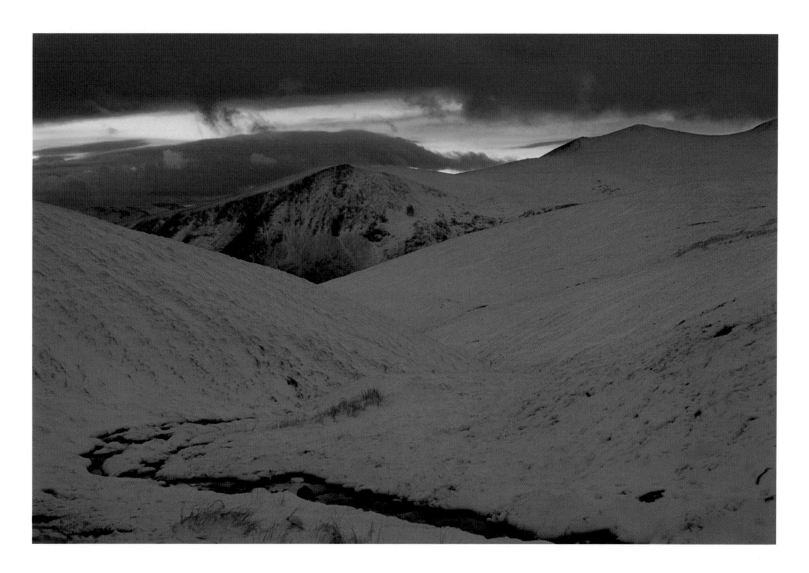

**Red Rocks and Moon, Llyn yr Adar – Snowdonia National Park,
North Wales, 2000**

The journey on which this picture came about was a purposeful immersion. For four days I did not move more than 1.6km (a mile) from my camp, high on the ridge overlooking Nantgwynant. I sat for a long time each day, listening, watching.

I made my way onto a rocky rise to take in the dusk. The rich red of the rocks was appealing, especially with pink-tinged clouds in the sky beyond. Only when the clouds parted for a second was the moon revealed for the first time, and I photographed it quickly before the light faded.

There was little in the way of light on this expedition; I remember it as much for the peace and the intensity of wild sounds. Making so few photographs did not detract from the experience in the slightest, but some photographers I know would have branded the trip a failure.

50mm lens, Fuji Sensia ISO 100

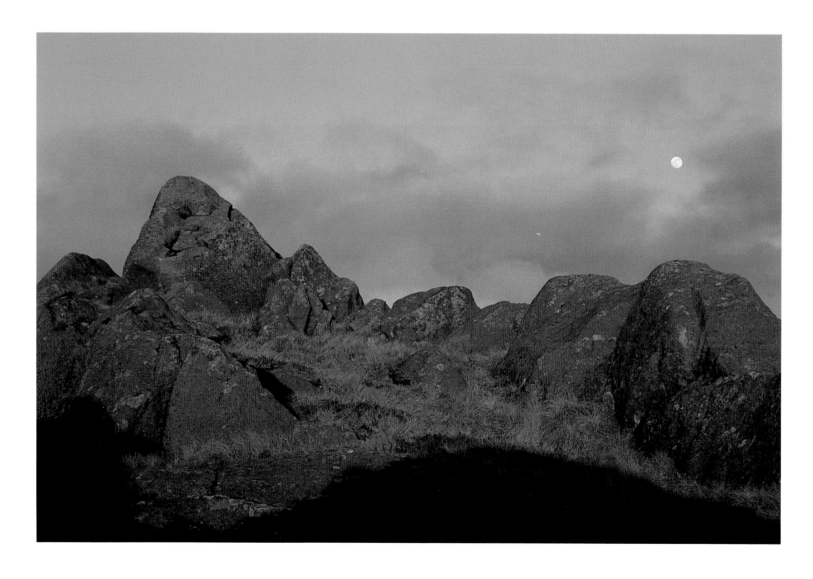

Fireclouds over Glaslyn – Snowdonia National Park, North Wales, 1989

I started this section by describing a photograph – Cloudscape, Crib Goch, on page 86 – taken on the fastest-moving day of light I have ever encountered. This image was almost the last I made that day.

I often walk the Snowdon 'horseshoe' in reverse to avoid the crowds. Descending from Crib Goch to Pen-y-pass is steep, though, and dangerous if left until too little light remains at the end of the day. Nevertheless, stunning light on this exposed crest and summit has often rewarded me. On this occasion I was in the process of reversing down a rock step when my two companions starting shouting loudly 'It's going red, it's going red'. The cloud that had played with us all afternoon had suddenly turned to a fiery orange in the cwm below us. I could go nowhere except up. I re-climbed the step just in time to secure the scene, and the colour was gone as fast as it arrived.

This felt like going beyond the call of duty, but this fabulous scene was too good to miss, and worth the risk.

50mm lens, Fuji RF50

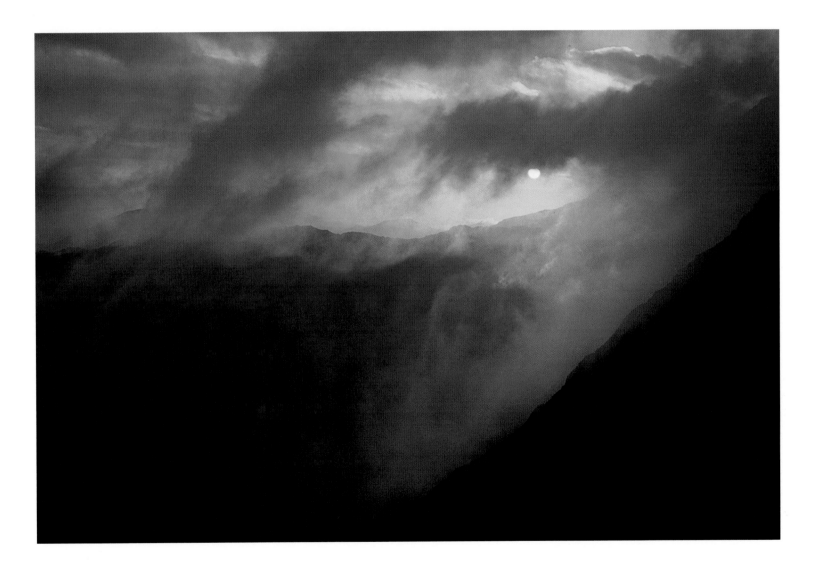

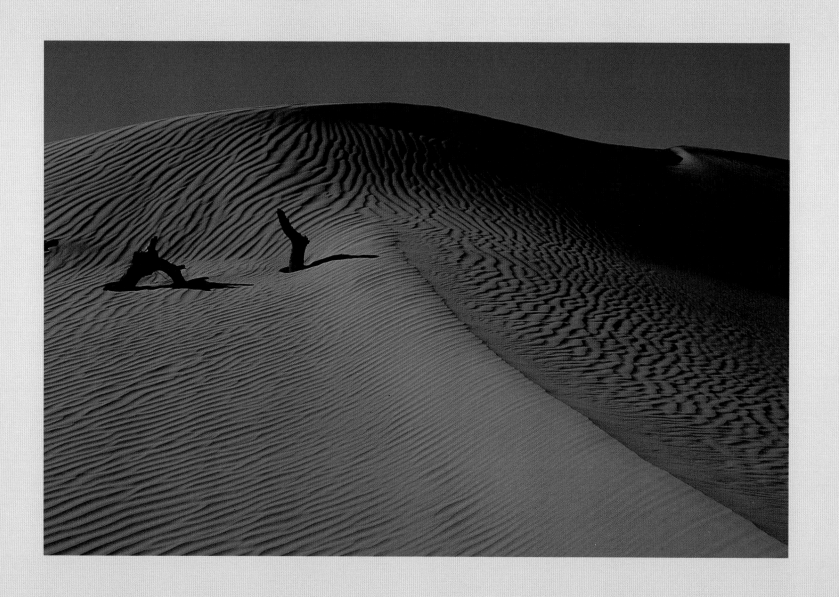

Section ④ **Movement** in the landscape

Going with the Flow

So far we have become aware of changes in light, some dramatic, others subtle and fleeting. We have then involved ourselves more in the scenes around us, and stopped thinking and trying too hard. This has freed us up to see and to respond at an appropriate speed to what is really happening.

Now that we are immersed, and confident that images will present themselves to us, we can go where the mood takes us, following hunches, exploring possibilities. We can go with the flow. Artists and writers are well acquainted with flow (and often its lack). When everything is right, paint flows onto the canvas and words flow onto the page. Everything is effortless. The task is completed fully and without error. It feels natural.

Throughout this section we will go with the flow of the landscape, exploring images which rely on movement, either of the scene or the photographer. Most of the compositions did not present themselves in the normal sense. Many required me to move myself quickly into

position to capture a scene where the subject itself was moving. In others, I felt able to move myself easily around between subjects, exploring the relationships between elements until the perspective and framing felt just right. Sometimes, several alternative compositions resulted.

Movement itself is also a subject: perhaps water or lights flowing through the scene or movement implied by the inclusion of objects that are in motion.

In each case, though, everything came together into a representation of the landscape that was unusual and satisfying.

This is the final stage. Photographing changing light is an active pursuit. We should now find that this approach is a very practical one, because photography is no longer the primary aim of being in the landscape. We can walk, we can cycle, we can run even. We can enjoy the experience of the landscape without the pressure of looking for photographs. If photographs come, then we have made something special. If not, we can enjoy the walk.

Exercises

1. Find a subject, or a relationship between things, that catches your eye. Take your time to explore it, with your eyes and through the viewfinder. Look at the textures; feel it if you like.

2. Observe the colours, the shadows, and the reflections. Is it big or small? Can you change its size, relative to other things, by moving around it? How does it look from different angles, high up or low down, or from the other side? What is its shape against the sky? Change lenses. See it.

Walkers on Blencathra – Lake District National Park, England, 1995

This image captures a scene of relative quiet, with a lone walker standing on the point of Knowe Crag on Blencathra in the English Lake District, but the moments leading up to making the image were anything but quiet.

Near the top of Hall's Fell ridge I saw the walker and somehow knew that he would stand on the point. The potential for a photograph was clear, but I was too low: the ridge competed with the background mountain. I ran to a higher viewpoint, until the crest fell just below the distant ridge. As the walker lingered on the summit. I changed to my 200mm lens and made two exposures before

the group of walkers below had moved on. A brisk wind made a hand-hold very difficult and I had to select a fast shutter speed of at least 1/500sec to have any chance of sharpness.

The light was a bonus in the shot, but on this occasion it was not the priority. People moving, moving myself to compose the scene, changing lenses and solving an exposure problem all coalesced in a minute or so of 'going with the flow'.

200mm lens, Fuji Sensia ISO 100

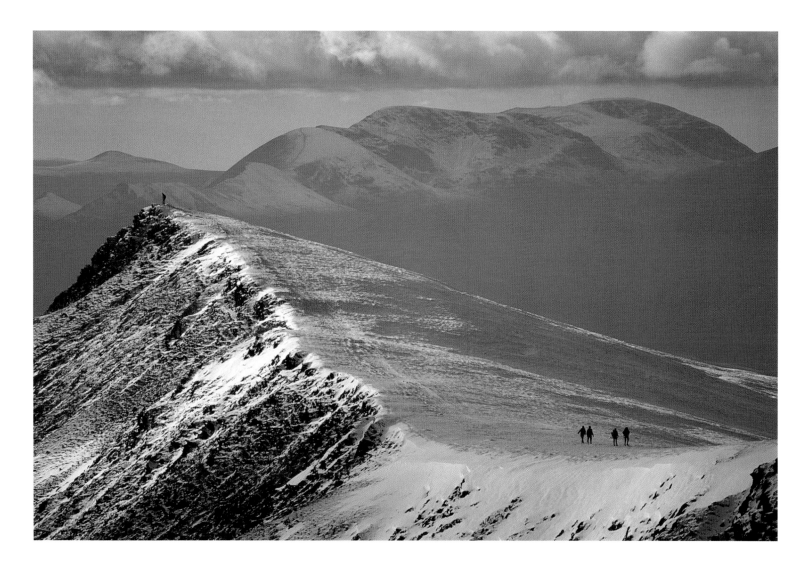

Half Dome and Moon – Yosemite Valley, California, USA, 1989

I found it difficult in Yosemite Valley to find new angles on familiar subjects. Apart from the 'Bridalveil' shot on page 67, I struggled for a couple of days with the notion that everything had been done before. Only when I remembered to enjoy the moment for what it was did I let go of this restrictive thinking and, all of a sudden, the valley seemed fresh.

With a new enthusiasm I set out to enjoy the evening light on the Half Dome, and made a simple shot of the mountain from the bridge over the Merced River. Trees form an ideal frame, and the moon is perfectly placed in the sky.

Everything we see for the first time, with our own eyes, is ours, even if thousands have seen it before. A new situation of light makes it unique.

I used my 200mm lens here to simulate a spot meter on the face of Half Dome, before switching back to the 50mm lens. My centre-weighted meter wanted to take account of the dark trees, which would have grossly overexposed the scene.

50mm lens, Fuji RF50

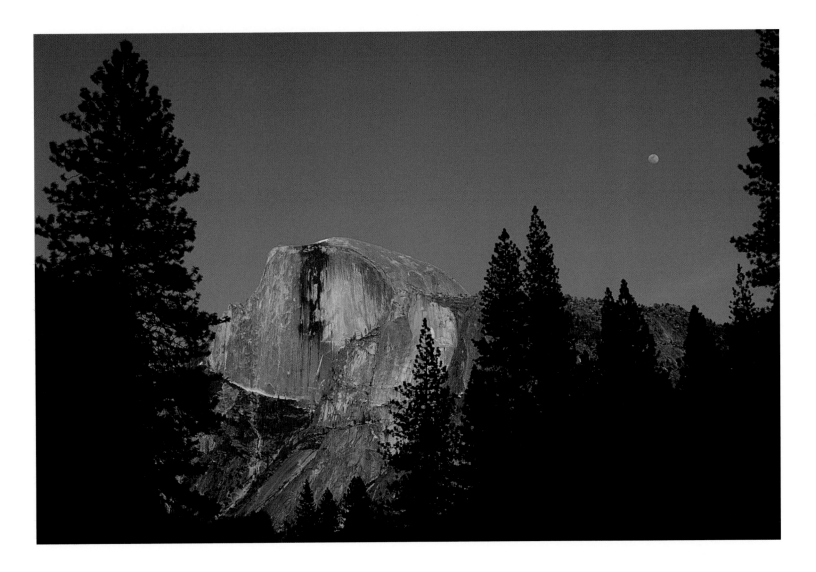

**Big Lake, Small Lake – Cadair Idris,
Snowdonia National Park, North Wales, 1988**

On a warm but hazy spring walk around Cadair
Idris in Snowdonia, I had made a number of images
of the mountain and the cliffs, and the blue lake
of Llyn Cau that nestles in the amphitheatre.

Late in the afternoon though, whilst relaxing
in the warm sun, I noticed a tiny puddle in the
grass near where I sat. It was no more than a foot
across. By the same coincidence of distance that
allows total eclipses of the sun, the puddle
seemed to be the same size as the distant Llyn
Cau, perhaps 100m (300ft) across.

Getting extremely close to the puddle with my
24mm lens, allowed me to frame both in a
pleasing diagonal, with a mid-ground ridge to give
some separation.

Perspective has always fascinated me, and
positioning was a key to this image. As I moved
further back, the puddle appeared smaller, but the
apparent size of the lake did not change. The
success of the image depended on my finding a
focusing distance that achieved the intended
illusion, but also balanced the elements.

24mm lens, Fuji RF50

**Rockscape, Kinder Scout – Peak District
National Park, Derbyshire, England, 1989**

The moors of Kinder Scout are renowned for their
gritstone sculptures, often known as 'salt and
pepperpots', that stand on the ridges. My
favourite set stands on Ringing Roger, a spur of
the Kinder plateau above Edale.

I was keen to find a composition that set the
smooth shapes off against the sky, but which also
showed some texture and modelling on the stone.

The light was consistently bright, but finally I
found an angle on these rocks that brought out
everything I had wanted in a balanced image. It
also gave me the bonus of a narrow band of
colour on the summer heather. To avoid
overexposing the sky, I decided to meter from it
and to let the sunlit rock underexpose a little,
enriching the colours.

Whatever compositions we might see, often it
is light that leads us to the final version. I did not
compose this photograph in this way until the
light had come around to just this angle.

50mm lens, Fuji RF50

Perspectives with 50mm

I use a 50mm standard lens for the majority of my images, because it has a number of useful features, including a compact size and light weight, large maximum aperture (f/1.4), and clear depth of field indicator marks. However, I value its flexibility most. When I have used a zoom lens for landscape work, I have been surprised by how complacent I became. I was tempted to zoom from where I first saw the scene instead of moving myself around to find an interesting composition.

These pairs of images show how position can alter the perspective of a scene, either by creating distance or by adding new elements. A 50mm can become a wider-angle lens just by moving a short distance.

La Phare de Sein – Ile de Sein, Brittany, France, 1993

Ile de Sein is a tiny, flat island off the western tip of Brittany. The island had a particular interest for me, so I photographed it extensively that day, despite the flat light.

I was able to give a different perspective to the two images of the lighthouse by creating distance. In the second one, a couple of hundred meters (200yds) further away, the addition of the boulder is not only a more creative interpretation, but gives the impression of a wider view.

50mm lens, Fuji RF50

Totem Poles and Tree – Monument Valley, Utah, USA, 1989

This composition of the Totem Poles and a small tree seemed balanced at first from my position on a small rise. However, by moving lower down, I was able to change the apparent size of the tree, relative to the background, quite considerably. I was also better able to use foreground grasses, and the second shot has much better balance.

50mm lens, Fuji RF50

Dune Tree – Death Valley National Park, California, USA, 1989

It is always interesting to move around a subject, not to settle necessarily on one aspect, but to see it from a variety of angles. Walking in the early morning around the dunes near Stovepipe Wells I was drawn to this shapely old tree.

My first angle of view revealed the tree atop a ridge of soft sand, looking striking against the blue sky. By moving up and down just slightly, I was able to position the setting moon under the curved branch.

50mm lens, Fuji RF50

Just a small change of position gave me an entirely new image of the tree set against the Panamint mountains. This time, the darker background gave more emphasis to the light on the boughs.

50mm lens, Fuji RF50

Props in the Desert

This pair of images comes from the same sand dunes in Death Valley, and they are interesting for the similar props of dead wood that add interest and balance to the sands.

Dune Crest – Death Valley National Park, California, USA, 1989

The ridge leading into the heart of this desert scene is the starting point. My eyes had been attracted initially by the low-angled light giving texture to the ripples in the sand, and to the dead wood, but only as I approached did the arrangement come together. At just this point I saw the light catching the skyline, and everything was balanced.

50mm lens, Fuji RF50

Desert Storm Approaching – Death Valley National Park, California, USA, 1989

Later in the afternoon the sky became very threatening with dark clouds, but as long as the sun continued to shine there was a chance of a good image. Once again it was the scrag of dead wood that gave an ideal foreground to the scene.

In both images I needed to be very aware of leaving my own footprints in the scene. If I walked too far before deciding that my ideal composition lay further back, then I would have spoiled the opportunity.

In general, in sand scenes, I try to walk between the dunes and not over them.

50mm lens, Fuji RF50

Rock and Reflections, Mirror Lake – Yosemite National Park, California, USA, 1989

Once I was in the right frame of mind in Yosemite (see page 115), images started to flow, and at last it felt as though I was achieving some originality.

At Mirror Lake, as one might expect, we found a smooth expanse of water. Wider views didn't catch my attention particularly, but I worked for some while with a rock near the shore. This image framed itself when I crouched low to the water's edge, the rock and the reflection of the mountains above the far shore working together in a fascinating combination. When I excluded the horizon, I knew I had an interesting photograph.

The aperture I selected kept the rock, no more than 2m (6ft) away, and the distant ridge within the depth of field.

Everything that we see is recorded in the subconscious, in the stream of ideas that we can tap into when we are in good flow. I was not aware of it when I made the image, but I had seen it before. Galen Rowell's image 'Reflection in Lake Louise' uses a very similar idea, and the similarity seemed too close to be entirely a coincidence. Rowell himself also acknowledges the similarity of one of his own photographs to an Ansel Adams image (Rowell, 1986). Influences, it seems, run deep.

50mm lens, small aperture for depth of field, Fuji RF50

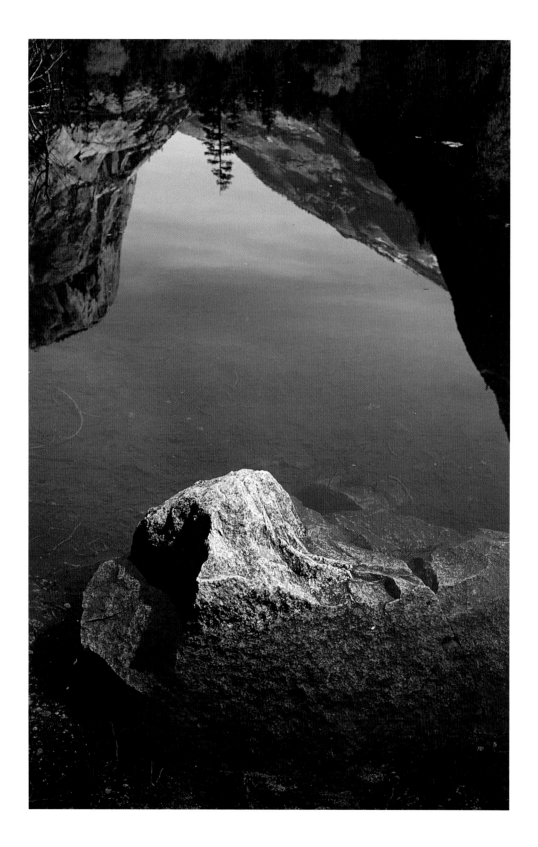

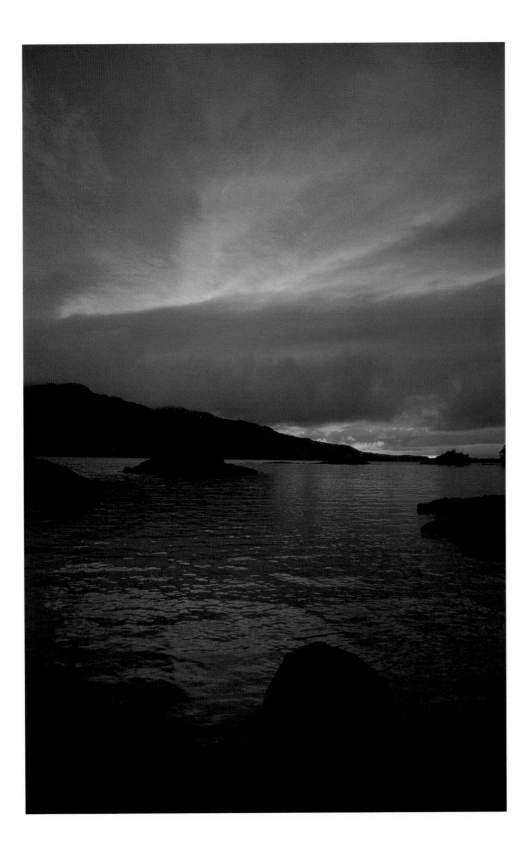

Sunset, Loch Morar – Scottish Highlands 1997

We had pitched a camp beside Loch Morar in a persistent drizzle and I had given up on photography for the day.

However, by the time our dinner was cooked, it was dry but grey and overcast, and a small sliver of brightness out to the west reminded me of the possibility of some light in the sky.

When it happened, though, I was unprepared; I had not even surveyed the scene in advance. In a matter of moments, the sky turned to fire. I picked up the camera and ran over to the loch shore, moving backwards and forwards, and changing lenses.

My position was not ideal and, although I found a composition that included a small foreground rock and a reflection on the water, I am still a little disappointed that there was no time to achieve more with this image.

50mm lens, Fuji Sensia ISO 100

**Roots in Rock, Llanberis Pass – Snowdonia
National Park, North Wales, 1989**

One of the most effective compositional tools
for a photographer is to move the position of
the camera up or down, either by standing or
crouching, or alternatively by moving to a higher
or lower viewpoint.

When I first saw this remarkable tree, its bare
limbs lit by the strong sunlight, I knew I had to
place it against the dark flank of the mountain
on the other side of the valley. Achieving this was
not so easy, as the ground on the north side of
the Llanberis Pass is steep and rocky, and I had to
play around the scene for some time until I had
the balance right.

The problems were not solved though. Light
came and went, and I had to be sure to expose
for the bright ground to show the tree off to
best effect.

50mm lens, Fuji RF50

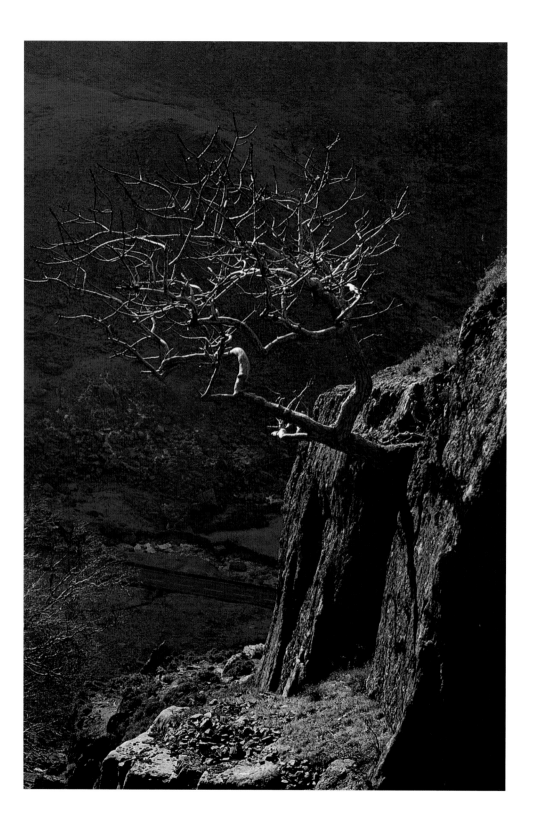

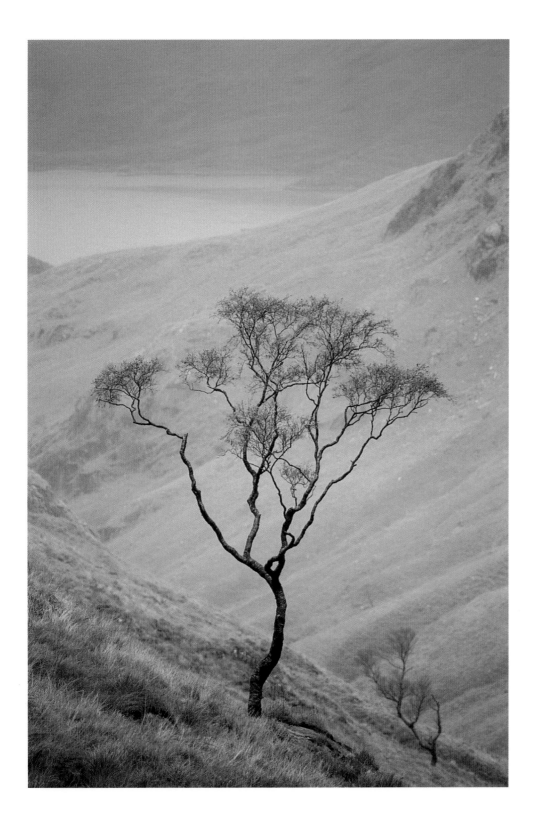

Tree and Loch Hourn – Gleann Unndalain, Scottish Highlands, 1997

The elegant form of this tree in its autumn dress was what first attracted me to it. There was a soft, still light which illuminated the glen gently after morning rain.

I moved around the tree, again up and down, to place it in my frame in such a way as to show its isolated position on the steep slope. When the distance was right, I had separated it from the water of the loch in the background. The 200mm lens was ideal to achieve this balance, though I had to find a firm brace for support.

I made several pictures, some of them without the small horizon in the top left. I prefer this one that includes it, as it draws my eye further into the depth of the scene.

Dramatic light is not necessary. In this image, it is the softness that provides the atmosphere. Similarly, a soft light after rain often accentuates and enriches colours to a surprising degree.

200mm lens, elbows braced for support, Fuji Sensia ISO 100

Shadow Self-portrait – Bryce Canyon, Utah, USA, 1989

When we move around, trying to decide what to include and exclude from a scene, we are sometimes faced with no option. I stood on this small ridge in Bryce Canyon, taken initially by the brightly lit, statuesque rocks on the skyline. Longer focus compositions did not work for me, yet, however hard I tried, I could not remove my own shadow from the base of the scene in a wider view. Hiding behind the tree unbalanced the scene.

Then I saw the image; it was there all the time, my shadow, in the centre beside two diagonal gullies that also created a shadow. I completed the photograph by lifting my arm for an instant self-portrait.

This image would be next to impossible to achieve in England. Mostly the hazy air scatters too much light into the shadows for them to be sharp and black.

50mm lens, Fuji RF50

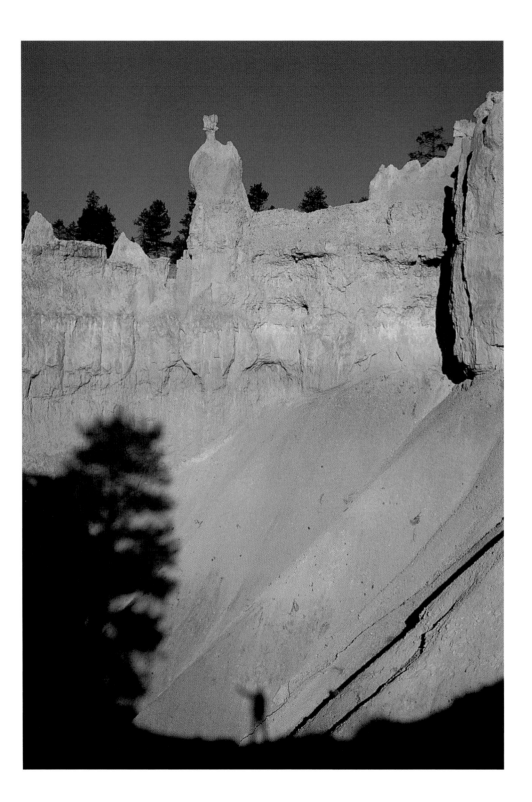

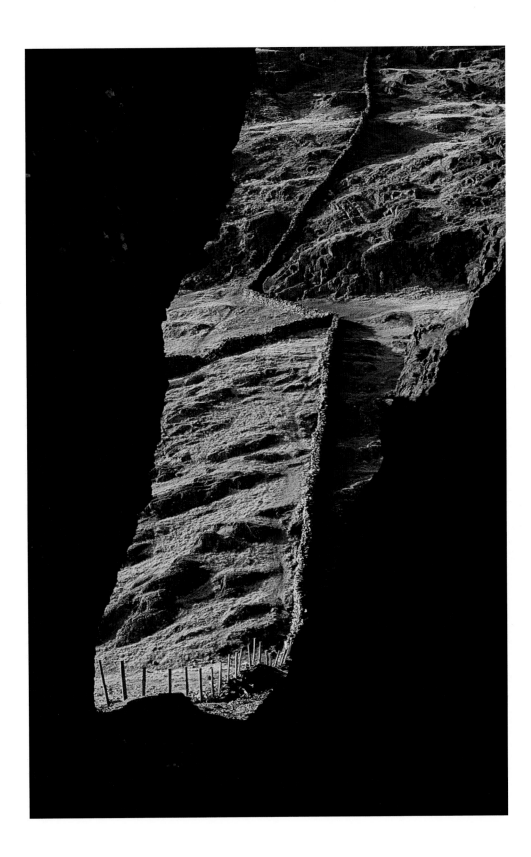

**Rock Cleft and Light, Moel yr Ogof –
Snowdonia National Park, North Wales, 1993**

There are some fascinating micro-landscapes that
present themselves on the walk from Moel Hebog
to Moel Lefn by Beddgelert. At one point, the path
climbs steeply up through a deep rock-cleft onto
Moel yr Ogof.

I had walked the ridge on a number of
occasions, but had not found a pleasing image of
the cleft until I came across this interesting
arrangement looking down to the sunlit flank.

I moved myself to a place where the dark
walls formed a shapely frame and, by under-
exposing the bright ground slightly, removed
detail from the walls which, in a brighter exposure,
were slightly distracting.

Using a frame for a scene is a popular
technique in scenic photography. Doorframes, or
archways, or windows all give us a view from
within to the outside. All too often, though, the
framed view is less interesting than the frame. It
is important to pay attention to both.

50mm lens, Fuji RF50

Electric Sheep – South Downs near Steyning, West Sussex, England, 1996

There are a number of entertaining optical effects that can be obtained using just the lens and a little knowledge of how light behaves.

I stopped along the South Downs Way on a clear winter evening, having noticed a flock of sheep in a field. Nothing remarkable there. However, the sun was setting bright behind them, and I saw that one of the animals had a bright fringe of light around it. Portrait photographers use this rim-lighting effect often in the studio, backlighting a model's hair to lift it from a dark background. The sun was simply backlighting the sheep's woolly fleece, and I metered from the sky (without the sun visible in the frame) to allow the sheep to remain in silhouette. The composition was fortuitous, a bush allowing me to close off the left edge of the frame, to draw attention to the animal.

In a clear sky, this effect can be reconstructed by putting a person between the lens and the sun. The sun's rays bending slightly around the edges of an object create a diffraction fringe, a bright edge of light.

200mm lens, Fuji Sensia ISO 100

Light in the Window, Notre Dame de la Serra – Calvi, Corsica, 1988

Cross-screen or starburst filters can be used to create multi-point stars from bright lights in a scene but, with a knowledge of the lens and the ways of light, they can be created at will, with no filtration.

The chapel and statue of Notre Dame de la Serra stand on the hillside high above Calvi in Corsica. Observing the buildings at a distance, I saw that the sun was about to move behind the tower and, with careful positioning and timing, I could perhaps place the sun in the small window to enliven what was otherwise a heavy silhouette. Finding the exact spot proved to be rather elusive, but a precarious rock and tiptoe-balancing act got me the shot with a 200mm lens. The precision of the sunstar was apparent only afterwards.

At small apertures, the blades in the iris of the lens cause points of light to flare into small stars. Coupled with light diffracting around the edges of objects, the effect can be stunning. Experiment with your own lenses, but do be careful not to look straight at the sun.

200mm lens, Fuji RF50

Morning Dance – La Soula, Pyrenees, France, 1999

This image started out as a simple composition of light. On a crystal-sharp morning in the French Pyrenees, we emerged from the deep shadows to a point where the sun was just cresting the ridge and I noticed the way it illuminated the tree in brilliant white light.

Exposure was difficult, but I settled on metering from the sky to the side of the sun. I could not find a composition that satisfied me totally, but I made an image, deliberately placing the sun on the edge of the ridge in the knowledge that it would create a sunstar flare.

Only when I examined the transparency did I see the 'morning dance' of thousands of insects around the tree, also lit by the sun. I am still not happy with the dark space to the right of the frame, but I do like the accidental bonus.

200mm lens, Fuji Sensia ISO 100

Montgo Sunstar – Javea, Costa Blanca, Spain, 1996

Montgo rises spectacularly out of the sea near Javea on Spain's Costa Blanca. I had climbed it several days previously (see image on page 57), and took an evening drive to the headland across the bay to enjoy it in evening light.

The silhouette of the mountain was heavy. The bright sun also prevented any meaningful photography over the town, as there was too much flare and contrast for shooting into the light (contre-jour). However, I saw another sunstar possibility as I prepared to move on. This time I moved in advance, until a composition of the sweep of the ridge looked balanced, and included a few of the town's buildings. I waited until the sun just dipped behind the ridge, making this photograph with a small aperture. Note the shadow in the image; where the sun is illuminating the air just above the shadow of the ridge, it creates a beam of light.

200mm lens, Fuji Sensia ISO 100

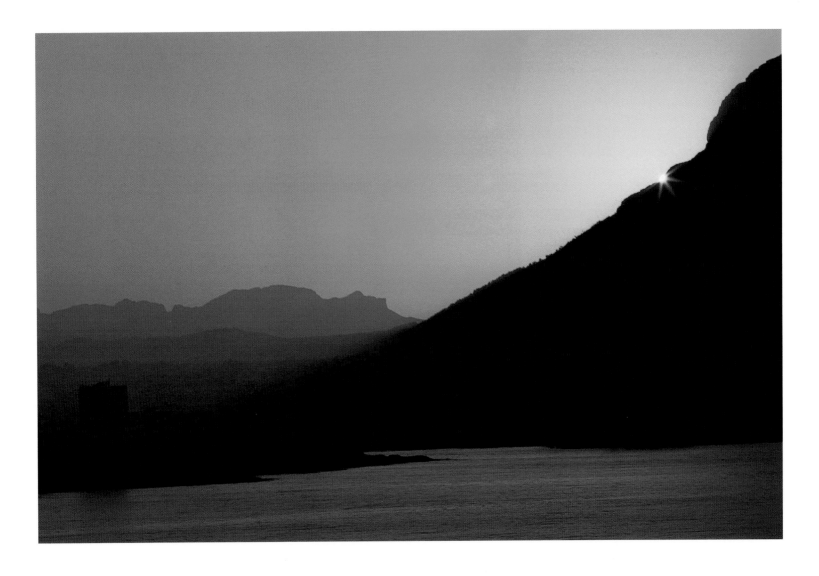

131

Havasu Falls – Havasu Canyon, Arizona, USA, 1989

Movement is implied in many photographs throughout this book, especially in situations of fast-changing light and drifting clouds. Nothing, though, provides the same scope for capturing movement as water.

Havasu Canyon is a remote side reach of the Grand Canyon north-east of Kingman, Arizona. The Havasupai native Americans live here: 'the people of blue-green water', the water that tumbles in three spectacular falls over drapes of travertine near the village. The falls are reachable only on foot and a 16km (10 mile) hike down from the roadhead.

Havasu Falls is right next to the campground, and I made some successful images from below, but this one from the side is my favourite. I exposed for the bright trees, and then closed the aperture right down to give me a corresponding slow shutter speed.

A shutter speed of 1⁄4sec or longer is usually required to blur water to give this silky effect. This was right on the limit of my ability to hand-hold, but with my elbows braced securely on some rocks (see also Appendix 2) I was able to maintain sufficient sharpness.

50mm lens, elbows braced on rocks for support, Fuji RF50

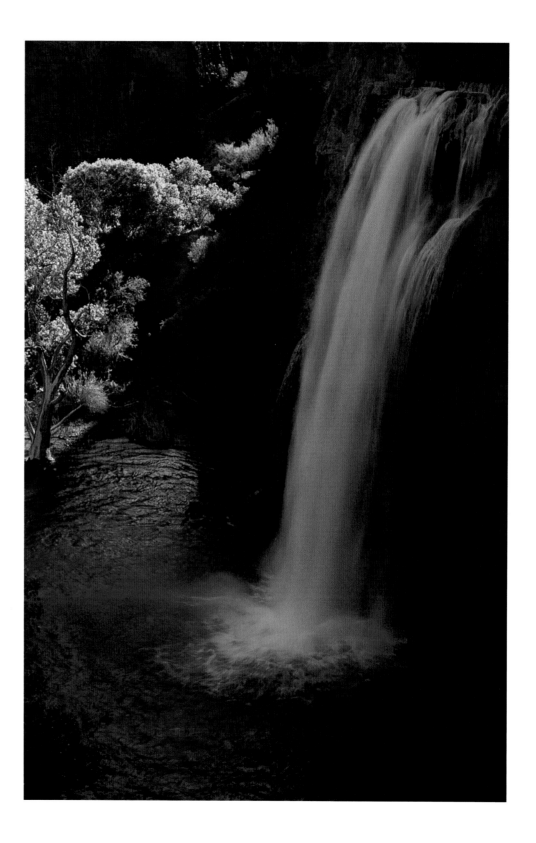

Kisdon Force – Keld, Yorkshire Dales, England, 1988

Conditions were ideal for this image, as the sky was cloudy-bright, providing light, but no difficult highlights, and I managed to achieve a slow enough shutter speed – about 1⁄4sec – by stopping the lens right down to f/22 with the camera supported on a mini tripod.

Kisdon Force is much smaller and more delicate than Havasu Falls. The finer the detail in a waterfall, generally, the longer the exposure may be. Conversely, larger, more powerful falls often look better when the movement of the water is frozen by a short exposure.

50mm lens, slow shutter speed to blur water, tripod mounted, Fuji RF50

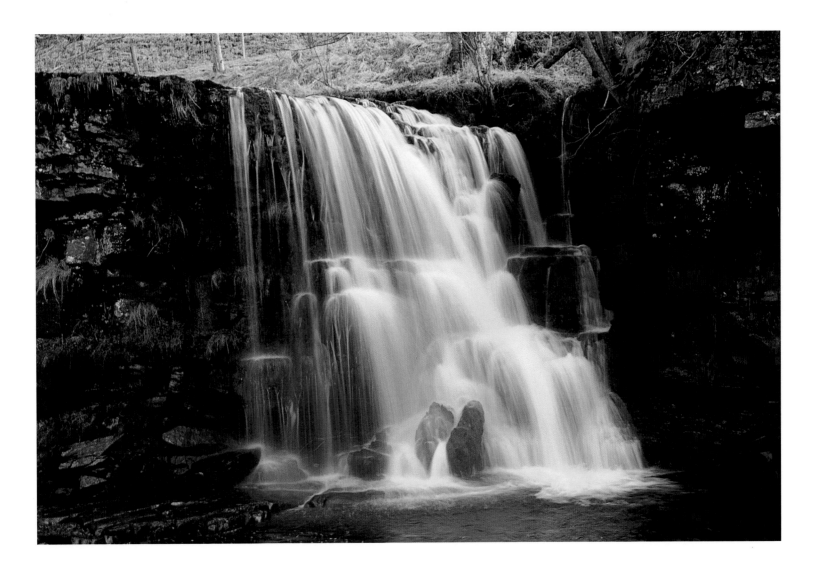

**Mallyan Spout – North York Moors,
England, 1990**

Again with this delicate fall in Yorkshire, a long
exposure has created the impression of
movement, with the gentle stream of water
appearing as a thin mist.

Light levels under the cliffs here were very
dark, so achieving an exposure of two seconds was
possible, with the camera mounted on a tripod.

Even with slow film, achieving shutter speeds
of a second or more in daylight is not possible
without overexposing the image. To do this, you
must use either a neutral-density or polarizing
filter to remove two stops or more of light.

*35–105mm zoom lens, slow shutter
speed for blurring effect, tripod mounted,
Fuji RF50*

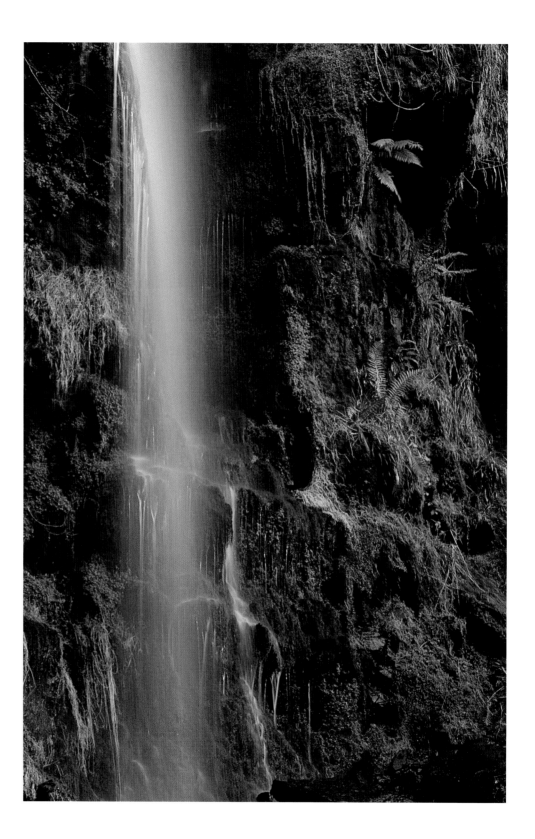

Aira Force – Ullswater, Lake District National Park, England, 1988

I have detoured many times to Aira Force, mainly on wet days when the weather has been too poor to get high on the fells. This time was a proper visit, made in good morning light.

Winter light angles across Aira Force in such a way as to create rainbows in the spray. These can be photographed in many ways from the pretty stone bridges that span the force.

This image was one of a number I made to explore detail. Given the bright light, I used a polarizer to cut the light levels slightly and stopped the lens down to slow the shutter as far as possible. The mix of greenery and the misty water work well with the rainbow. A polarizer can remove a rainbow from the scene completely; to retain it, it is important to rotate the filter to achieve the desired effect.

200mm lens, tripod mounted, slow shutter speed, Fuji RF50

**Seathwaite Tarn Outfall – Lake District
National Park, England, 1992**

The coincidence of light here happened as we
passed the sluiced outfall to Seathwaite Tarn on
an autumn afternoon. Low sunlight broke through
at the perfect angle to light the water flowing
over the sluices.

I had not intended to make any images here
at all, so I switched into my fast-response mode at
the breaking light, and found a composition that
made good use of the footbridge and the
diagonal lines of shadow. Having four sluices
helped, too, breaking up the water into four
distinct falls. I was not concerned to blur the
water here. The textures and the colours were
fascinating as they caught the golden light.

In an experiment, I tried to place a companion
at the vanishing point on the bridge, but was
disappointed with the result. I found that it
distracted my attention from the water.

50mm lens, Fuji RF50

Cascade de la Billaude – Jura, France, 1995

Not only is this one of my favourite waterfall images, but it also gave me a tricky composition challenge as the wooded area around the plunge-pool offered only limited perspectives. A long-focus lens did not give me a satisfying frame, so I carefully chose a position on the shore that included a substantial and well-textured rock on the left of frame.

I knew that I wanted to blur the water, so I hyperfocused the lens on the rock and the falls at the minimum aperture, and let the shutter speed take care of itself. As the falls were in spate and powerful, ¼sec was sufficient. Unusually, I waited for sunlight to disappear before making this shot. Not only could I then lengthen the shutter speed, but the contrast and glare on the white water reduced.

50mm lens, small aperture for depth of field and slow shutter speed, tripod mounted, Fuji Sensia ISO 100

Evening Gale – Hove, East Sussex, England, 1987

As I live near to the coast, and always feel at home near the sea, I ought to make more seascapes than I do. The fact is, I am too often in the mountains, and the shingle beaches of Sussex are not the most inspiring in the world.

Nevertheless, the wind blows often and hard. A good gale that is blowing the tops of the waves, combined with bright evening light, is an opportunity not to be missed.

I framed this image to make use of the light on the pebbles and the marker post, letting the eye run along the shore as far as Worthing in the distance.

This composition is most effective in a cropped, 'letterbox' format. Even with a longer lens to work with, I elected to use the shorter-length zoom and fully intended to crop the sky and the foreground.

35–105mm zoom lens, elbows braced, Fuji RF50

Sailing a Silver Sea – Brighton, East Sussex, 1987

I watched for some time from the front at Brighton. The light was strange;
a white light shining through dark clouds and giving the sea the look and
texture of crumpled tin foil.

 None of the straight shots I framed looked interesting, but the appearance
of a windsurfer gave me a photograph. The coincidence of his arrival and the
light was the only one. The light deteriorated soon afterwards.

 I have often wondered about the movement out of the frame in this image,
but the left to right travel feels natural. I still cannot make up my mind.

200mm lens, Fuji RF50

Desert Forest – Bryce Canyon, Utah, USA, 1989

Returning deep into the slots and gullies of Bryce Canyon, I recall this shoot as being one of the easiest and most flowing I have embarked on. It seemed that every corner we turned revealed a new potential image.

This slope attracted my attention because it was different from the vertical faces and spires of red rock. In particular, the wispy cloud has obscured the sun, creating an ethereal light, somehow perfectly in keeping with the atmosphere of the canyon.

The arrangement of the various trees and bushes with the shapely rock is very satisfying. I set the lens to hyperfocus on the rock and the tree. The 24mm wide-angle lens is not so wide that it distorts angles and perspectives wildly, but tilting it upwards always creates converging verticals. These can be exciting when they are created intentionally for drama; otherwise they can look awkward.

The peripheral trees in this shot are tilting, but I made sure that the key one was upright.

24m lens, small aperture for depth of field, Fuji RF50

Cnicht – near Croesor, Snowdonia National Park, 2000

Cnicht is a statuesque and shapely peak that belies its modest height. It is often referred to as the Welsh Matterhorn, in common with peaks in other countries that bear some resemblance to the alpine peak.

A simple and pleasant walk winds up the ridge to the top from the small village of Croesor, and provides great vistas of the hill throughout.

I was very keen to frame a photograph that emphasized the length of the ridge, and found, about halfway, a perfect dry-stone wall for the purpose. Hyperfocusing on the close wall and the peak, I could lead the eye directly to the summit.

The light on the mid-section of the ridge was my preference from a number of exposures made as the light drifted.

One might have thought that light on the summit would have provided a more pleasing image but, as a general rule, when light is surrounded by darker tones, it works well.

50mm lens, small aperture for depth of field, Fuji Sensia ISO 100

The Pace of Life

Until now I have deliberately avoided any consideration of the urban landscape in this book, even though city photography would have fitted well with the theme of changing light, as there is movement, the pace is fast, and change is constant. But I began this book by urging you to apply photography to your own passions, and I am not as motivated by urban landscapes.

The countryside is seen as an antidote to the noise and the traffic. Yet I hope that I have been able to demonstrate that the pace of the natural landscape is often as fast as anything we experience in a city.

People often used to welcome me 'back to the real world' of normal life after my trips away to the hills. For many of you, turning the page to these images will be a return to normality. If you feel a slight jolt, there is just a chance that you might have been immersed with me for a while.

Nightlines – A27, Shoreham-by-Sea, West Sussex, 1994

200mm lens, tripod mounted, 4sec exposure

Traffic Light – Brighton, East Sussex, 1998

35–105mm zoom lens, tripod mounted, 4sec exposure

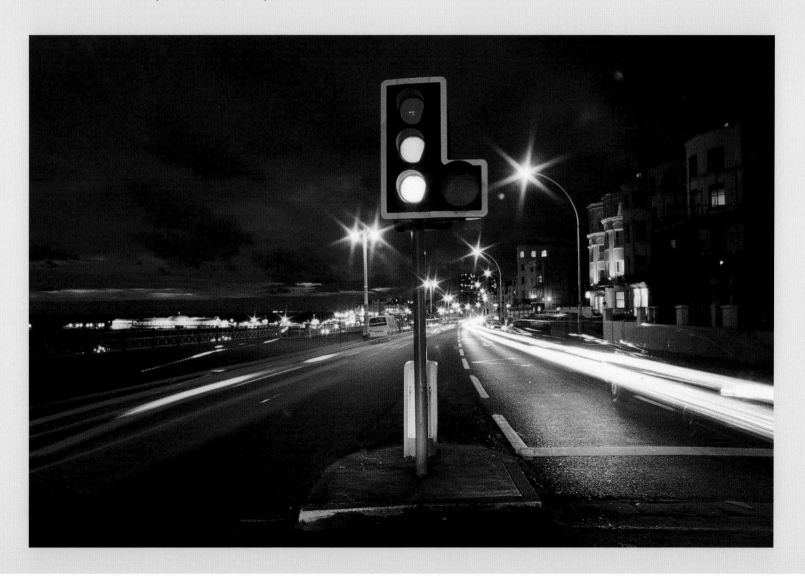

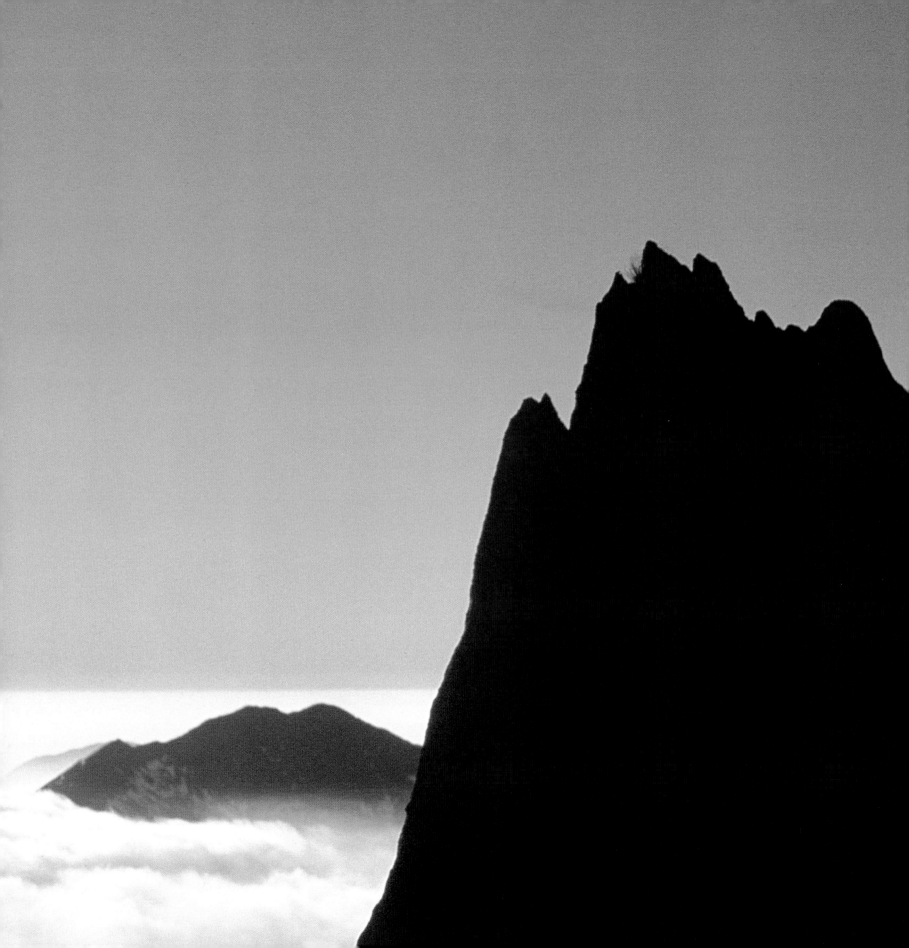

Appendix Tools of the Trade

see equipment merely as an essential tool of the trade, as already said, so my main intention in this Appendix is to cut through the marketing, and to consider the features of photographic equipment that are pertinent to a responsive style of landscape photography.

I chose my equipment 20 years ago, because at the time it suited my budget and my desire to travel light and work simply. I have seen few technical innovations since that have altered my thinking fundamentally. Therefore, I still use the same kit. It is perfect for the job I want it to do and that is what matters.

Finally, I have made some basic assumptions:

- That you understand the types of camera that are available – compacts, SLRs, medium and large format – and what the differences are between them.

- That our discussions will apply to the use of 35mm colour film, though the principles of technique may be applied to larger formats and to digital media.

- That this cannot be a buyers' guide. At a time when digital technology is creating perhaps the biggest and fastest upheaval in photography for 50 years, such a guide would be obsolete within a week. That is the job of the market magazines.

Which Camera? The Disposable Challenge

At my club each year, we run an event where every photographer, regardless of experience, purchases a cheap, disposable camera and uses it for the day. Some weeks later, we each display a storyboard or panel of prints. I am always intrigued by the way that it levels the playing field. The quality is more than acceptable, but it demonstrates more than anything else how important the photographer is in the process.

A significant proportion of the images made in this book were made with a prime 50mm lens. I would contend that all could have been made with those same disposable cameras or budget compacts, and almost certainly a good automatic zoom compact with some exposure control.

Although it gives one little or no control over the exposure or focus, the fundamental principles of photography allow even the cheapest of cameras to do a reasonable job most of the time:

- They utilize a fixed focus and small aperture, relying on depth of field to ensure that most things are sharp.

- They use a single shutter speed which, based on the film speed and fixed aperture, will give a good exposure on colour negative film in normal daylight. Colour negative film has a wider latitude and greater tolerance to exposure error than colour transparency film.

- Finally, as the focal length of the lens is fixed, all the compositions made have to be based on moving oneself to the right position.

I am not suggesting that landscape photographers should rush out to buy disposable cameras, but the message should be clear enough. Throughout the texts in this book I have talked about the process of seeing, and responding intuitively with the camera. If there are no settings to be altered, you are totally free to do nothing except see.

Manual vs. Auto

Personally speaking, for my landscape work, I find the variety of modes and functions on modern cameras bewildering. It is not that I could not take the time to learn them; it is just that many of the functions do not seem to be helpful.

Many beginning photographers want simplicity. I wonder how many people open the manual for the first time and are overwhelmed by the available choices. As a result, the camera is likely to be used permanently in a fully automatic program mode, which gets it right most of the time, and frees us up from the technicalities in order to make pictures.

However, this does nothing to encourage our understanding of the basics. The greater the variety of functions available, the more we have to learn the functions themselves, as opposed to the principles of photography.

Fully automatic SLR cameras with multi-modes are therefore a good choice for the seasoned professional or expert enthusiast, who understands how a camera arrives at its settings for, any given shot. A manual camera, however, is the perfect choice for the beginner.

A manual-focus SLR like the Pentax ME Super, which has been used for almost all of the images in this book, is simple, reliable and can be bought cost-effectively second-hand. The ME Super has an aperture-priority autoexposure (AE) mode, perfect for most landscapes, which are depth-of-field driven. Full manual control is also possible, making the camera versatile, quick and easy to use, and simple to learn.

Similarly, rangefinder cameras and manual compact cameras often offer a full range of shutter-speed and aperture controls. In addition, the Minox, Leica or Rollei models are among the finest quality cameras to be found anywhere.

Medium- and large-format cameras allow full manual control and are the choice of many professional landscape photographers for their unmatched quality. Nevertheless, their size slows down the way they are used, and results in a considered method of landscape photography that is very different to my own.

If I could add one feature of modern SLRs to the old Pentax it would be a matrix meter, which assesses each part of the scene for light levels in order to arrive at a (hopefully) balanced exposure.

Autofocus

Autofocusing (AF) is now extremely fast and accurate, which is fine if the subject requires it. We already know that some of the landscape situations we have encountered are fast moving. However, more often than not, the concern of the landscape photographer is which elements of the scene to render sharp: the depth of field.

The more able multi-mode AF cameras have a program mode known as 'Depth' or similar. In this mode, focusing on the nearest and furthest points of sharp focus causes the camera to select the appropriate aperture and set the lens to its hyperfocal distance.

If you have this mode, and are familiar with its use in practice, then great. Otherwise, autofocusing is more likely to hinder your landscape photography than help it.

AF can, in most cameras, be turned off. However, without clear depth marks on the lens, split-screen viewfinder, or depth previews available in older, manual cameras, manual focusing can be very much a matter of guesswork.

(See more on depth of field in Appendix 2.)

The Digital Question

Most of what I have written so far applies also to digital cameras, but, in terms of use, digital cameras have one great advantage: a video preview allows us to see immediately the image we have just made or are about to make. We can now see the effects of the adjustments we make, just as we can hear the effects of adjusting the bass, treble and volume on the hi-fi.

Film Choices

This book is in colour, so our consideration of films is limited to colour negatives or transparencies. Monochrome is a very different discipline in so many respects that it cannot be compared, and it is beyond the scope of this book.

Colour Negatives

Colour negative film accounts for a huge percentage of the film produced and consumed worldwide. It has a wide latitude, meaning that it can see a wide range of light and dark shades, and it is relatively tolerant to exposure error.

The quality of top emulsions, especially those in the ISO 100–400 range, is undoubted in terms of sharpness and colour. That it has a lesser reputation (compared with transparency film) rests more with the high-street processing laboratories (labs) than with the film itself.

Based on the 80/20 principle, auto-lab output is consistent and acceptable to the majority. Sharpness, contrast and colour, though, often leave much to be desired. Many labs also overcompensate with cropping, giving us perhaps 90% of the visible frame. Given that most SLR cameras only 'see' 95% of the viewfinder image, the combined result might be a long way from the picture composed in the camera.

To the discerning photographer, enprints supplied by the lab should be regarded only as a preview. The only way to bring out the full potential of a negative is to print it by hand under an enlarger, or to print from a high-resolution scan.

Professional wedding photographers gain stunning results with colour negative film; so too can landscape workers.

Although there are some conveniences to the APS format, I would always recommend working with 35mm or larger negatives.

Transparencies

My preference is for colour transparency film. When viewed large in a dark room with the transmitted light of a good projector, there is no better way to view a photograph. Slow transparency film (ISO 25–100) has a very fine grain structure, giving it excellent sharpness, clarity and contrast. For this reason it has long been the preferred choice of publishers.

For many years, ISO 25 Kodachrome was the leader by some way; Fujichrome Velvia makes a substantial challenge today and has unmatched colour depth, though it is not to everyone's taste and many photographers prefer the more understated colour balance of Kodachrome and other emulsions.

Contrast provides some difficulty, though; colour transparency film requires precise exposure and many photographers underexpose slightly to saturate the colours. The latitude is narrower, leading often to overexposed and washed-out highlights, or to heavy black shadows. This contrast was often compounded when printing colour slides using a conventional process such as Ilfochrome (formerly Cibachrome). Nevertheless, the prints look quite magnificent when they are produced with skill and care.

Slides can now be easily scanned for home or professional printing, increasing still further their versatility.

My choice is for the ISO 50–100 Fujichrome emulsions. These are of very high quality and the speed range is adequate in the majority of situations. Faster emulsions would benefit my approach marginally in very low light, which accounts for less than 10 per cent of my work.

Travelling Light: The Kit

This is the complete range of equipment that I carry on the hill. I work on the principle that if I have not used something at the end of a week's trek, then I did not need to carry it. Every one of these items is used on

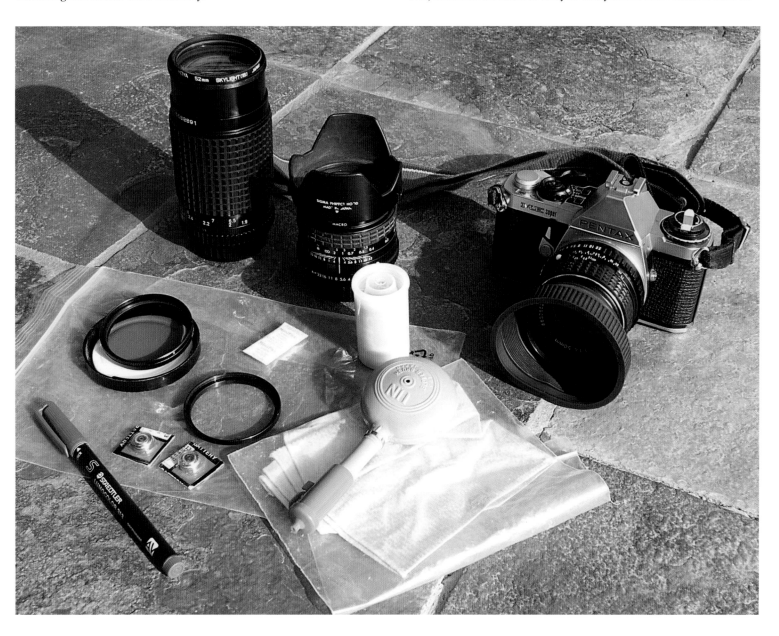

every trip, and I have rarely needed anything else. On longer travels, though, I might carry a second camera body.

1. Pentax ME Super

The camera used for the images in this book is a Pentax ME Super. Substitute any other similar make and you have a fine camera for this type of work.

Let us consider some of the options in the Pentax's favour:

- Aperture-priority autoexposure (AE) mode
 In most landscape situations, the main problem to be solved is one of depth of field. This mode allows me to work quickly, choosing my aperture to suit the depth of the scene and letting the camera follow with a corresponding shutter speed. Full manual control is also available.

- Manual focus
 Since I am aiming to hyperfocus (see Appendix 2, page 153) in many situations, manual focus is an advantage. The ME Super does not have a preview button to stop down the lens, but the Pentax lenses have very clear depth marks on the barrel.

- It is not totally battery dependent
 The batteries used are silver-oxide button cells. They are susceptible to failure in cold conditions, but spares are light, and the camera has a mechanical 1/125sec speed that does not rely on battery power.

- The film ISO speed can be set manually, providing instant 1/3 stop adjustments whilst in AE mode.

- It is small, light and extremely reliable. It has got damp, covered in spindrift and knocked against rocks, yet it still works.

2. Lenses

I carry just three prime lenses; a Sigma 24mm f/2.8, a Pentax-KA 50mm f/1.4 and a Pentax KA 200mm f/4.

This gives me a range from wide-angle to short telephoto and I am rarely found wanting any intermediate steps; adjusting my own position in the scene with the 50mm can compensate for this, and I use the 50mm for the majority of my work.

The 24mm lens is a joy, but is the most difficult of the three to use, simply because it creates so much space in the frame that needs to be filled carefully. Foregrounds are especially important to wide landscapes.

With a centre-weighted meter also, I have to be on my guard against overexposure, as dark foregrounds tend to dominate the metering area.

200mm is ideal for pulling in and compressing distant scenes creating recession and abstracts. Whilst too short for useful nature photography, it is fairly easily hand-held.

Prime lenses compel me to move myself around a scene rather than zoom from where I am standing. Generally speaking, primes also have a faster maximum aperture than zooms, making them more usable in low light. It used to be the case that they were lighter too, but modern zooms, unlike their cumbersome predecessors, are very light and compact.

Each lens has a lens hood, and a skylight 1B filter acting mainly as a protector for the front element.

I also own a Vivitar Series I, 35–105mm zoom, which is beautifully sharp but heavy, so it does not accompany me often in the field.

3. Accessories

My accessories are limited to the following essentials:

- A polarizing filter to fit the largest lens (a 52mm thread on the 24mm and the 200mm) and a stepping ring, enabling me to fit the filter to the 50mm lens (a 49mm thread size)

- A lens brush and cloth

- Spare batteries

- A permanent fibre-tipped pen for marking film canisters

- Silica-gel, a desiccant which I keep in every lens pouch to absorb any moisture

All of these fit neatly into a press-seal polythene bag for protection, which I carry in a small cotton pouch; this can be stuffed with anything – spare socks, food packets, and so on – and double up as a 'beanbag' for supporting the camera. On trips to hotter regions, I will always carry film in a small, insulated cool bag.

4. Notable Omission – Filters

Other than the skylights and polarizers already mentioned, filters are banned. After all, my aim is to photograph natural light. To add colours or special effects through the use of filters would feel like buying a fish on the way home from a fishing trip and pretending that I had caught it. Sure, the fish might taste good, but it just ain't the same!

I am not averse to neutral density filters, either solid or graduated, which are excellent for controlling contrast or allowing a greater range of shutter speeds. Neither am I commenting in any way on the use of controlling filters in monochrome photography.

5. Notable Omission – Tripod

I do use a tripod in certain circumstances, but I find that the act of setting up a tripod often kills the spontaneity of the moment. Many of the photographs in this book would not have been made had I tried to work with a tripod.

On expeditions especially, carrying the weight of a tripod would mean less food, something I am not prepared to consider, even though I sometimes feel the need for that extra stability.

(See also Appendix 2 – Supporting the Camera.)

Carrying Equipment

The range of bags and pouches and pocketed-jackets available for photographers is huge. However, hardly any of these is a practical choice for working outdoors some distance from the car, when other equipment should be carried (see Appendix 3).

My choice for carrying gear is based on two principles:

- That the amount of stuff always expands to fill the space available (the same goes for my rucksack when I am on an expedition)

- That my gear should be protected from the elements, yet accessible

Given the limited range of the things I carry, I can achieve both ideals using three Camera Care Systems pouches mounted on a belt, two for the spare lenses and one for the camera. These bags have a draw-closure and a large flap with a Velcro seal. The system fits neatly around my waist alongside any rucksack waistband, and gives quick access.

I have found them to be relatively waterproof, though this is not guaranteed and I would not deliberately expose them to prolonged heavy rain. The padding also provides excellent protection against knocks.

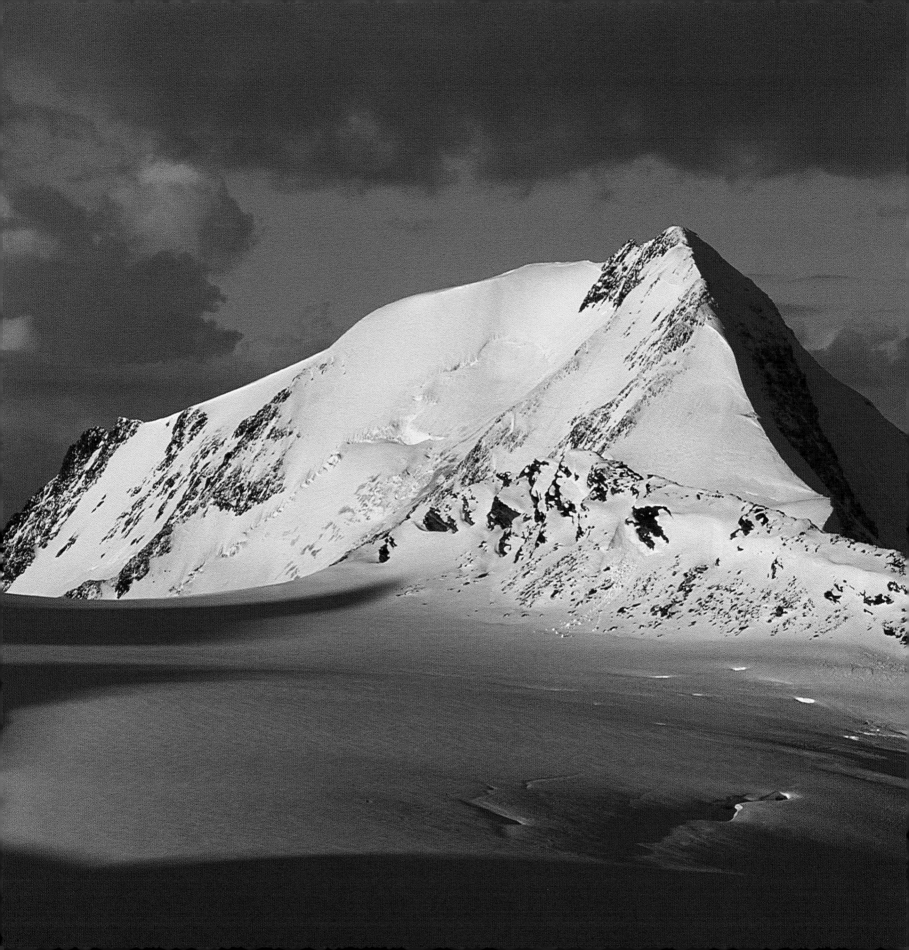

Appendix (2) Principles of Technique

I believe that photography is, essentially, a simple operation based around a few fundamental principles and techniques. This section is an attempt to demystify those techniques.

To put things into context, consider a typical sequence of decisions that regularly need to be made in the field. Although I am naturally averse to describing photography as a process, there is a repeatable sequence of decisions that can be practised. Once this sequence becomes intuitive, you will be better able to tune into – and respond to – the light and the scenes.

These are the five essential steps:

1. Composition
Having seen something – which is the most important step of all – compose your scene. Sometimes this will be instinctive and instantaneous; at other times, a composition arrives after exploring the scene for a while.

2. Focus and Depth
Decide what you want to be in sharp focus. The decision is simple. Is depth of field important to the image? If so, focus the lens accordingly and work with aperture as a priority. Otherwise, you can work with shutter speed as the priority.

3. Metering and Exposure
When you know the aperture or shutter speed you want to use, you can determine the exposure by taking light-meter readings from the scene. Where there is a large range of brightness, it is important to assess how each element will contribute to the image, and which is the most important. You can then set an exposure that gives the best balance.

4. Holding and Supporting the Camera
It may be that you are now working with a shutter speed that is too slow to allow you to hand-hold the camera. This could be due to low light levels, to working at a very small aperture for extreme depth of field, or to other factors, such as wind. If this is the case, you may have to provide support for the camera.

5. Taking Care of the Camera
Finally, ensure that your camera and lenses remain in optimum working condition. Shooting conditions may be harsh: rain or spray, spinning snow or sand, cold or heat. In reality this process might take anything from a few seconds to several minutes to complete. It is the seeing that takes the time; a photograph is taken in a fraction of a second, but takes many hours to make.

CONSIDERATION ONE: Composition
In the narrative attached to each image throughout the book I describe the events that led to my seeing an image, and the considerations that I made in choosing a composition. Composition is the final design of the picture, the result of seeing with a camera. I work on the principle that if it looks good in the viewfinder, then go with it.

But what constitutes a good picture? This is a question that has caused endless debate through the ages and there is no right or wrong answer.

There are, however, some useful guiding principles. As you look through any collection of images, you will find some that please you and others that do not. In the same way, every one of us, when facing the same scene, will interpret it differently to make our own compositions.

Looking at images is a great way to become familiar with what works or does not work for each of us. The more we do this, and the more we experiment and interpret the results, the more intuitively we are able to work in the field.

To summarize the general principles of good composition:

1. The Rule of Thirds
If you divide a picture space into nine equal areas, you have a central rectangle bounded by four intersecting lines. If you then place the main subject anywhere on these virtual lines around the central area – the thirds – the picture will look generally better balanced than it would if the subject was placed in the centre. For example, a central horizon can look awkward, but a horizon placed on either the upper or lower third looks more comfortable.

A two-thirds/one-third relationship is a good design principle. However, after a time this idea can become too familiar; when we instinctively look for the subject on the thirds, the image no longer provides a challenge when we find it there.

Therefore, be bold. Try putting the subject deliberately in the centre, or on the edges or corners of the frame.

2. Lead-in

Natural lines can lead the eye into the picture space. Fences, walls and the lie of the land can do this very effectively. In particular, diagonals coming in from the corners of the frame, or S-curves are classic techniques that give life and dynamics to an image.

However, beware a wall acting as a barrier across the scene, hindering access to the eye, unless, of course, you wish to make a statement about access to the land itself. Open gates help to get around this.

3. Lead-out

If a line leads the eye out of the frame and away from the scene, it can often be bound by the careful placement of a tree or a rock.

Occasionally, a line can both lead the eye in and out, providing a pleasing balance and sense of exploration.

4. Resting Place

When pictures are being appraised, there is often talk about the need for something, a single point of interest, on which the eye can come to rest. This is a good principle, but it is by no means mandatory. You can also roam a scene, exploring it visually. There could be many points of interest or none at all; either is fine.

5. Filling the Frame/Empty Space

Similarly, we are often implored to go in close and to fill the frame. Some subjects need to have emphasis, of course, but many scenic compositions need space in which to breathe. I am quite comfortable with tiny subjects (such as the Bridal Veil waterfall on page 67 or the village of Arnisdale on page 103) being almost overwhelmed by space; in many instances, space is the subject. Often, less is more.

6. Foreground

With wide-angle lenses especially, it is essential to pay attention to the foreground. In addition to lead-in lines, you can make use of grasses or rocks to provide foreground interest.

7. Scale and Perspective

Conveying the scale of a landscape is often difficult. In the Grand Canyon, for example (see pages 70 and 71), only the inclusion of small parts of the scene with a telephoto lens gave me a sufficient feeling of depth.

Telephoto lenses imply scale well, because they enable the scene to be compressed, allowing the eye to see in an image what the brain can interpret in the real world. I regularly make use of trees or people to give a reference point for determining scale or balance.

8. Light and Shade

Another good general principle of photographing light is to enclose light spaces with dark. The eye is drawn naturally to the lighter parts of an image, and viewing the picture will feel less comfortable if these are towards the edges of the frame.

9. General Techniques

• Viewfinder scanning

Scan the edges of the viewfinder for clutter before releasing the shutter. Highlights or defocused objects will be a major distraction, no matter how small.

• Pre-cropping

It is not always possible to have the right lens for every situation. Do not be afraid to make an image with the intention of cropping it later – although you should always aim to get it right in the camera if at all possible.

• Look at the viewfinder, not through it

Our eyes and brain are designed to interpret space in three dimensions; in photography, we have to translate what we see into two dimensions. Looking at the viewfinder helps us to make this translation more easily, because we see a 2D image, whereas looking through it keeps us too much in the real world. (Photographers using medium-format cameras with waist-level viewfinders will understand this exactly.)

• Widening the gaze

Occasionally, shadows may be too dark for detail to record on transparency film and I am happy to let them go black, provided that they make a comfortable pattern. To pre-visualize the patterns of light and shade in a scene, just defocus the eyes slightly and look at nothing specific.

• Narrowing the gaze

By way of contrast, shutting off any awareness of peripheral vision, and concentrating on the distance, will help you to pre-visualize telephoto scenes.

• Moving yourself

This is the most critical technique in composition, so I have left it until last. To close a scene and narrow the relationship between the foreground and the horizon, crouch down low; to open it up, move to a higher viewpoint. Move forward and back to adjust scale and distance.

Try to avoid just standing there and zooming the lens. And whatever you do, look behind you. Photographers have been known to step backwards over edges …

CONSIDERATION TWO: Focus and Depth

The next step is to decide where to focus the lens. Base your decision on what, from front to back in the scene, you want to appear sharp in the photograph.

What is Depth of Field?

The range of distance that you are able to render sharp is known as depth of field, and it varies according to the aperture you set on the lens. The smaller the aperture, the greater the depth of field, and vice versa.

Have you ever wondered why we often squint to see in low light? When it is dark, our pupils dilate to let in more light; in other words, we open the aperture. At a wide aperture we see a shallower range of sharp detail, so we squint in an attempt to close it down. By stopping-down our own eyes we increase the range of sharpness we can see. This is depth of field in action.

Deciding Priorities

Since depth of field depends on the aperture of the lens, I work in an aperture-priority mode whenever I need to control it. That means that I set the aperture according to the depth I require and adjust the shutter speed to give the correct exposure.

This decision is usually straightforward, so let us examine a few situations where different considerations come into play.

1. A general scene with all elements at infinity (see image on page 31)

We are looking at a distant mountain in clear air. There is no 'depth' as everything is 'in focus' with the lens set at infinity. Therefore, I can work in shutter-priority mode, choosing a shutter speed at which I can safely hold the camera without risk of camera-shake[1](see also Supporting the Camera, on page 156).

2. A stone bridge over a stream, with a prominent foreground rock (see image on page 40)

I required both the rock and the bridge to be sharp in this image. Therefore, I selected a small aperture (e.g. f/16) that would keep both within a range of acceptable sharpness.

3. An attractive composition of close grasses and distant mountains.

As an alternative to keeping everything sharp, I could choose to focus close on the grasses using a wide aperture (e.g. f/2), letting the background become soft and diffused. The two images above right show both these effects.

4. A low-light scene with foreground snow and a distant mountain (see image on page 18).

Ideally I would want to keep both the foreground and background sharp. However, in the low light, the aperture I need requires a shutter-speed that is too slow for hand-holding the camera. Therefore, I set a wide aperture and, as the mountain is the prominent part of the scene, I am prepared to let the foreground soften.[2]

5. A waterfall scene (see image on page 132)

Here, a slow shutter-speed is set to blur the water. In daylight, this can only be achieved with a small aperture, so I am also able to control depth of field easily.

Hyperfocusing: Working with Depth of Field

How do you decide what aperture to set and where to focus the camera? To discuss this practical matter let us return to the grasses images.

The grasses were approximately 2m (6ft) from the camera. With my 50mm lens set to its minimum aperture of f/22 and focused precisely at 2m, I know that a range from 1.3–5m (approx. 4–16ft) could be held sharp, because the f/22 marks on the barrel of the lens correspond to these distances on the focusing ring. Anything closer or further away would be out of range.

[1]Note that choice of aperture can still be important. Lenses often give best overall sharpness across the frame when set to apertures in the middle range, say f/5.6 to f/16. Extremes can give a fall-off in quality towards the edges.

[2]This is clearly a compromise. With a tripod, I could have achieved the desired result, but I do not carry a tripod on expeditions. Also, I do not generally favour elements close to the camera being out of focus. Whilst our eyes can ignore such effects, they become rather too obvious and jarring on a flat image.

However, in this scene the range I require for maximum depth is from 2m (the grass) to infinity (the mountains). Therefore, if I turn the focusing ring so that both 2m and infinity sit within the two f/22 marks, the lens is now focused at approximately 4m (13ft). For the scene in question, this is the hyperfocal distance; I have focused the lens on the hyperfocal point.

Looking at the viewfinder, I notice that the grasses appear blurred. Depth of field in the viewfinder is minimal, because the lens aperture remains wide open until the shutter is released.

The working steps involved in hyperfocusing are as follows:

1. Focus on the nearest object that is to be sharp. Note the distance – in the example, 2m (approx. 6ft).

2. Focus on the furthest object to appear sharp. Note the distance – in the example, infinity.

3. Turn the focusing ring until both distances sit beside or within the bounds of a set of depth-marks on the lens barrel – in the example, f/22. This is the hyperfocal distance.

4. Set the lens to the indicated aperture. Working with the depth-marks is an approximation, so in practice I always work one f-stop smaller than that shown on the lens marks, light levels allowing.

I can also use hyperfocusing to prime the camera for fast shooting (see Section 3 – Working at the Speed of Light). In good light, I can set the lens to f/11 and hyperfocus it. I can then, literally, point and shoot.

Returning to the original focus at 2m, I would know that the background would appear soft. Note that depth of field can be minimized by opening the aperture to, say, f/4 or f/2.8. This concentrates attention on the grasses. The furthest range of sharpness then decreases from 5m (16ft) to a few centimetres (1–2in).

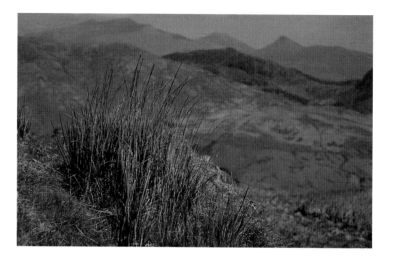

Further Considerations

Many cameras today, particularly autofocusing models, do not have the depth-marks on the lens to aid hyperfocusing. Nevertheless, there are a number of ways around this:

1. Depth Mode
Multi-mode cameras often have a mode called 'Depth'. In this mode, autofocusing on the nearest and furthest elements of the scene will allow the camera to select the appropriate aperture and to set the hyperfocal distance.

2. Fall-off
Depth of field falls away roughly twice as fast in front of the point of focus as behind it. Therefore, for any given aperture, focusing roughly one third of the way between the nearest and furthest elements will find the hyperfocal distance. Although a very rough approximation, this technique works quite well with autofocus compact cameras that work with small apertures.

3. Depth Preview
If the camera has one, the Depth Preview button stops the lens down to the working aperture so that the effect can be previewed. However, I have frequently found that the viewfinder image becomes too dark to see anything meaningful.

4. Calculation

Depth of field can be calculated exactly, using a mathematical formula for any lens. Various calculators are available to download for free from the Internet. Whilst I have never used them, I have printed and kept a sheet for each of my lenses.

CONSIDERATION THREE: Metering and Exposure

Having set the aperture required for depth of field, and focused the lens, there is just the shutter speed to be set before exposing the film.

There is more confusion about exposure and metering than almost any other technical aspect of photography. It would warrant a book in itself. However, since I am most often in a responsive mode when photographing changing light in the landscape, I like to strip it down to the bare essentials, and remind myself that film is unable to reproduce the range of tones that our eyes can perceive, so exposure is always a compromise.

The Law of Averages

In-camera light meters measure the amount of light reflected from an object. They are calibrated to assume that the average amount of light being reflected is about 18 per cent. This means that in most general lighting situations, the camera meter will get it right.

Confidence in this principle allows film manufacturers to suggest exposure values for different lighting conditions inside every film carton. For example, in good sunny conditions in the UK, an exposure of 1/125sec at f/11 would give an acceptable result on ISO 100 film.[3]

Some scenes, however, fall outside this average range. For example, scenes featuring snow or predominant black shadows will cause the meter to think that there is too much or too little light respectively. Left to the camera's own devices, both scenes will turn out a very average grey, so an exposure compensation would be required. Armed with this knowledge, you have a good idea when the meter is giving you appropriate information. You then need to decide where to point the meter, and to be aware of which scenes will require a compensation.

Where to Point the Meter

The first step in metering a scene accurately is to ensure that the meter is reading from that part of the scene that must be 'correctly' exposed.

Using colour transparency film, I always err towards exposing for well-lit areas, and allow shadows to take care of themselves (I have also allowed for this in my compositions).

Using the centre-weighted meter in my Pentax, I know that the metering area is in the lower central area of the viewfinder. Especially with a wide-angle lens, this gives a slight priority to the ground, so it is essential to check the difference in light levels in the sky before choosing a balanced exposure.

Where the critical subject forms just a small part of the frame, it is difficult to isolate it in order to gain an accurate meter reading. There are several options that can be taken:

- Look for something close by that has average reflectivity, or is in similar lighting conditions to the subject: areas of grass, the back of your hand, or even an 18 per cent grey card. These might not be 100 per cent accurate, but will give a clue as to how far the scene as a whole differs from the subject.

- Use a spot-meter, either in-camera or hand-held. This gives a reading from a very small area of the scene, maybe 2°, and is very accurate selectively. Alternatively, use a telephoto lens to simulate a spot-meter.

- Modern SLR cameras use a multi-segment matrix system, which compares readings taken from different parts of the scene and attempts to interpret and balance them. This is probably more accurate more often than a centre-weighted meter, particularly in high-contrast situations, but it may or may not give the effect you want. The only advice is to know your camera well.

Typical Compensation Situations

Having chosen which part of the scene to meter from, you need to be aware of those situations where further compensation might be required. The most common situations that I encounter are these.

- Small highlights amidst dark shadows
Take the image on page 71. Allowing the camera to expose for the black shadows would have overexposed the window of light. However, the rocks were of average reflectivity, and I was able to fix an exposure for the highlight using the telephoto lens. The issue is to choose carefully the area of a high-contrast scene that you wish to expose 'correctly'.

- Bright land/dark sky
Here a centre-weighted meter works well. Exposing for the bright ground, even underexposing it slightly, gives drama in the dark sky.

- Bright sky/shadowed land
This is the classic situation for a grey-graduated or graduated neutral-density filter, which allows for the sky to be effectively underexposed. I rarely use these. Instead, I expose for the sky, and compose my foreground carefully, using water or other features to provide detail in the shadows.

[3] 1/125sec being the shutter speed closest to the reciprocal of the film speed of ISO 100. For ISO 50 film the shutter speed would be 1/60sec at the same aperture.

- Snow (or anything bright white)

 Snow is perhaps the most difficult of all situations to get right. Metering from bright snow will cause underexposure and a flat, grey result. However, over-compensation can easily wash out any hint of detail and texture. Do not be misled into believing that snow is always white. Look carefully at the colour, the brightness and the effect you perceive, and shoot accordingly.

 Where there is even light in the sky and the snowy ground, or a balance of shadows and highlights, straight metering from the scene often gives acceptable results. However, in high contrast, for example with a rich, deep-blue sky, or when shooting contre-jour (into the light), then I will almost certainly need to compensate by up to two stops.

In all of these situations, there is one golden rule: if in doubt, bracket. Bracketing means shooting several frames in small increments of, say, 1/3 stop either side of the meter reading.

Making Adjustments and Compensations

Exposure is a combination of the aperture and shutter speed. Having already set my aperture for depth, I would adjust exposure by changing the shutter speed.

In manual mode, I can only adjust shutter speeds by one stop, which is usually too much for transparency film. However, in aperture-priority AE mode, the camera can make smaller adjustments, so I most often use the ISO film-speed dial to compensate in 1/3 stop increments in either direction. Effectively, this fools the meter into thinking that I am using slightly faster film, causing slight underexposure (or vice versa).

Older cameras have a compensation dial, marked +1 or -1, sometimes x2 or x1/2. This operates in a similar way to the ISO dial, but adjustments in whole stops are often too much.

On modern SLR cameras, these adjustments are to be found in one or another of the mode settings. It pays to find them and to become very familiar with their fast operation.

Film Considerations

Finally, it is important to know that different types of film require slightly different approaches.

Colour transparency film requires precise exposure. As little as 1/2 stop over- or underexposure can be enough to burn out highlights or block shadows. Small adjustments of 1/3 stop are often all that is required. My general rule of thumb is to maintain highlight detail, and I am often happy to let shadows go to black, provided that they make a pleasing arrangement.

Colour and monochrome negative film has greater latitude. Therefore, more detail can be allowed to record in the shadows, though this also requires skilled printing to show to best effect.

CONSIDERATION FOUR: Holding and Supporting the Camera

Hand-holding the camera is a key part of my responsive approach. It is true that I have to make the occasional compromise through not using a tripod, e.g. if the shutter speed is just too slow to hand-hold successfully.[4] Nevertheless, this is compensated for by greater number of situations when I am able to capture an image by working at the speed of light.

Knowing that I often push the limits, I have tried to perfect my camera-holding technique in all lighting situations. Using the techniques described below, I have achieved successful images with exposures as long as 1/2sec.

Stances

I see the challenge of holding the camera steady as being similar to that of a rifle shooter. In the biathlon (combined skiing and shooting), competitors adopt three positions – standing, crouched and prone. I have adapted those positions to suit my photography, and used a variety of props to give me further help.

① Standing
Position/Camera Horizontal

This is the standard position. Note how the elbows are tucked in, and the left hand cups the base and the lens controls. The feet are placed one ahead of the other so as to give a solid stance.

② Standing/Camera Upright

This position is similar, except that the camera has been turned through 90°.

③ Crouched

I adopt this stance often, because it allows me to close down a scene and maximize use of the foreground. Placing one knee on the ground, it becomes more stable, but wet ground is a deterrent. The hands are unchanged from the standing position.

[4]The reciprocal of the lens focal length is the accepted limit, e.g. 1/60sec for a 50mm lens, 1/250 for a 200mm lens.

④ Prone or Propped/Camera Horizontal

Natural props such as rocks or fences or walls provide a great base for bracing the elbows. With feet in a solid stance and two elbows braced, I find this to be almost as effective as using a tripod.

⑤ Prone or Propped/Camera Upright

Note the difference in hand positions to the standing version with the camera upright. Turning the camera through 90° in the opposite direction allows both elbows to stay firmly braced on the prop.

⑥&⑦ Makeshift Monopods

Walkers carrying trekking poles, walking sticks, or ice axes can use a beanbag on any of these as a good substitute for a monopod. It is also possible to buy a 'ball and socket' head that can be clamped onto an axe or pole. The beanbag is useful on any prop when using a telephoto lens.

Releasing the Shutter

The preparation of the stance is pointless unless the shutter is released with the utmost care.

Try this:

- When you are happy with the stance and prop, inhale and exhale slowly twice, relaxing consciously as you exhale.

- At the bottom of the second exhale, pause for a second and then squeeze the shutter very gently, using only the tip of the forefinger.

- Do nothing else.

CONSIDERATION FIVE: Taking Care of the Camera

Cameras are not generally designed to withstand the rigours of rain, cold and dust that they can be subjected to. Indeed, in the British climate, we might be sometimes tempted to believe that an underwater camera would be the ideal choice!

Protecting the camera and lenses in harsh conditions is mostly a matter of common sense. Here are some tips:

In Rain or Spray

- Work out what you are going to do before removing the camera from the pouch, then work quickly. It helps to have an assistant to provide a little shelter using an umbrella or anything available.

- Take care to avoid salt-water spray if at all possible.

- Keep some tissue handy for removing excess water from the front of the lens.

- Dry cameras and lenses thoroughly but gently with tissue at the first opportunity. Then let the camera dry naturally in a warm environment for several hours after working, if you can.

In Sand, Dust or Spinning Snow

- These are almost worse than spray, as they work their way very quickly into every conceivable crevice. Again, keep cameras and lenses out of their pouches for as short a time as possible.

- Clean them thoroughly afterwards using a fine blower brush.

In Cold

Working in the cold might not seem to be a major issue. However, there are some points to bear in mind:

- Keep the batteries warm. Put in a new set periodically, or swap them for warm ones.

- If you are camping and you want a functioning camera for the morning light after a night of frost, take the pouches into your sleeping bag with you.

- If you wear spectacles you will know what happens when you go into a warm room from the cold. Cameras fog up quickly. Keep a tissue handy to wipe the filter and the camera body. Leave them in the warm environment to dry naturally.

- Wind film carefully. Cold can create ideal conditions for the build up of static, which can fog the film.

In Heat

- Heat affects film more than cameras. Keep a small, insulated bag for storing films.

- Carrying the camera around your neck whilst walking can fog the viewfinder with perspiration. Use a viewfinder cap, or dry it often with a tissue.

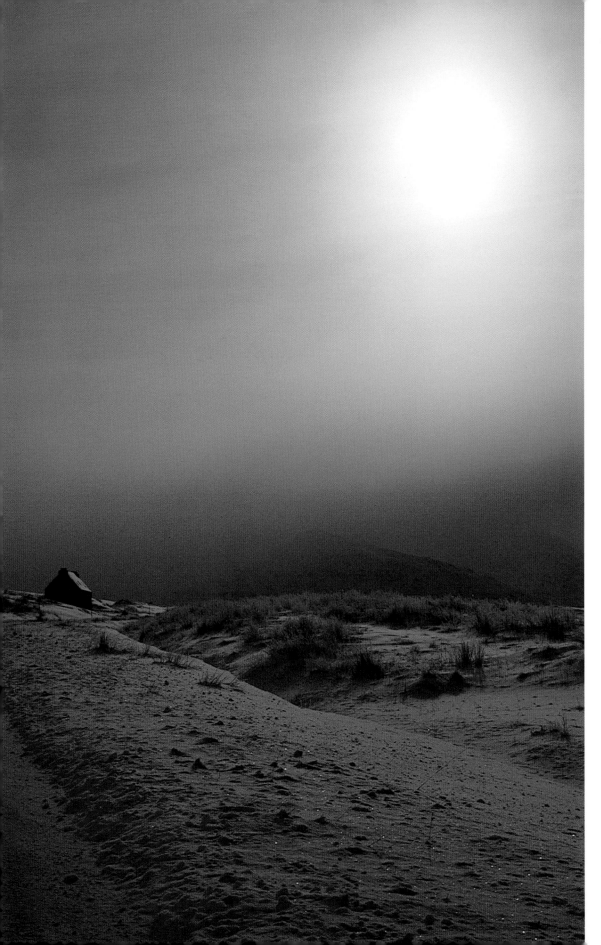

**Winter Sunlight and Barn, near Durdonnell,
Scottish Highlands, 2001**

Fuji Velvia ISO 50

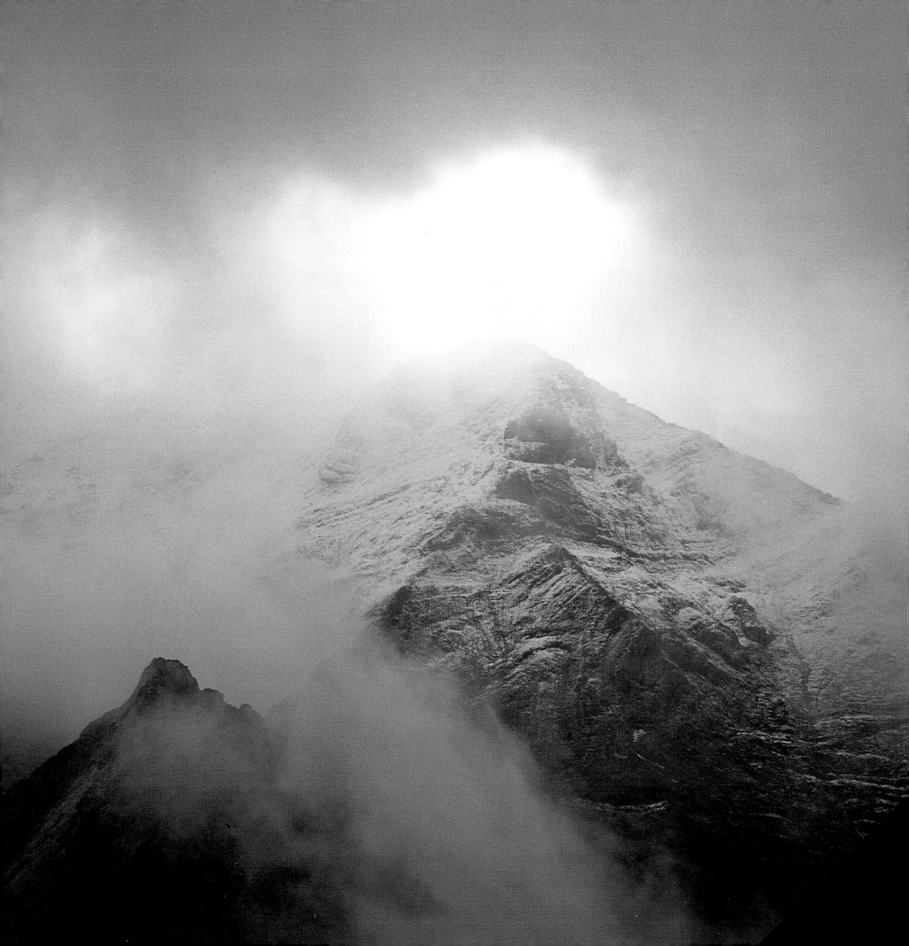

Appendix ③ Hill Safety

I am all too aware that the photographs in this book span 20 years, during which time I have amassed a wealth of experience of walking in the hills and in wild country.

Few of the images required mountaineering experience; indeed a good many were made in places very accessible to walkers of all abilities. Nevertheless, I often advocate the merits of hunting the edges of the weather, or of being out early and late, which means sometimes returning after dark or camping out.

It would be remiss of me, therefore, not to say a short word about the importance of hill safety.

There are many general guidelines:

- Practise your hillcraft often, especially navigation using map and compass. There is no more common cause of hillwalking accidents than becoming lost in mist.

- Know your route. If you are new to staying out high for sunsets, start with easy tracks close to the road.

- Wear strong boots and appropriate clothing, and take spares for rain and cold. It has been said that there is no such thing as bad weather, only the wrong clothing.

- Always carry a torch and spare batteries, food and water, first-aid kit.

- Be aware of weather forecasts, and become familiar with weather signs.

- Leave word, either locally or at home, as to your intentions and planned routes.

- Observe the country code and local bye-laws concerning parking, access and camping.

- Practise 'no-trace' camping always. Carry everything out that you took in.

- Travel with a companion wherever possible.

- Finally, if you wish to venture up into the hills in winter, there is no substitute for training, especially in the use of ice axe and crampons.

There are numerous guidebooks on hillwalking areas. However, there is no better source of reference on everything connected with hillwalking than Eric Langmuir's *Mountaincraft and Leadership A handbook for mountaineers and hillwalking leaders in the British Isles*. See full details and other recommended reading in the Bibliography section that follows.

bibliography

On photography (and being at one with the landscape):

Brandenburg, Jim
Chased by the Light
(NorthWord Press, Minnesota,1998)

Patterson, Freeman
Portraits of Earth
(David & Charles Publishers plc, Newton Abbot, London, 1987)

Rowell, Galen
Mountain Light
(Century Hutchinson Ltd., London, Melbourne, Auckland, Johannesburg, 1986)

On creativity and being in the present moment:

Cameron, Julia
The Artist's Way
(Pan Books, Macmillan Publishers Ltd, London, 1993. Basingstoke, Oxford, 1995)

Carlsson, Richard and Bailey, Joe
Slowing Down to the Speed of Life
(Hodder & Stoughton, London, 1997)

On hillcraft and mountain weather:

Langmuir, Eric
Mountaincraft and Leadership
A handbook for mountaineers and hillwalking leaders in the British Isles
(The Scottish Sports Council/Mountain Leader Training Board, 1995)

Moran, Martin
Scotland's Winter Mountains
(David & Charles Publishers plc, Newton Abbot, London, 1988)

Pedgeley, David
Mountain Weather – A practical guide for hillwalkers and climbers in the British Isles (Cicerone Press, Cumbria, 1979)

On optical effects in the atmosphere:
Atmospheric Optics: www.sundog.clara.co.uk

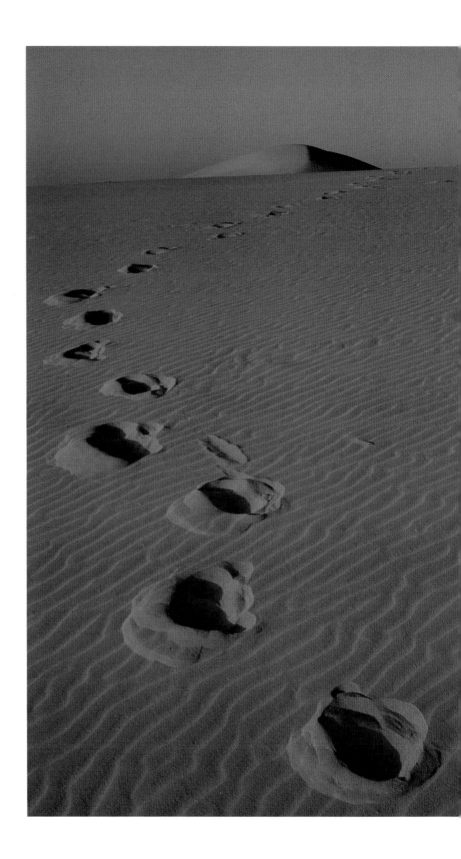

DEDICATION

For Craig, Gavin and Liam

Acknowledgements

To Carolyn: for 25 years you have allowed me the space to grow in every way, and to enjoy my love affair with the hills. You have listened to the stories, shared in some wonderful outdoor moments yourself, and have been there for us both through everything. Thank you. I love you.

To Wayne Gosden: how many nights is it now in that tiny tent, brewing tea, solving the world and hatching plans? You have laughed your way through every soaking and every summit from Truleigh Hill to the Hochwilde, standing in your red hat just where a photographer wants you to stand. Cheers mate!

To Mum and Dad: for taking me to the hills of Snowdonia when I was 11 and getting me started. Nothing ever inspired me more.

To Linda Simpson: for continually helping me to believe in myself, for your appreciation of beauty and your tireless enthusiasm and encouragement.

To all of you who encouraged my emergence from the 'crevasse' at Cortijo Romero in May 2001. You continue to light my journey.

To all the members and friends at Steyning Camera Club, for your appreciation and support, particularly Cliff Carter, whose images appear in the Appendix and whose technical guidance is always so valuable.

To Gareth Williams: who found my camera on a wall in North Wales and returned it with more joy than one could imagine.

To Kylie Johnston: who was touched by something in what I said at Brighton & Hove Camera Club, and whose vision started this project.

To Gill Parris for expertly helping me through the texts, to Danny McBride for the inspiring design, and to April McCroskie and all at GMC for believing in me and for taking the risk.

This book would not have happened without you. I am greatly indebted to you all.

index

The Photographers' Institute Press, PIP, is an exciting name in photography publishing. When you see this name on the spine of a book, you will be sure that the author is an experienced photographer and the content is of the highest standard, both technically and visually. Formed as a mark of quality, the Photographers' Institute Press covers the full range of photographic interests, from expanded camera guides to exposure techniques and landscape.

The list represents a selection of titles currently published or scheduled to be published.

All are available direct from the Publishers or through bookshops and specialist retailers.

To place an order, or to obtain a complete catalogue, contact:

**Photographers' Institute Press,
Castle Place,
166 High Street, Lewes,
East Sussex BN7 1XU
United Kingdom**

Tel: 01273 488005
Fax: 01273 402866
E-mail: pubs@thegmcgroup.com

Orders by credit card are accepted

Animal Photographs: A Practical Guide Robert Maier
ISBN 1 86108 303 3

Approaching Photography Paul Hill
ISBN 1 86108 323 8

Bird Photography: A Global Site Guide David Tipling
ISBN 1 86108 302 5

Digital SLR Masterclass Andy Rouse
ISBN 1 86108 358 0

Garden Photography: A Professional Guide Tony Cooper
ISBN 1 86108 392 0

Getting the Best from Your 35mm SLR Camera
Michael Burgess
ISBN 1 86108 347 5

How to Photograph Dogs Nick Ridley
ISBN 1 86108 332 7

Photographers' Guide to Web Publishing Charles Saunders
ISBN 1 86108 352 1

**Photographing Changing Light:
A Guide for Landscape Photographers** Ken Scott
ISBN 1 86108 380 7

Photographing Flowers Sue Bishop
ISBN 1 86108 366 1

Photographing People Roderick Macmillan
ISBN 1 86108 313 0

Photographing Water in the Landscape David Tarn
ISBN 1 86108 396 3

The Photographic Guide to Exposure Chris Weston
ISBN 1 86108 387 4

The PIP Expanded Guide to the: Nikon F5 Chris Weston
ISBN 1 86108 382 3

The PIP Expanded Guide to the: Nikon F80/N80
Matthew Dennis
ISBN 1 86108 348 3

The PIP Expanded Guide to the: Canon EOS 300/Rebel 2000 Matthew Dennis
ISBN 1 86108 338 6

Travel Photography: An Essential Guide Rob Flemming
ISBN 1 86108 362 9